MARY BLACK'S
FAMILY QUILTS

746.46 H789m
Horton, Laurel
Mary Black's family quilts :

MARY BLACK'S FAMILY QUILTS

Memory and Meaning in Everyday Life

LAUREL HORTON

Foreword by Michael Owen Jones

University of South Carolina Press

© 2005 Black & Phillips Foundation, Inc.

Published in Columbia, South Carolina,
by the University of South Carolina Press

Printed in Canada

09 08 07 06 05 5 4 3 2 1

Library of Congress Cataloging-in-Publication Data

Horton, Laurel.
 Mary Black's family quilts : memory and meaning in everyday life / Laurel Horton ; foreword by Michael
Owen Jones.
 p. cm.
 Includes bibliographical references and index.
 ISBN 1-57003-609-8 (cloth : alk. paper)—ISBN 1-57003-610-1 (pbk. : alk. paper)
 1. Black, Mary Louisa Snoddy, 1860–1927—Family. 2. Quiltmakers—South Carolina—Biography.
 3. Snoddy family. 4. Black family. I. Title.
 NK9198.B57H67 2005
 746.46'09757—dc22

 2005013004

TO DAN PATTERSON

Material culture may be the most objective source of information we have concerning America's past. It certainly is the most immediate. . . . If we bring to this world, so reflective of the past, a sensitivity to the meaning of the patterns we see in it, the artifact becomes a primary source of great objectivity and subtlety.

It is terribly important that the "small things forgotten" be remembered. For in the seemingly little and insignificant things that accumulate to create a lifetime, the essence of our existence is captured. We must remember these bits and pieces, and we must use them in new and imaginative ways so that a different appreciation for what life is today, and was in the past, can be achieved.

—James Deetz, *In Small Things Forgotten*

Material culture is as true to the mind, as dear to the heart, as language, and what is more, it reports thoughts and actions that resist verbal formulation. Like a story, an artifact is a text, a display of form and a vehicle for meaning. . . . The artifact has its own way to meaning, and in learning it we begin to hear the voices in things, the screams of the stone gods prisoned behind glass in the museum. Then we accept the strange responsibility of putting into words that which is not verbal.

—Henry Glassie, *Material Culture*

CONTENTS

ILLUSTRATIONS

FOREWORD

LIKE THE SIXTEEN QUILTS collected by Mary Black throughout her life, many objects made by hand in the past perplex us. Who created these things and why, we wonder. How and when were they constructed? For what purposes, and for whom, were they produced? What values do they embody, and what meanings were ascribed to them? In regard to Mary Black, how did she acquire the items, and why did she bequeath them to others? The greatest puzzle of all, however, may be what methods—concepts, assumptions, and analytical approaches—can we employ to answer these questions.

Laurel Horton has devoted her career to researching quilts, quilters, and quilt-making. Her studies have taken her to Sweden, Great Britain, and various parts of the United States. She has traveled through time, from the present to several centuries in the past. Her thirty years of work provide the foundation for this book, which is a unique contribution not only to exploring quiltmaking traditions among specific individuals in a particular place, but also to developing procedures that others can utilize in their own investigations.

In seeking to understand how and why the quilts in Mary Black's collection came about, as well as their role in the daily lives of family, friends, and community, Laurel Horton draws upon oral history interviews and archival materials. She immerses herself in written documents such as personal letters, journals, ledgers, wills, estate records, newspaper articles, obituaries, and census reports dating back to the eighteenth century. She ferrets out financial resources, household belongings, religious precepts, community values, local customs, family history, biographical data, relationships among individuals, and experiences of Mary Black and her forebears that relate to textile traditions.

In addition to examining written documents, Laurel Horton closely scrutinizes each quilt. She discerns the materials and analyzes the techniques of construction. When viewing the patterns and colors of a quilt, she notices the dyes used (an important factor in dating the material), the care exerted in cutting and assembling the pieces (a clue to skill, interest, and attitude), and the hues chosen (a basis for inferring taste, aesthetics, and preferences). She pays as much attention to the back and inside of the quilt as she does to its top.

Throughout her book Laurel Horton seeks to uncover the material and social influences on the quilts and their construction, along with the various meanings and significance assigned to these textiles by makers, recipients, and other individuals in the immediate locale. She writes, "Mary Black's collection reflects the quiltmaking activity of a single family within a specific time period in one geographic area."

This book does not take the broad cultural approach typical of so many works on quilts and other artifacts, but neither is it parochial when it insists on documenting particular individuals, their relationships and interactions, and the multivalent meanings attributed to objects. The term *material culture* at minimum describes the tangible things crafted, altered, or used by people. Despite its "bristling ugliness" (George Kubler, *The Shape of Time,* 1962), the term had caught on by the 1960s. However, the appellation *material culture* coincides with a particular bias and preoccupation in research. "The assumption is that there is always a culture behind the material," contends Thomas J. Schlereth in *Material Culture* (1985). Further, he insists, the designation *material culture* "simultaneously refers to both the subject of the study, material, and to its principal purpose, the understanding of culture." This, however, is not Horton's goal or method. Rather, she seeks to determine how "a particular combination of circumstances and influences has resulted in a unique configuration of patterns, fabrics, motivations, and meanings." As she acknowledges, "The accumulated quilts of other families, near or far, would evince different conditions and resources."

Horton's method exemplifies a behavioral approach to research on objects and their makers and users. As I defined it in an article in *Western Folklore* (1997), "material behavior"—short for "material aspects and manifestations of human behavior"—refers first of all to activity involved in producing or responding to the physical dimension of our world. Material behavior also includes objects and the processes by which they are conceptualized and fashioned, along with the uses to which they are put. It consists, too, of the motivations for creating things, sensations involved in fabricating the objects, and reactions to artifacts and their manufacture. Material behavior encompasses matters of personality, psychological processes, and social interaction in relation to the things created. It also comprises ideas that people associate with objects, the meanings they attribute to them, and the ways in which they use them instrumentally as well as symbolically.

It is with these elements of a material behavior approach that Laurel Horton is concerned. In her study of Mary Black's collection of quilts, she emphasizes motivation, meanings, creative processes in construction, identities and relationships among makers and recipients, and the symbolic significance of specific elements in a quilt or of the quilt as a whole. A number of studies utilizing the method of material behavior have appeared, particularly since the mid-1980s. Among them are Linda Pershing's *"Sew to Speak": The Fabric Art of Mary Milne,* Simon Bronner's *Chain Carvers: Old Men Crafting Meaning,* and my book *Craftsman of the Cumberlands: Tradition and Creativity.* These are ethnographic accounts based largely on interviews with and observations of contemporary behavior. The

past plays a relatively minor role in these studies compared to the present. Laurel Horton, however, reverses this relationship. She interviewed people, yes, but most of her documentation concerns objects and their makers long ago and therefore derives from records generated in earlier eras. Her research demonstrates the utility of the method of material behavior for historical studies. Her book, in fact, is a model for such investigations. It will inspire and guide other researchers, whether they seek to understand quilts or the making and using of other objects made in the past.

MICHAEL OWEN JONES

PREFACE

MY WORK ON THIS BOOK began in December 1997, with a phone call from Dr. Janice B. Yost, who was at that time president of the Mary Black Foundation in Spartanburg, South Carolina. She briefly described to me a collection of quilts that had belonged to Mary Black, for whom the foundation was named, and asked me if I would be interested in researching and writing a book about them. Intrigued, I agreed to meet with Jan and two of Mary Black's granddaughters, Marianna Black Habisreutinger and Paula Black Baker. When I talked with these women and saw the quilts, I knew immediately that this could be an important book and that I was uniquely positioned to write it.

I have conducted research on quiltmaking traditions since 1975. From 1983 to 1985, I directed the South Carolina Quilt History Project sponsored by the McKissick Museum, and this opportunity gave me an overview of quiltmaking traditions throughout the state. Subsequent research projects have allowed me to explore some of the puzzles and intricacies of human involvement with quilts, but they also produced additional questions and mysteries. Learning the identity of a quiltmaker or the local name for a pattern provided useful information, but somehow this was not enough. What seemed to be missing from my research was a real understanding of the *meaning* of quilts in the daily lives of the people who made or inherited them. I found myself envisioning an in-depth project that would allow me to study a specific group of quilts in more detail within the context of a family and community. The opportunity to research Mary Black's family quilts has allowed me to fulfill that desire.

I started my research for this book with a close examination of the quilts themselves, attempting to set aside what I thought I already knew and trying to be receptive to what they could tell me. My interpretations and analyses of these primary sources are supported by what I have learned about quilts during more than a quarter century of research. As I look back, the majority of my research projects have related in some way to the present work, from my 1979 thesis on nineteenth-century Scots-Irish quilts to research in British Isles and Sweden. In support of this artifact-based approach, I have also relied on family documents, interviews, public records, archival collections, and published sources. These sources alone, however,

would have been insufficient. Women in our culture have left comparatively few documents, and the quilts themselves have remained primary sources.

I have attempted to attend to the quilts and "listen" to their stories objectively, without rushing to supply answers to my emerging questions. Given the impossibility of real objectivity, I have tried to separate supportable statements of fact from my own speculative observations. In the text my unsupported hypotheses are couched in conditional terms, that is, I suggest what *might* have been true. As human beings we are story-telling animals; and, given a string of unrelated data, we automatically connect the dots into a narrative. Without this narrative impulse, we would be unable to interpret the meaning of factual material. With it I have created a story that interprets, to the best of my knowledge and understanding, the lives of Mary Black and her family.

ACKNOWLEDGMENTS

I AM DEEPLY GRATEFUL to Marianna Habisreutinger and Paula Baker for their generous and enthusiastic support of my work on this book. They helped locate what family documents have survived and contributed their own family memories and reflections. Their steadfast patience and encouragement sustained my work, even as the project grew beyond the scope they had originally imagined. I appreciate their willingness to share my vision of a book that would not only honor their grandmother but also make a major contribution to the study of American quilts.

Mary Black's other grandchildren, Sam Orr Black Jr. and Shirley Black Barre, also graciously shared their memories, family stories, and personal reflections of their grandmother and other family members, and I regret that they did not live to see this book. Among Mary's great-grandchildren, Wally Barre was helpful in lending me family artifacts, and Sallie Barre James gave the first draft of the book a careful reading shortly before her untimely death. Jane Snoddy Cook and Margaret Snoddy Culclasure, Mary Black's great-nieces, graciously supplied me with information, genealogical charts, copies of documents, and a drive-by orientation to the area. Jimmy (James Dunlap Snoddy Jr.) and Mary Neely Snoddy generously offered access to the latter's meticulous transcription of the journals of Mary Black's brother, James Robert Snoddy, and their compiled genealogical materials were invaluable. Miss Agnes Coleman, church historian and a longtime friend of the family, shared her living memories of Mary Black. Without these individuals and their memories and materials, my work would have been much more speculative and insubstantial.

The staff of the Mary Black Foundation provided me with workspace, photocopies, refreshment, and other assistance and encouragement on a number of occasions. I am grateful to President Philip B. Belcher and current staff members Amy M. Page, Molly Talbot-Metz, Christina Godfrey, Amy D. Herd, and Curt McPhail as well as former staff members Dr. Janice B. Yost, Mary Kuehne, Allen Mast, Sheila Davis, and Jill Samith. Special thanks to Jim Quick and the late Cheryl New of Polaris Corporation, who recommended my work to the foundation. Betsy Wakefield Teter, executive director of the Hub City Writers Project,

shared copies of this group's fine publications on Spartanburg history. Susan Turpin, executive director of the Spartanburg County Historical Association, generously offered administrative support and an extensive knowledge of local history.

To provide a ground for the contributions of human resources and family documents, I have relied heavily on published and archival sources. I wish to thank the helpful staff members of library and archival collections: the Spartanburg County Library; the Greenville County Library; the Oconee County Library; and the South Carolina Department of Archives and History. Allen Stokes, director of the South Caroliniana Library at the University of South Carolina, and Edith Brawley, archivist and cataloger at Erskine College Library, were particularly generous with their advice and assistance. Special thanks also are due to Linda Dennis, director of Alumni Affairs, and Dan Lee, reference librarian, both at Lander University; Bill Bynum, Presbyterian Historical Society, Montreat, N.C.; Joey Gainey, Spartanburg County Law Library; Jim Harrison, Converse College Archives; Phillip Stone, Wofford College Archives; and the Rev. Chuck Wilson, former pastor of the Oconee Associate Reformed Presbyterian Church.

The work of a writer would be lonely indeed were it not for the sustenance of a few good friends and colleagues, particularly Kathy Staples, Paul Jordan-Smith, and Nancy Jackson. Finally, life and work, as I know it, would be much less joyous and fulfilling without the presence of my husband, Wayne Richard.

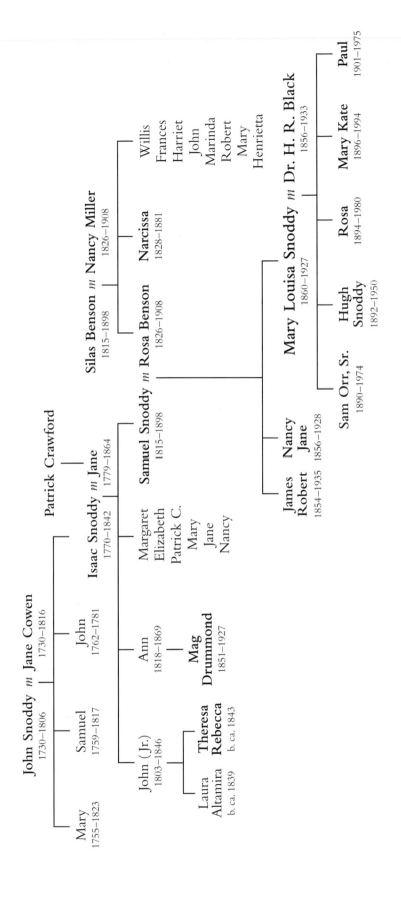

Snoddy/Benson/Black Families

Family members named on quilt labels are indicated in red.

MARY BLACK'S
FAMILY QUILTS

INTRODUCTION

Who Was Mary Black?

THIS BOOK EXPLORES the changing functions and meanings of quilts within the life of a South Carolina family from the late eighteenth century to the present day. At the heart of this story is Mary Louisa Snoddy Black (1860–1927), who accumulated sixteen quilts made by women in her family and made an effort to ensure that these women and their work would be remembered by later generations. Looking backward into the lives of Mary's ancestors, we can better understand the motivations and choices made by quiltmakers within the social and economic contexts of their lives. Looking forward through the lives of Mary's children and grandchildren, we can see how the quilts have continued to function within the collective memory of the family and community.

Sometime in the mid-1920s, Mary Black gathered with her two adult daughters, Rosa and Mary Kate, to pass on to them the responsibility for the family heirlooms, which included jewelry and clothing as well as the quilts. A family inheritance of sixteen quilts is not, in itself, noteworthy. What makes this collection unique is that Mary and her daughters attached a written label to each quilt explaining its significance. Because of these labels, we can look beyond the intrinsic physical evidence of the quilts themselves and attempt to analyze and interpret the changing functions and meanings of quilts for this family within historic and geographic contexts.

The passing of family heirlooms from one generation to the next is a common practice. The transfer of such objects is often accompanied by oral narratives about their connection to members of the family. For Mary each quilt contained the seeds of stories about the intertwined lives of the women in her family. She

LEFT *Mary Louisa Snoddy Black (September 5, 1860– March 11, 1927).*

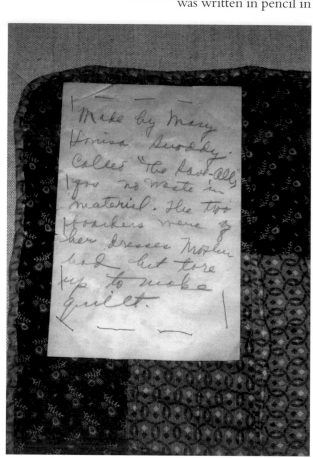

Information about each quilt was provided by Mary Black and written on the labels by Mary Kate Black.

valued these stories, but she also recognized the fragility of relying solely on oral transmission for such information. The written descriptions, brief as they are, include details that would certainly have been forgotten and lost had they not been committed to paper.

The small rectangular labels were cut from tablet paper, and the information was written in pencil in Mary Kate's characteristic spidery handwriting under her mother's direction. The labels were attached to the quilts, not with metal pins, which might become dislodged or leave rust marks, but with stitches. This decision indicates that the labels were not merely temporary reminders but were intended to remain as permanent records of the quilts' provenance. As Mary Kate did the writing, it seems likely that her older sister Rosa took needle and thread and sewed the labels to the quilts with large stitches. Mary could have written and attached these labels herself. Instead, she involved Rosa and Mary Kate in the physical process of labeling the quilts, apparently hoping that they might experience a more personal connection with the generations of women in their family.

The labels contain, at most, a few sentences, providing such information as the identity of the maker, the source of the fabrics, the pattern name, and the purpose for which the quilt was made. In many cases, the names and relationships of family members are given in full, as in official records or legal documents. This degree of detail would have been unnecessary for Rosa and Mary Kate, therefore it seems clear that Mary Black provided these details for the benefit of future generations.

The sixteen quilts in Mary Black's collection were made between about 1850 and 1917. During the nineteenth century, quilts were closely associated with the traditional roles of women as maintainers of the home and family. Quilts functioned as a kind of currency in an informal, female-centered economy based on kinship, mutual support, and the transformation of ordinary materials into objects of significance and value. The short textual descriptions attached to Mary Black's quilts provide clues to the interactive processes of construction and the importance of exchanging gifts. Mary's quilts were tangible evidence of her relationships to other women in her family and community.

Quilts have been the subject of serious research and analysis beginning in the 1970s.[1] Since that time, hundreds of books and articles have explored the history of quilts and their makers in the United States, Australia, and several European countries. National, state, and regional surveys of large numbers of quilts have contributed greatly to a better understanding of historical trends and regional

variations in quiltmaking.[2] While these large-scale studies have identified the names of thousands of quiltmakers, they were not designed to examine the lives of these women and men in detail. Other researchers have addressed this need by publishing biographical portraits of noteworthy individuals.[3]

Biographical studies are essential in order to refine our knowledge of American quiltmaking. However, individual biographies tend to describe their subjects as *quiltmakers,* as if that were their predominant or only role in life. Life roles, however, are not one-dimensional. For Mary Black, as for countless other Americans who made quilts, quiltmaking was not her only occupation; it was simply one activity among many that engaged her in different ways at different stages of her life.

The Mary Black Memorial Hospital is familiar to residents of Spartanburg, South Carolina. Some may be aware that Mary's husband and sons were doctors and chose to honor her when they first established the hospital. Others have no idea who she was. In outward accomplishment Mary Black was not an extraordinary woman. She lived her entire life in the vicinity of Spartanburg, South Carolina. Her devotion to her husband and five children and her contributions to her church and community have left few impressions on the written historical record. Only a few personal letters survive to tell her story in her own voice, and few people who knew her are still living. The bits of memory that survive, however, all point toward a woman of admirable character. Mary's death in 1927 elicited an outpouring of heartfelt letters of condolence describing her warmth, generosity, and piety. Though she led an ordinary life, Mary Black seems indeed to have touched many lives in special ways.

Many writers in the 1980s and 1990s have pointed out that quilts can be read as documents of the lives of ordinary individuals and families. Unlike a written narrative, however, the meanings expressed by an artifact are not presented in a straightforward, linear fashion. Just as with written documents—a personal diary, for example—a reader may have to translate, read between the lines, or rely on additional documentation to come to an understanding.

Scholars in various fields have long stressed the importance of the study of material culture, which is frequently interpreted as the study of *objects.*[4] Folklorist Michael Owen Jones has suggested the term *material behavior* to expand the scope of this research direction:

> Material behavior includes not only objects that people construct but also the processes by which their artificers conceptualize them, fashion them, and use them or make them available for others to utilize. . . . Material behavior encompasses matters of personality, psychological states and processes, and social interaction in relation to artifacts. It also comprises ideas that people associate with objects, the meaning they attribute to them, and the way in which they use them symbolically and instrumentally.[5]

The detailed study of the material behavior of a living quiltmaker would be challenge enough, but the attempt to identify these influences through the surviving

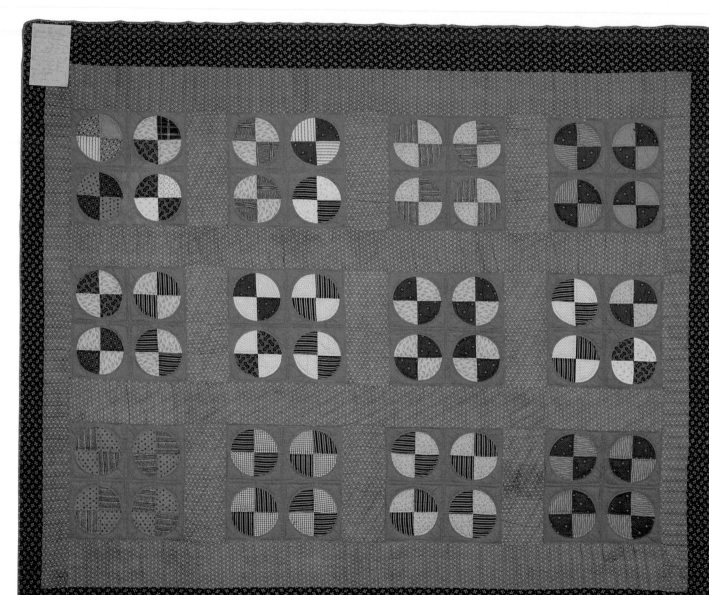

quilts of past quiltmakers is even more daunting. Interpretation of material artifacts also requires an ability to recognize the significance of the particular combination of clues embedded in the object itself within the context of other available written, oral, and comparative data. In this process the effective researcher needs to have established a broad knowledge base and must rely on both cognitive and intuitive functions. The greatest danger is that pre-existing assumptions and emotional identifications inhibit one's ability to see an object clearly, and, while it is impossible to eliminate these influences, one must attempt to recognize and circumvent them. Interpretation traces a fine line between description and imagination, between fact and fancy; and the researcher must accept that there will be many questions for which no adequate answers are available.

The Save All Quilt

"Made by Mary Louisa Snoddy. Called 'The Save All,' for no waste in material. The two borders were of her dresses Mother had but tore up to make quilt."

A detailed analysis of one of the quilts in Mary's collection demonstrates how clues in the physical artifact can be combined with contextual materials to reveal aspects of the maker's life and her character. The three short sentences on the handwritten label, written down by Mary Kate Black from her mother's dictation, record the facts that Mary regarded as important to future generations: the identity of the maker, the name of the pattern, and the source of the material. From these simple statements much more can be extracted by a careful reading.

The statement "Made by Mary Louisa Snoddy" does more than just identify the maker. Mary Kate abbreviated information elsewhere, but here she wrote out her mother's maiden name completely. The form of the name not only reveals that Mary made this quilt before her marriage in 1889, but it also suggests Mary's pride in her own identity and family connections.

Mary's Save All is an example of a family of patterns usually called Rob Peter to Pay Paul today. These patterns became popular during the late nineteenth century and were published under many names during the twentieth.[6] The common element is the basic design unit of a square, from which a quarter-circle appears to have been removed and replaced with a contrasting fabric. The particular pattern name, Save All, and the phrase "no waste in material" support one of the traditional values associated with quiltmaking: thrift.

The pattern name and the written label suggest that thrift is the predominant value expressed by this quilt, but the construction and materials tell another story. The visual appearance of the pattern is deceiving. One might assume that the convex piece cut from one fabric square might be used in another block, but this is not the case. The maker must add seam allowances, typically about a quarter-inch, on all sides when cutting out the templates for a quilt pattern. The addition of seam allowances to both the concave and convex parts of the quilt pattern results in two curved edges that no longer match. The maker could still place the templates relatively close together when cutting the fabric, but the claim of "no waste in material" is not entirely accurate.

LEFT Plate 1. "Made by Mary Louisa Snoddy. Called 'The Save All,' for no waste in material. The two borders were of her dresses Mother had but tore up to make quilt." Hand-pieced by Mary Snoddy, ca. 1880, 95 × 85 inches. Cotton printed fabrics, moderately thick cotton batting, backed with unbleached sheeting. Quilted by hand, following pieced seams. Applied straight-grain binding of brown print fabric.

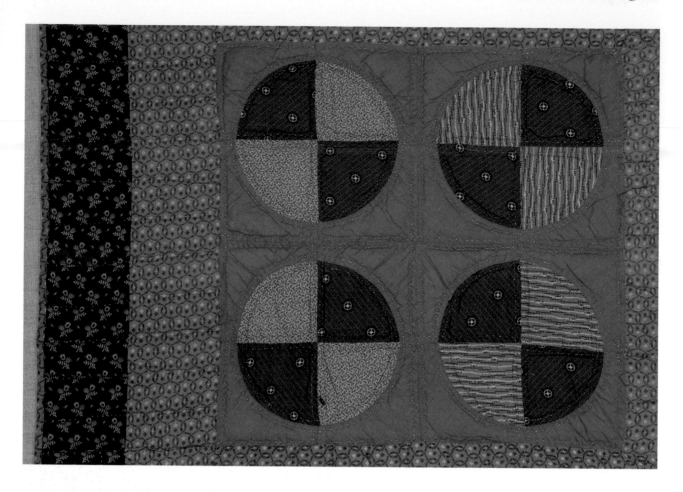

Plate 2. Save All quilt—detail. At least twenty-one different fabrics were carefully selected, cut, and arranged to create contrast between the dark, predominantly brown, fabrics and the lighter ones. The blocks are unified through the use of a single blue fabric for all of the concave corners.

Making a quilt can express thrift in a number of ways, but it is rarely the only factor or even a major motivation. The cotton fabrics in Mary's quilt are all of good quality. The weight and the scale of the printed patterns are typical of late nineteenth-century fabrics manufactured in New England's textile mills and shipped to southern dry goods stores. Spartanburg County did not develop into a major textile production center until the end of the century; consequently, the quilt contains no local materials.

The fabrics in the Save All blocks were probably remnants left from family sewing. If the maker's intent had been to use up whatever fabric scraps were available, the resulting quilt would likely include many different colors and a variety of plain and printed fabrics. The fabrics in this quilt were not used randomly, however, but were carefully selected, cut, and arranged to form a pleasing overall appearance. At least twenty-one different fabrics are represented in the blocks, yet the color palette is carefully controlled to create contrast between the dark, predominantly brown, fabrics and the lighter ones. The blocks are unified through the use of a single blue fabric for all of the concave corners; the quarter-circle remnants from this fabric were not used elsewhere in this quilt. Mary Black expressed thrift by making use of small pieces of perhaps otherwise unusable leftovers, but

the overriding message conveyed by this quilt is one of careful attention to the selection and placement of color and value.

The inscription on the quilt describes a second form of thrift. Without the written label, we would never have known that the fabrics in the "two borders were of her dresses Mother had but tore up." The use of recycled clothing in quilts is frequently misunderstood as an indication of poverty. It is often assumed that fabrics were so scarce that they were reused by necessity. Before the development of the throwaway culture of the late twentieth century, however, even wealthy families actively practiced thrift and recycling. Anything valuable that was not immediately needed was reused, stored, sold, or given away rather than discarded. This practice included clothing and fabric as well as tools, furniture, and other household items. Skirts of the Victorian era contained many yards of fabric, which would have been considered a valuable resource to be reused when the dress was no longer needed.

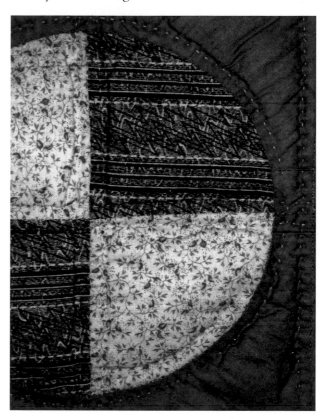

Mary carefully pieced the curved seams of her Save All quilt.

Mary Snoddy tore up her dresses not because they were worn out or because this was the only fabric she had available for her quilt, but because the dresses had either gone out of style or no longer fit. She might have attempted to alter and update them, or she could have given them away to servants or her less affluent neighbors. She chose instead to incorporate the fabric into her quilt, in this way transforming items of diminishing value—the dresses—into something with a different function but retaining some of the personal associations of the original clothing.

The fact that the dresses Mary recycled for this quilt were made of cotton is consistent with what is known about her personal philosophy. During the 1880s silk was the preferred fabric for women's dresses for those who could afford it. The Snoddy family was wealthy by local standards, but Mary took seriously the virtues of modesty and humility prescribed by her Christian faith. She wore a brown silk dress for her wedding, but surviving documents from her school years indicate that as a young woman she chose to wear cotton dresses instead of more fashionable silk gowns.

The quilt is carefully constructed, indicating that Mary was an accomplished seamstress. The curved seams are pieced by hand with precision, and the seams match perfectly. The placement of the blocks, however, suggests that Mary made decisions to expedite the completion of her quilt rather than to prolong the construction process. The twelve pieced blocks are separated by five-inch-wide strips of the inner-border fabric. She could have made more blocks—twenty perhaps— and joined them with narrower strips and still have produced a quilt of similar

size. Instead she used more of the recycled dress fabric and fewer small fabric remnants. She seems to have negotiated a balance among various expressions of thrift in regard to available materials and time.

The Save All quilt is over a hundred years old, but there are no signs of wear to indicate that it was ever used regularly as a bedcover. In fact, none of the quilts in the Black family collection show evidence of serving what is thought to be the primary function of a quilt. If the quilts were not made to be used as bed-covers, what, then, was their intended function? On one level, this collection of quilts can be viewed as a stockpile, a cache of household goods reserved against future need. On another level, the quilts represent a family archive, or even a repository of personal capital, reflecting the commerce of women's mutual obligations and relationships.

Mary's Save All quilt, then, is not a simple statement about thrift. Instead it is the product of a complex interplay of values and choices. The theme suggested by this quilt, of starting with sufficient resources and continuing to use them efficiently and effectively, without waste and without ostentation, is emblematic of the philosophy espoused by the maker throughout her life. The other quilts in Mary Black's collection illustrate the values and experiences of the family through the generations, beginning with the arrival in this country of her great-grandparents and continuing through the lives of her descendants.

Mary's foresight in providing written documentation for her quilts suggests that she perceived them not just as individual objects but as a *collection*. The number of quilts and the care with which they were labeled point to a conception of them as members of a set, a group of similar objects, having value not only as individual pieces but as a cumulative *body,* the culmination of the work of many hands. As a group the quilts form episodes in a story of women's lives over time. The value of the whole collection becomes greater than the sum of its individual quilts.

As James Deetz urges, it is terribly important that those "small things forgotten," the ordinary objects that remain from past generations, be not only remembered but examined in "new and imaginative ways" in order to achieve "a different appreciation for what life is today, and was in the past."[7] Within the context of Mary Black's life, the quilts may be seen as a reflection of her relationships, her economic philosophy, and the personal values she inherited, espoused, and passed on to future generations. There are many ways to approach the history of a family, and this book is an attempt to use quilts as the key to recovering the stories and unlocking the meanings and memories of the family's everyday life, through the generations from their arrival in South Carolina up to the present. 🙰

"ARRIVED FROM IRELAND AND THIS DAY PETITIONED FOR LAND RIGHT"

The First Two Generations of the Snoddy Family in South Carolina, 1773–1850s

TO UNDERSTAND THE WAYS quilts were made and valued by Mary Snoddy Black and her family, it is useful to examine first the lives of their ancestors. No family textiles and few documents survive from the first two generations of the Snoddy family in South Carolina, but general information about family life and textiles in the late eighteenth and early nineteenth centuries provides clues for recreating their experiences and interpreting the role of quilts in their lives.

Life in the Carolina Backcountry

The story of Mary's family in America began with the arrival of her great-grandparents in South Carolina in 1773. The Snoddys were among the quarter-million emigrants from the north of Ireland who came to the American colonies during the eighteenth century.[1] Many of these Ulster Scots, or Scots-Irish, settled in South Carolina and greatly influenced the state's agricultural, religious, cultural, and textile traditions.

In 1670, a century before the arrival of Mary's ancestors, English colonists had established Charles Town, later called Charleston, as the first permanent European settlement in South Carolina. Throughout the eighteenth century, Charles Town served as the major port of the southern colonies and supported the development of a wealthy society based on exports of agricultural commodities and forest products. For the first century, the European population of the colony remained in the *lowcountry,* close to the coast.

At this time the Carolina *backcountry,* the comparatively inaccessible country beyond the coastal plain, was home to a number of native peoples, including the

*Spartanburg County,
showing nineteenth-century
boundaries and locations.
Based on the work of
E. M. McCollogh, 1887.*

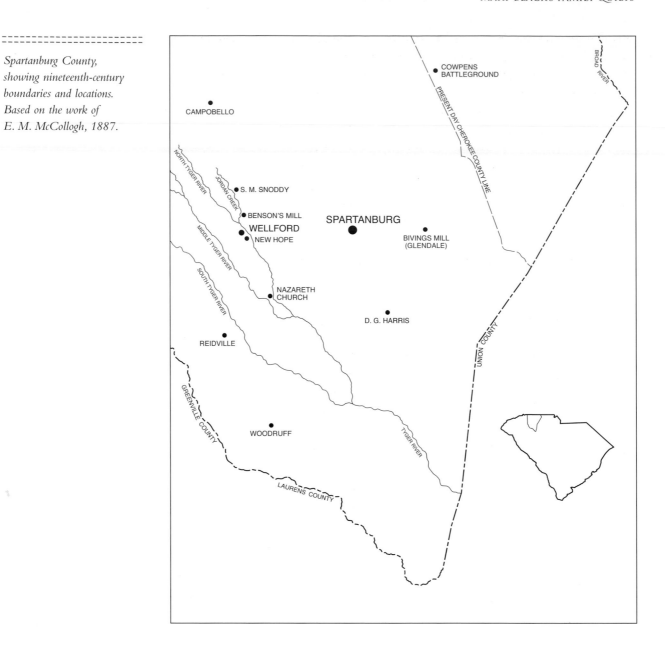

Cherokees. Throughout the late seventeenth and eighteenth centuries, white traders carried on an active and lucrative trade with native villages, resulting in the establishment of a number of backcountry trading posts. Cherokee villagers brought large quantities of furs and deerskins to these outposts to exchange for blankets, fabric, guns, and ammunition of European manufacture.[2] By the end of the eighteenth century, through the cumulative effects of treaties, smallpox, and armed conflict, the Cherokees gradually ceded to the colonial government their lands, including the area that became Spartanburg County.[3]

Nearly all of the first white colonists to settle the Carolina backcountry arrived not as an expansion of the southern coastal population but as an extension of an

inland migration trail from Pennsylvania through the Shenandoah Valley into Virginia and the Carolinas. Among the new arrivals who followed the Great Wagon Road from Pennsylvania to the South Carolina backcountry in the 1760s were Mary Black's ancestors on her mother's side: the Bensons, Millers, and Vernons.[4] These families staked out land claims in what would become Greenville and Spartanburg counties. Within a few years they were joined by additional Scots-Irish families coming directly through Charleston. These included Mary Black's ancestors on her father's side: the Snoddys, Crawfords, and Cowens.[5]

Mary Black's paternal great-grandparents, John and Jane Cowen Snoddy, came from County Antrim, near the town of Larne.[6] The Snoddys departed from Belfast on the ship *Pennsylvania Farmer* on October 16, 1772, and arrived in Charles Town on January 6, 1773.[7] John and Jane Snoddy were both forty-three years old, and their family included daughter Mary, age eighteen, and three sons, Samuel, age fourteen; John, age eleven; and Isaac, age three. Isaac would become Mary Snoddy Black's grandfather. John's uncle, Samuel Miller, traveled with them and reportedly carried young Isaac on his shoulders as the family left the ship.

One of the primary motivations for immigration to the American colonies was the availability of land. Colonial governments offered land grants to immigrants willing to settle in the backcountry. Local authorities in Charleston maintained lists of new arrivals and their applications for land warrants. "A List of Passengers arrived from Ireland in the Ship Pennsylvania Farmer and this Day petitioned for Land right" enumerated the Snoddys among the majority of passengers who were identified as "poor people who have sworn they are not worth £5 each." As head of household John received a warrant for three hundred acres, and daughter Mary and son Samuel were entitled to one hundred acres each.[8]

Emigrants typically carried few material goods with them on the passage, but Snoddy descendants still possess artifacts the family brought from Ireland, including John Snoddy's brier pipe, Samuel Miller's flint-lock shotgun, and a child's split-bottom chair belonging to Isaac. They would have purchased supplies in Charles Town and arranged for a wagon to carry their belongings inland. Travelers typically made the journey on foot, following the old Indian trading path further worn by thousands of newcomers who preceded them.[9]

Beyond the coast the path branched and led to scattered backcountry settlements, but the Snoddys knew where they were going. Their wealthier neighbors in Ireland, the Vernon family, reportedly emigrated earlier, about 1770, and went first to New Jersey before moving to what is now Spartanburg County. The "comparatively poor" Snoddys corresponded with the Vernons and, having determined to join them, took the more direct route through Charles Town.[10]

Arriving at their destination, the Snoddy family staked their claims on Jimmie's Creek, a tributary of the Middle Tyger River, in present-day Spartanburg County.[11] John's claim was described as "Bounded on all Sides by Vacant Land," but the Snoddy family immediately became part of a dispersed community of other Scots-Irish immigrants.[12] The land was heavily wooded, and new owners, including the Snoddys, needed to secure their survival by clearing trees, building

shelter, and preparing fields for planting. New colonists typically built makeshift shelters of branches covered with dirt to protect them from the elements until they could construct more substantial log or frame cabins. There is evidence that the Snoddy family, like their neighbors, built a succession of larger houses over the years as their economic conditions improved.[13]

Newly arrived families worked quickly to clear land and establish their farms. Besides growing food for their own use, settlers gathered or produced goods for the lowcountry market, including cattle, tobacco, deerskins, tallow, ginseng, hemp, flax, beeswax, and iron wares. Transporting these products to the coast was difficult but lucrative for those who had the means for hauling goods back and forth. According to a local writer, "wagoneers were among the first capitalists; and it was possible in the years immediately preceding and during the Revolutionary War for a man and a four-horse wagon to make as much as 300 percent on a trip from the upstate to Charles Town."[14]

During the 1760s the Carolina backcountry settlements were vulnerable to attacks from roving bands of outlaws who looted homes and killed or injured their occupants.[15] "Frontiers attract the lawless, and the great grievance of honest back settlers was their lack of any legal means to repel or drive out the motley crew of adventurers and criminals that arrived among them."[16] Colonial government officials in Charles Town provided no defense, so local settlers built a series of forts to house families fearing attack, and they formed impromptu offensive companies, sometimes called "regulators."

Early backcountry settlers lacked access to other government services as well. At first they had to travel to Charles Town, a week each way, to register deeds, vote, or conduct other official business. In 1772 the establishment of a backcountry district court in the town of Ninety Six provided some relief. By the time the Snoddy family arrived in 1773, the distant colonial government had begun to address some of the grievances of the growing backcountry settlements. By 1776 new administrative districts were established, including a new "Upper or Spartan District," in response to demands from the rapidly expanding backcountry population.[17]

The Tyger River area was officially part of the colony of South Carolina, but the growing settlements were adjacent to the border of the Cherokee nation (now the border between Greenville and Spartanburg counties). During the 1770s the Cherokees responded to threats and encroachments on their remaining lands by attacking white settlements. The Snoddy family did not suffer directly from Indian attacks, but some of their neighbors were massacred or injured. The family of Anthony Hampton, who lived near the South Tyger River, were killed, and James Reed survived an Indian attack "at the old ford on North Tyger River, a short distance below Snoddy's Bridge."[18]

According to an oral family narrative, the Snoddy family protected young Isaac from the threat of marauders by hiding him in a field of tall grass during the day.[19] The nearby home of the Bishop family was attacked by Indians, the father killed, and three small children carried off. The children lived with the Cherokees for

six months before a neighbor arranged for them to be returned to their mother.[20] No doubt the news of these events elicited genuine fears for young Isaac's safety, and these experiences were repeatedly retold as cautionary tales to children and grandchildren.

Within a few years of the Snoddys' arrival in South Carolina, the American colonies fought a war for independence from Great Britain. The key role of the Carolina backcountry in the Revolutionary War is well documented, if not widely acknowledged.[21] Patriot victories in the battles of Kings Mountain and the Cowpens reversed what appeared in 1780 to be a successful subjugation of the colony by the British forces.[22] Although these battles form the basis of the historical account of the war, they merely punctuated an ongoing brutal struggle between backcountry residents called Whigs or Patriots, who favored independence, and those called Tories, who remained loyal to Britain. Historian Walter Edgar describes the American Revolution in South Carolina as a *civil* war: "Many of the atrocities—and *atrocity* is not too strong a word—committed in the civil war in South Carolina were initiated by British regulars or their Tory allies. Patriot militia bands responded in kind, and the violence escalated into a fury that laid waste to entire communities."[23] The larger issue of independence versus loyalty became secondary to more immediate threats to life and property.

The Snoddys supported the Patriot cause. John's two older sons served in Roebuck's Regiment of Anderson's Return.[24] Samuel was twenty-one years old in 1780. He survived the war and was later known by his military rank of "Captain Samuel" to distinguish him from others with the same name. John, age nineteen, was killed by Tories led by "Bloody Bill" Cunningham at a fortification at Poole's Iron Works near the end of the war in 1781.[25]

The ancestor whose memory is most frequently evoked by the family, however, is Patrick Crawford. Born in Ireland in 1750, Crawford immigrated to the Tyger River with his wife and children, including daughter Jane, who would become the grandmother of Mary Snoddy Black. During the Revolutionary War, Crawford fought on the Patriot side with Capt. Andrew Barry's militia company. In 1781 Patrick Crawford was mistakenly shot and killed by his friend Thomas Moore. According to one version, "the Patriots were camped on the steep bank of a local, small stream. Before dawn young Patrick slipped down to get a drink without telling the sentry. When he returned, the sentry thought he was an enemy soldier and shot him."[26] The more frequently quoted version of the story was collected and published by local historian J. B. O. Landrum:

> The company was to rendezvous at the two roads above Cashville for the purpose of following up a noted Tory scouting party. Two parties of said company came in contact, each believing the other the enemy they were seeking. Patrick Crawford was at the head of one of the Whig scouts and was killed before the mistake was discovered. Thomas Moore took deliberate aim and killed him in the fight, which continued until Captain Barry's noted dog trotted between the combatants, and seeing old Hunter, as the dog was called, they at once realized their mistake and ceased firing.[27]

The regrettable circumstances of Patrick's death had a powerful effect on later generations. The story was frequently retold within the community and periodically reprinted in newspaper articles during the following two centuries. In 1897 Mary Black's father erected a monument marking the spot where his grandfather died.[28] Throughout the twentieth century, family descendants took their children to this nearly inaccessible spot and photographed them with the monument honoring their ancestor.

In 1916 Mary Black and her daughters Rosa and Mary Kate referred to the incident of Crawford's death when they applied for membership in the Daughters of the American Revolution, an organization open to women descended from men who fought in that war. In their application forms, they traced their lineage to Patrick Crawford, not only citing his company and the date of his death but retelling the story as published in Landrum's *History of Spartanburg County.*

After the turmoil of the Revolutionary War, families in the Carolina backcountry returned their attentions to their daily lives. Virtually all families farmed, and some men also practiced trades as blacksmiths, wheelwrights, and mill-wrights.[29] Some visitors described backcountry farms as "isolated," not understanding the dispersed web of neighbors across the wooded landscape. The families saw themselves as a community and relied on assistance from their neighbors to clear land and raise houses.

As backcountry farmers became more successful, some of them emulated low-country plantation owners by purchasing slaves. Because enslaved labor increased the family's productivity, farmers who could afford to buy slaves generally did so. At the time of the first United States census in 1790, the majority of families in the Spartanburg district owned no slaves. Among those who did, the numbers owned range from one to as many as a dozen.[30] John Snoddy owned four slaves, indicating that, while not as affluent as some of his neighbors, his family had achieved a notable degree of economic prosperity.

As the Snoddy family seems to have attained an economic foothold early, it is unlikely that John's wife, Jane, or their daughter, Mary, were required to work in the fields. The lives of backcountry women in the late eighteenth century are poorly documented. All frontier women had to work hard, but the status of a family was measured by whether the adult women worked indoors or outdoors. In successful families, women's tasks included cooking, baking, caring for live-stock, preserving food, processing fiber, making and washing clothes, and child-rearing. In struggling families, women had to help with heavy outdoor work; consequently, their domestic performance suffered.[31] The presence of several adults or adolescents of both sexes enhanced a family's chances for survival and success.

Women in frontier settlements dressed and behaved differently from those in cities and towns. A family's economic status was reflected by the styles and materials of their clothing in Charleston, where, according to one author, the "splendor, lust, and opulence there has grown almost to the limit. If the family did not go with it, it would be despised."[32] On the frontier, however, practicality and

comfort outweighed fashion. Women's clothing generally consisted of a simple shift and a short petticoat, an outfit that would have been described as underwear by city dwellers of the era but that allowed freedom of movement and relief from heat. An indication of a family's growing affluence would have been the acquisition, for women and men, of outfits reserved for church and special events, the proverbial "Sunday-go-to-meeting" clothing. Women's Sunday dresses would have reflected current fashions to the degree that their circumstances allowed. In the late eighteenth century, men's Sunday clothing consisted of "knee-breeches and long waistcoats, and low-crowned and broad-brimmed hats," and they typically came to church without coats in summer.[33]

Backcountry residents had a range of options for supplying their clothing and textile needs, and choices depended largely on a family's resources and aspirations. In the eighteenth century some Scots-Irish immigrants had set up looms and produced linen for their own use and for local trade. Gradually most families concentrated their labors on producing goods for sale, enabling them to purchase clothing for themselves and their slaves. Fabrics were available in abundant variety in local stores for home sewing as was ready-made clothing. Most desirable of all were the wares offered by Charleston merchants, and affluent families made regular shopping excursions to the city.[34] In the 1790s, as cotton superceded all other crops, some affluent farmers found it cost-effective to set up cloth and clothing production facilities to provide clothing and bedding for their slaves.

Fabric woven for slave clothing was selected for practicality, and homemade garments were designed and cut out as a series of simple rectangular shapes to minimize waste. The resulting rough, shapeless garments contrasted with the tailored lines of ready-made fashions and indicated the wearer's low status. The construction process produced few fabric remnants, and these served multiple uses in cooking, cleaning, and personal hygiene. Worn-out adult garments were cut down for children's clothing. Backcountry residents had a wide range of fabrics available to them and many ways to put them to use.

Bedcovers, Quilting, and Patchwork

To examine the role of quilts in the Carolina backcountry, it is necessary first to understand that twentieth-century notions and attitudes have led to misconceptions about the origins and development of America's distinctive quiltmaking traditions. An almost universal, but mistaken, belief is that patchwork quilts originated on the American frontier as a response to the need for warmth and the lack of other options. Generations of writers have reinforced this notion. For example, Ruth Finley wrote in 1929 that "the practical bed-quilt, essential to comfort and within the economic means of all, was a universal form of needlework prior to 1750. In mansion house and frontier cabin, from the Cavaliers of Jamestown to the Puritans of Plymouth, scraps of linen, cotton, silk and wool were jealously saved and pieced into patchwork quilts."[35] This theory is popular because it promotes American notions of democracy, equality, and self-sufficiency; and it is consistent with a desire to honor the active role of frontier women in the survival of

Corded quilt of white linen, thought to have been made in Bessbrook, county Armagh, Ireland, ca. 1790. Detail. Photograph courtesy of the National Museums and Galleries of Northern Ireland, Ulster Folk and Transport Museum.

their families; however, careful examination of historic evidence indicates that this notion is untrue.

Bedding textiles were among a family's most valued possessions during the Colonial and Revolutionary War eras. Families were large, and their houses were comparatively small. Most rooms, even the kitchen, might hold one or more beds. Consequently, bedding would have been visible even to casual visitors to a home, and families took pride in displaying textiles as evidence of both women's needlework skills and their economic and social status. For example, when John Snoddy's estate was inventoried after his death in 1806, the most valuable item listed was "1 Feather Bead with Curtains & Bead Stead," valued at forty dollars.[36]

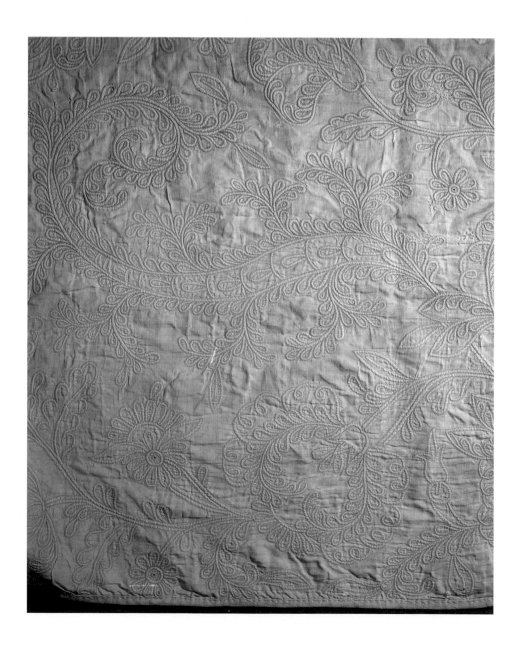

Early South Carolina probate inventories rarely provide an appraised value for individual quilts and coverlets. Typically the appraiser recorded a single monetary evaluation for each "bed, bedstead, and bedding." At this time *bed* referred to what we would now call a mattress, and the *bedstead* described the supporting rigid structure, usually of wood. The undifferentiated term *bedding,* sometimes listed as *bed furniture,* included pillows, bolsters, sheets, and whatever bed coverings were used in that particular household. There are few documents from this period that describe bedding textiles, and very little information survives to provide an indication of the significance of quilts and other textiles to the families who made and used them.

Colonial American probate records reveal that, among the many types of bedcovers available, quilts generally were less common and more highly valued than blankets, woven coverlets, or bed rugs.[37] Throughout the eighteenth century, in both Europe and the Colonies, quilts were made from fine fabrics, usually silk or imported Indian cotton. Quilts of this period represented a considerable investment of time and effort and were generally made and used only by upper- and middle-class families, including the fashionable families of Charles Town.[38]

One source of the misunderstanding about the development of patchwork quilts is that many people do not understand that the terms *patchwork* and *quilting* refer to two different processes. Not all patchwork is quilted, and many quilts are not made of patchwork. Both techniques were part of a large vocabulary of European decorative sewing techniques that could be used alone or in combination to embellish clothing, bedding, or other textile items. The roots of these techniques date back many centuries, reflecting both ancient European traditions and the influences of the rich textile traditions of Asian cultures.[39]

Quilting describes the process of layering two or more textiles and stitching through all the layers, often forming a design through the alignment of the rows of stitches. Depending on the number and thickness of the layers, quilted textiles can provide warmth, padding, and protection; or, with little or no padding, they may be purely decorative. Quilting is an ancient technique that has been variously used in bedding, clothing, and even armor. Americans generally consider quilting and patchwork to be inseparable; however, this combination of techniques has emerged relatively recently in the world's textile history.

A much older and widespread tradition than patchwork quilts is that of *wholecloth* bed quilts, made by seaming lengths of fabric to the desired size, which are then layered and quilted.[40] The range of whole-cloth quilts extends from delicate examples of decorative needlework to thick utilitarian comforters and down-filled duvets. The layers of thick comforters are generally fastened together with heavier yarn, either with rows of large stitches or with individual knots spaced across the surface. In finer whole-cloth quilts, the quilting stitches are used to create intricate outlines of pictorial, floral, or geometric designs.

Other needlework techniques, including various forms of embroidery, have been used alone or combined with quilting to produce decorative bed coverings.

The use of white yarn on white fabric, producing texture without color contrast, has been a perennial favorite for centuries, and colored yarn was also used at times. The sculptural bas-relief effect of an embroidered or quilted design was sometimes heightened by stuffing loose cotton into areas outlined with quilting stitches, or by threading yarn through quilted channels.[41] Well-to-do families in Ulster made fine whole-cloth quilts from white linen or cotton and decorated them with cording, stuffed work, or embroidery.[42] These early decorative all-white quilts were typically made of two layers, without a layer of batting sandwiched between them.

Patchwork involves combining small pieces of fabric to create a decorative surface. The term usually encompasses both *piecework,* in which fabric elements are sewn directly to each other, and *appliqué,* in which the fabric pieces are arranged and sewn onto a larger fabric ground. The earliest surviving examples of patchwork date from the early eighteenth century in the British Isles. Eighteenth-century English patchwork coverlets were sometimes backed with a large sheet of plain fabric, but they were not usually quilted.[43]

Many writers have imagined early patchwork quilts to be *sturdy* and *practical,* but patchwork is actually both too fragile and too time-consuming to be a viable technique for producing utilitarian bedcovers. The idea of piecing together small fabric remnants for everyday bedding would have impressed busy frontier women as impractical, unattractive, and a waste of time. The women who wished to make a quilt and who were fortunate enough to have the time for fine handwork would have invested in materials worthy of their time and effort.

By the end of the eighteenth century, skilled needleworkers in European and American cities were combining patchwork and quilting for fine bedcovers. In Charleston fashionable quiltmakers cut out the large floral motifs from printed fabrics and appliquéd them onto plain fabric, often creating new arrangements. This technique required access to a variety of expensive fabrics imported from England and France; and the resulting quilts served as tangible signs of wealth, skill, and leisure. These floral appliqué quilts were very popular in Charleston in the early nineteenth century, and a few examples survive from inland towns where lowcountry families spent the summer months.[44]

On the Carolina frontier, as back home in Ireland, families needed bedcovers for warmth and comfort, and surviving evidence suggests that these practical needs were served not by *patchwork* quilts but by whole-cloth comforters and blankets. In Ulster the Scots-Irish were known as weavers, primarily of linen. Museums in Ireland include examples of utilitarian whole-cloth comforters made of two sheets of coarse home-woven linen stuffed with tow, the short unusable fibers left from spinning flax into linen. Early settlers in the Carolina backcountry planted flax, and they continued to use linen for clothing and household textiles until the ascendancy of cotton in the late 1790s. When John Snoddy died in 1806, his estate included a loom, a flax wheel, several bunches of cotton thread, and "30 yds new cloth."[45] It is likely that settlers in the Carolina backcountry made whole-cloth comforters similar to those they had known in Ulster.

Colonial backcountry families had ready access to wool blankets. Woolens were prominent in Britain's early industrial efforts, and wool blankets were among the primary commodities in the Indian trade in the seventeenth and eighteenth centuries. British-made woolen blankets were inexpensive and readily available in the Carolina backcountry. Some early backcountry farmers raised a few sheep as part of the diversified agricultural practices they brought from Ulster, but this wool was usually knitted into stockings rather than woven into blankets.

Surviving examples of the fine bedcovers made in the Carolina backcountry during the late eighteenth and early twentieth centuries were typically white, whole-cloth quilts made from two large sheets of plain cotton or linen layered together and decorated with quilting, stuffed work, or embroidery. The comparatively simple floral and curvilinear designs typically feature a single, large, central motif, such as a basket of flowers, surrounded by one or more concentric rings of smaller motifs.[46] As often as not, these white whole-cloth bedcovers consist of only two layers, without a layer of cotton batting. The fine quilts and spreads made by Scots-Irish families in the Carolina backcountry during the early years of settlement were more similar to the quilts made in Ulster than to the floral appliqué quilts made in the Carolina lowcountry during the same period.

Scots-Irish settlers in the South Carolina backcountry continued to make stuffed and corded whole-cloth quilts throughout the first half of the nineteenth century. Made by Mildred Rowland, Greenville County, S.C. Detail. Hanover House Collection, Historic Properties, Clemson University. Gift of the Spartanburg Committee of the National Society of the Colonial Dames in America.

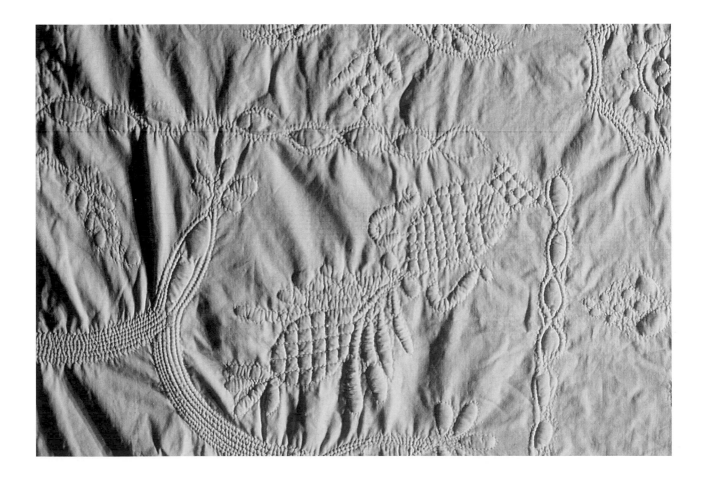

Jane McJunkin's Quilt

We have no descriptions of the bedding textiles used by the Snoddy family during this early period, but a quilt is featured in a Revolutionary War–era narrative of a Scots-Irish family in neighboring Union County. The story was collected by the nineteenth-century historian Elizabeth Ellet and published in her collection of the biographies of prominent women in the war. This narrative serves to illustrate the emotional attachment of Colonial women to their quilts. In 1780 a Tory raiding party led by Col. Patrick Moore commandeered the home of Samuel McJunkin, "a stout patriot":

> They stayed all night; and when about to depart, stripped the house of bedclothes and wearing apparel. The last article taken was a bed-quilt, which one Bill Haynesworth placed upon his horse. Jane, Mr. McJunkin's daughter, seized it, and a struggle ensued. The soldiers amused themselves by exclaiming "Well done woman!"—"Well done Bill!" For once, the colonel's feelings of gallantry predominated; and he swore if Jane could take the quilt from the man, she should have it. Presently in the contest, Bill's feet slipped from under him, and he lay panting on the ground. Jane placed one foot upon his breast and wrested the quilt from his grasp.[47]

As recorded by Ellet, this story is told as an amusing anecdote of a young woman's success in rescuing a prized possession through determination, luck, and physical strength. Other sources provide additional contextual details toward a fuller understanding of the meaning of the incident to the participants.

Samuel and Ann McJunkin had come to South Carolina from Pennsylvania in 1755. Settling on Tinker Creek in Union District, they raised eight children.[48] Patrick Moore's raid on the McJunkin home took place between July 20 and July 26, 1780.[49] At that time the two oldest McJunkin sons were serving in the regular Continental army.[50] Two younger sons had enlisted in the local partisan militia, and eighteen-year-old Robert had been killed by "Bloody Bill" Cunningham's Tories only a few weeks earlier. Jane was about sixteen at the time of Moore's raid, the oldest of the four children still at home.[51]

The quilt that triggered Jane McJunkin's resistance might have been simply the last straw, the culminating indignity that unleashed her frustration. It is more likely, however, that the quilt held some special significance that caused her to risk violence for its protection. Jane may have made the quilt herself, perhaps in anticipation of marriage; or it might have been made by her mother or another relative. The quilt was most likely a whole-cloth cover of linen or, perhaps, cotton. If it was indeed considered special, it may have been decorated with embroidery or stuffed work. It is also possible that the designation "quilt" in the narrative was used generically to refer to some other type of bed covering. Regardless of the details, the story of Jane McJunkin demonstrates the strong feeling that connected frontier women to their household textiles. There are no stories of similar raids on the Snoddy family home, but the families were similar in their Scots-Irish heritage, their support for the Patriot cause, and the loss of a son in the conflict.

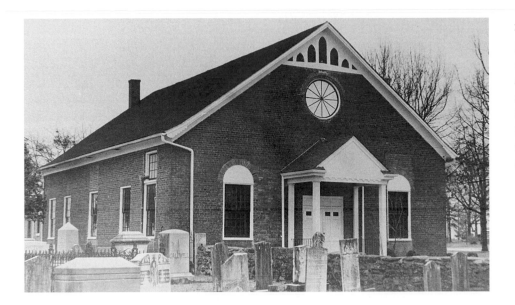

Nazareth Presbyterian Church. The present building, constructed in 1832, replaced an earlier frame structure. Photograph courtesy of James Buchanan and the Spartanburg County Regional Museum of History.

The Role of the Presbyterian Church

The Scots-Irish families who settled the Carolina backcountry, including the Snoddys, the McJunkins, and most of their neighbors, continued to practice the textile traditions they brought from Ulster. An even stronger link among them, however, was their religious affiliation. The overwhelming majority of the Scots-Irish emigrants were Presbyterian, and their backcountry churches served as the primary institutions to meet the moral, social, and educational needs of the emerging communities. The influence of the Protestant church, particularly Presbyterian and other Calvinistic denominations, has been one of the predominant unifying and motivating forces in the American South, and the Carolina backcountry was no exception.

The earliest arrivals to the Tyger River frontier met to worship in homes until the first log meetinghouse was built in 1765.[52] Nazareth Presbyterian Church, formally organized in 1772, was the first religious congregation formed in the Spartanburg District. By obtaining an ordained pastor in 1772, Nazareth established itself early as the religious center for Presbyterians in the area. Because there were so few Presbyterian ministers available, many families flocked to Baptist and Methodist meetinghouses.[53] Within a few years Baptists and Methodists outnumbered Presbyterians in many backcountry settlements. The Snoddy, Coan, and Vernon families were associated with Nazareth in the early years, and many by these names were buried in its cemetery.

Sunday services were all-day affairs. Families arrived on foot or on horseback and sat on backless benches through the sermon and congregational singing of psalms. After a midday recess, with socializing and food brought from home, the service resumed into the afternoon. On Sundays when there was no public worship, families typically observed the Sabbath at home with prayer, Bible-reading, psalms, and a suspension of daily chores.

One perennial area of controversy among Presbyterians concerned the acceptability of various forms of singing. Conservative groups insisted that only strict translations of the biblical psalms were acceptable in worship, and they objected strongly to "hymns of human composure."[54] American congregations gradually adopted the more poetic metrical texts, singing them to one of the eight or ten familiar interchangeable tunes, such as "Old Hundred," a tune still commonly sung as the "Doxology."[55] Even after Nazareth adopted the new hymns, the innovation was not universally approved: "Robert Dickson, accustomed only to the singing of Psalms, thought it a great sacrilege to sing hymns. For years he would come to church and sit on the outside until the minister was ready to preach. He would then march in reverently and take his seat, but as soon as the sermon ended he and his family would march out again."[56]

The use of musical instruments in worship also sparked disagreements within Presbyterian congregations. Questions regarding the suitability of metrical hymns and the use of organs or pianos remained controversial among the various Protestant denominations during much of the nineteenth century. These controversies may have had an influence on the decisions of some members of the Snoddy family to refrain from formally joining Nazareth Church and, later, to join a more conservative branch of the Presbyterian church.

Religious activity was not limited to meetinghouses. At the turn of the nineteenth century, frontier areas throughout the country were swept by a movement of religious fervor known as the Great Awakening.[57] This movement was characterized by open-air camp meetings, where thousands gathered to hear fire-and-brimstone preaching. On July 2 through 7, 1802, some five thousand people gathered near Nazareth Church for a camp meeting, to hear thirteen Presbyterian preachers as well as Baptist and Methodist ministers.[58] "It was noted that if a stranger had come to the Spartanburg District at that time, he might have thought it had been evacuated because so many were away from their homes attending the meeting. It was the first large revival in the Spartanburg District."[59] An event of this magnitude was a rarity in a backcountry settlement, and John and Jane Snoddy, both now age seventy-two, no doubt attended the festivities with their children, grandchildren, and neighbors.

Isaac and Jane's Family

The 1802 camp meeting was likely a notable event in the life of thirty-two-year-old Isaac Snoddy. Five months earlier he had married Jane Crawford, the twenty-three-year-old daughter of Patrick Crawford. For Isaac and Jane, who would become the grandparents of Mary Black, the camp meeting would have been an opportunity to participate in a community event as a couple just beginning their lives together. Jane was about two months pregnant with the couple's first child. Isaac and Jane reportedly lived with his parents for two years before setting up housekeeping in a log cabin nearby.[60] The couple farmed, raising a variety of crops for their own use and growing cotton as a cash crop. By 1810 they owned nine slaves.[61] Isaac's great-uncle Samuel Miller, who never married, lived with Isaac's

family until his death at age 102. Between 1803 and 1820, Jane bore ten children, six daughters and four sons: John, Margaret, Elizabeth, Patrick Crawford, an unnamed son who died in infancy, Mary, Jane, Samuel Miller, Ann, and Nancy Vernon.[62] About 1816 Isaac Snoddy purchased a large tract of land and the family moved to their new house, "his wife carrying her baby, Sam, on one arm and the clock on the other."[63] This child, Samuel Miller Snoddy, grew up to become Mary Black's father.

Isaac and Jane Snoddy lived with their family in Beech Springs, one of a number of rural settlements that dotted the landscape. Such settlements evolved independently of administrative districts, and most of them never developed into villages or towns.[64] These largely self-sufficient communities were usually loosely centered around a general store and post office, where residents gathered to purchase goods such as salt, sugar, cloth, and gunpowder and to exchange news with relatives and neighbors.[65]

The Snoddy home, called "New Hope," served as a post office for local families.[66] Because of its location along the old road between Greenville and Spartanburg, the family home also served as a way station for the stagecoach. Landrum described the station's function in poetic terms:

> When the mellow notes of the stage driver's horn were heard it indicated the number of passengers on board. Then there was a busy scene in both kitchen and stableyard. The busy housewife preparing meals for the tired and hungry travelers, and the negroes getting fresh horses ready for the lumbering stage

coach. This was a famous stopping place for emigrants on their way from Virginia and North Carolina to the southwest. Also the Creek and Catawba Indians in passing back and forth would stop here to rest.[67]

Isaac Snoddy developed a reputation for generosity. "At his log rollings, corn shuckings and wedding feasts of his children, all his neighbors, even the poorest, were invited."[68] Log rollings were held when farmers cleared new ground of trees to prepare fields for planting crops. Over time the fields cleared by the first settlers declined in productivity, and farmers created new fields from the forest. Trees were abundant and uneconomic to transport, so they were cut and the logs rolled into piles to be burned.[69] Farmers invited neighbors to help with the work and rewarded them with an abundant dinner.

The information passed down in the Snoddy family does not mention quilting, but recollections of nineteenth-century log rollings in neighboring North Carolina suggest that the women might have quilted while the men cleared the land: "The log-rolling and quilting were generally held at the same time. The men rolled the logs in the 'new ground' into heaps, while the women stitched quilts, gossiped, and cooked dinner for the hands at the farmer's house."[70] Such communal work parties were often followed by music and dancing.

Isaac and Jane's daughter Margaret was the first of their children to marry. On October 4, 1827, Margaret's marriage to Joseph Thompson was celebrated at the family home, where "there was an immense crowd," as Isaac "often said if his poor neighbors were good enough to come to his log rollings, they were good enough to come to his wedding feasts."[71] Later recollections of Margaret's wedding further assert that "this was about the time they commenced to put on airs."[72] This gently humorous statement suggests that the family's growing affluence had begun to be reflected in their homes, personal belongings, and behaviors. Isaac's parents had struggled to establish themselves in a frontier community and had suffered attacks from Indians and Tories. Fifty years later Isaac and Jane had established a comfortable existence for themselves and their children.

Late in life Isaac Snoddy was described as "somewhere under the medium size, but rather corpulent and blind in one eye from the effects of typhoid fever. His complexion was ruddy; his hair was light and eyes blue. He was a great talker and dressed in homespun, rarely wearing a coat except in the winter time." He was also recalled as "a kind husband, father, and grandfather" and a "successful farmer and trader."[73] Isaac Snoddy was characterized as "patriotic, peaceable, hospitable, truthful, and kind to the poor," and he was said to be "a liberal supporter of the church but not a member, and rarely attended."[74] Isaac and Jane were buried at Nazareth Church, as were five of their children with their spouses.[75]

At the time of his death in 1842, Isaac Snoddy owned some two thousand acres of land and about forty slaves.[76] In his will he listed the distribution of land to his sons and personal property to his daughters, noting in most cases that these bequests had already been granted. Each child received two slaves, identified by name. The oldest son, John, had already received three tracts of land totaling some

four hundred acres; and Samuel, still living at home at age twenty-seven, was to receive three tracts totaling seven hundred acres.[77] Each of the six daughters was to receive, or had already received, her portion (or its financial equivalent), consisting of a horse, with bridle and saddle; two beds, bedsteads, and furniture; and three cows and calves.[78]

Isaac bequeathed the whole of his cash and the remainder of his personal property to his widow. Jane Crawford Snoddy was later described as "a kind and devoted wife, . . . [who] managed well the business of a large farm, and divided every year the profits of the same among her children."[79] Following Jane's death in 1864, the homeplace went to Samuel Miller Snoddy, the sole surviving son, and the remaining personal property was divided among all of Isaac's children.

Within two generations in South Carolina, the Snoddys had transformed themselves from landless immigrants into prosperous landowners. Their success derived from a combination of opportunity, personal characteristics, and favorable political and economic conditions. Having access to fertile land and the labor of enslaved African Americans enabled the Snoddys and many of their neighbors to establish substantial legacies to pass on to their descendants.

Community, Family, and Textiles, 1840–1860

In the Beech Springs community, as in similar rural communities throughout the south, family connections influenced every aspect of community life. Most residents had little reason to leave their home communities, and they spent their entire lives in proximity to neighbors and kin. These rural southern communities developed a distinctive pattern of marriages. Prospective partners typically considered not only their own wishes but those of their relatives and friends.[80] Within the small but relatively stable population of a rural area during the nineteenth century, marriages between second, or even first, cousins were not unusual. After several generations each person recognized some degree of kinship, by blood or by marriage, with nearly everyone else in the community. Kinship networks in a community imprint each person with a sense of his or her own place in relation to others on a human "map." This invisible grid, superimposed on the actual landscape, is an important component in the traditional concept of *home* shared by many rural southerners.

By the mid–nineteenth century, the Snoddys had allied themselves by marriage to many of the other prominent families in the area. These extended relationships were not always harmonious, as lawsuits periodically erupted in disputes over property and inheritance issues. The marriages of two of Isaac and Jane Snoddy's children illustrate the complex webs of relationships among neighboring families. Their oldest son, John Snoddy, married Thressa Daniel in 1833.[81] Five years later John's youngest sister, Nancy, married Andrew Jackson Daniel, Thressa's younger brother. Thressa died in 1842, and John married Elinor Pearson less than a year before his death in 1846.[82] A complicated and contentious lawsuit ensued between the Snoddy and Pearson families over the settlement of John's estate.[83]

The United States census of 1860 indicates that John's two oldest daughters, Laura Altamira, age nineteen, and Theresa Rebecca, age seventeen, were living with A. J. and Nancy Daniel, their double aunt and uncle. Laura's occupation is given as "teacher," and five young Daniel children are listed as "students." Laura and Theresa were to receive their portions of their father's estate at age twenty-one, each consisting of "a horse, saddle and bridle; one cow and calf; a feather bed, bedstead and furniture; a bureau, and a small black trunk." In addition John left each of his children two slaves: Laura inherited Silva and Rachel; and Theresa was bequeathed Clara and Charles.

Both Laura and Theresa were to play important future roles in the life of their younger cousin Mary Snoddy, later to become Mary Black. Laura would be Mary's first teacher, and Theresa would help Mary make a quilt. Laura and Theresa Snoddy were orphans, but the estate of their father John and that of their grand-father Isaac provided for their survival until such time as they were expected to marry. More important, they were part of an extended family providing mutual support.

Although Laura and Theresa's father had died in 1842, his estate was not set-tled until the death of their stepmother, Elinor Pearson Snoddy in 1861. At a pub-lic auction of the remaining property, Laura purchased a Bible for one dollar; three lots of books for a total of $5.25; two "coverlids," at $5.00 and $6.00; and a quilt for $5.00. Theresa paid $6.00, $5.00, and $7.50 for three coverlids, and $6.00 for two "counterpins."[84] These brief notations can be deciphered to some extent to reveal information about Snoddy family textiles.

The meaning of "coverlids," or coverlets, in this context is uncertain. By the mid–nineteenth century, this term probably referred to *overshot* woven coverlets, made on home looms, with colored wool yarn "shooting over" the cotton or linen warp and weft threads to create intricate geometric designs. Overshot coverlets were commonplace in the Carolina backcountry during this period, and many examples have survived.[85] A "counterpin," also rendered as *counterpane* or *countypin,* would have been some type of decorative outer spread, which could have been embroidered, pieced, appliquéd, quilted, or woven.

Quilts were rarely enumerated separately in nineteenth-century probate records. Presumably some were included in descriptions of "one lot of bedding." It is also likely that quilts, clothing, and other personal textiles frequently did not go through the probate process at all but were transferred from one living woman to another as direct gifts. Laura and Theresa were small children when their mother, Thressa Daniel Snoddy, died in 1842. If Thressa had lived to see her daughters into young adulthood, it is likely that she would have given them quilts and other textiles, whether family heirlooms or the work of her own hands. Instead any quilts and coverlets owned by Thressa at the time of her death became part of her husband's estate. The items Laura and Theresa purchased at auction in 1861 had likely belonged to their mother. The prices they paid for these items indicate that they were probably fine textiles having some significance within the family. Any

fine quilts made before 1842 would almost certainly have been white whole-cloth work, characteristic of the area during the early nineteenth century.

During the two decades before the Civil War, quiltmaking styles in the Carolina backcountry shifted dramatically. Printed cotton fabrics from New England textile mills were available in stores alongside imported goods. At the same time, a technique of creating quilts in a grid of repeated blocks spread into the Carolina backcountry, largely supplanting the tradition of white whole-cloth quilts. For the generation of the Snoddy family that included Mary's parents, changes in quiltmaking styles were largely overshadowed by the dark days of the Civil War. �86

"I AM DOING THE BEST I KNOW HOW"

Samuel and Rosa's Family,
1850s–1860s

B Y THE MID–NINETEENTH CENTURY, the Carolina backcountry had been transformed from a sparsely populated wilderness to an *upcountry* filled with well-established farms.

The earliest quilts in the collection of Mary Snoddy Black date from this period, and she inherited these from her mother's family, the Bensons. During the nineteenth century, women typically passed quilts down to daughters rather than sons. Any quilts handed down in the family of Mary's father, Samuel Miller Snoddy, would have been distributed among his six sisters. The quilts Mary received through her mother, however, reflect the experiences of both these families as well as their neighbors in the years leading up to the Civil War.

On October 5, 1853, Samuel Miller Snoddy was married to Rosa Miller Benson by the Reverend R. H. Reid.[1] S. M. Snoddy, age thirty-seven, owned a farm on Jordan Creek, a tributary of the North Tyger River, about three miles northeast of the center of the Beech Springs community. Until his marriage he "lived the life of a bachelor" and "amused himself largely in fishing and hunting." He maintained a pack of hunting dogs, was reported to be a good shot, and "possessed a vigorous and robust constitution." About 1850 he was elected captain of the local militia, who met at "Gowen's old muster ground." By the time of his marriage, he had been promoted to the rank of major of the 36th Regiment, and later to colonel.[2]

Rosa Benson, age twenty-seven, came from a prominent family in the same community. Her grandfather Robert Benson migrated to Greenville County, South Carolina, from Fauquier County, Virginia, sometime before 1800. A Baptist

minister, he married a Miss Stringfellow, and they had eight children. Their son Silas was born in 1800 in Greenville County. In 1825 Silas married Nancy Miller, "a woman of domestic accomplishments and exemplary piety," and they moved to Spartanburg District.[3] According to Landrum, Silas Benson "possessed an ingenious turn of mind, and was by occupation a machinist and millwright. He was described as a model citizen, honest, industrious and progressive, and well-informed on all the current topics of the day." After moving to the North Tyger River area, Silas set up several operations on Jordan Creek, including a flour mill, sawmill, and a wool-carding mill.[4]

Rosa was the oldest of the eleven children of Silas and Nancy Miller Benson. At the time of her marriage, Rosa's siblings ranged in age from twenty-five-year-old Narcissa to three-year-old Henrietta. Like the Snoddys the Bensons were connected by marriage to many of the prominent families in the area.[5] Benson relatives lived close to the Snoddys and remained close to Samuel, Rosa, and their children throughout their lives. Silas and Nancy Benson were Baptists, and Rosa may have maintained her association with her parents' church after her marriage to Samuel Snoddy.[6]

Portrait of Col. Samuel Miller Snoddy in his military regalia, ca. 1855.

A Whole-cloth Wedding Quilt

"Quilt given Rosa Benson Snoddy by her mother and father when she married Col. Sam Snoddy. For Mary Kate Black."

The quilt that Silas and Nancy Benson gave their daughter was a whole-cloth quilt of printed chintz—that is, the quilt was made from lengths of fabric featuring a factory-printed design of large floral wreathes. As a wedding gift, the quilt was symbolic rather than practical. Rosa's new husband could certainly afford to supply the household goods the couple needed. In many communities, however, it was traditional for the bride's family to supply the couple with household textiles, including both fine and utilitarian bed coverings, sheets, tablecloths, and towels. The particular local traditions that influenced the Bensons' choice of a gift are unknown, but in some communities in the nineteenth century, a bride's parents presented their daughter with one or more quilts.

The type of quilt selected by the Bensons to give to Rosa and Samuel reflects their values and aspirations as upcountry gentry. The fabric is a roller-printed chintz, which in this period referred to cotton fabrics printed in floral designs with several colors and finished with a glazed surface.[7] The particular fabric in this quilt has been identified as typical of the chintzes produced in England in the 1840s, which "show an impressionistic shading of flowers achieved with a limited number of colors and characteristic dotted backgrounds in black or blue."[8] Imported chintzes were more expensive than fabrics used for everyday textiles, so

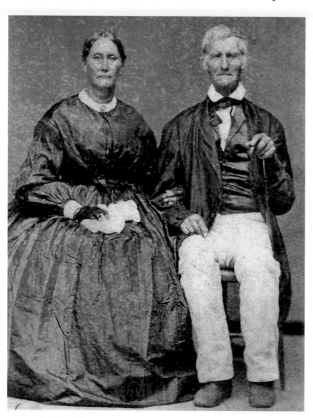

FACING Plate 3. "Quilt given Rosa Benson Snoddy by her mother and father when she married Col. Sam Snoddy. For Mary Kate Black." Whole-cloth chintz quilt, probably made by Nancy Miller Benson, ca. 1850, 96 × 85 inches. Cotton fabrics, moderately thick cotton batting, backed with plain white sheeting. Quilted by hand in diagonal crosshatch. Bound by turning backing to front.

the choice of an imported chintz for a wedding quilt made a significant statement about the family's values.

The Bensons could have purchased the chintz locally. Local stores offered a wide variety of goods. No records survive of the Benson family's shopping, but the papers of another Spartanburg District family include receipts from local stores from this period. For example, in 1847 a Spartanburg man named N. D. Simpson purchased nine yards of "calico" at 31¼ cents per yard from the store of William Mills Jr., and in 1852 another local resident, J. F. Coleman, paid a Greenville store 12½ cents per yard for 34 yards of "homespun," a coarse, factory-made cloth typically used for slave clothing.[9]

It is also quite possible that the Benson family demonstrated the importance of their eldest daughter's marriage by making a shopping excursion to Charleston to buy special items such as fabric for a wedding quilt. Charleston was the favored shopping destination for well-to-do families. For example, in 1852 J. F. Coleman conducted a multiday shopping excursion during which he purchased a waffle iron, toaster, teakettle, glassware, teapots, sugar, coffee, mustard, whiskey, brandy, and champagne from various Charleston merchants. He also paid 41 dollars for a "fine black marble clock."[10] According to family oral tradition, Samuel Snoddy also made a shopping trip to Charleston around the time of his marriage. He reportedly purchased a magnolia tree seedling as a gift for his bride and planted it next to their house. A century and a half later, the house is gone, but the tree remains.[11]

The Bensons' choice of fabric for their daughter's quilt reflects an awareness of the popularity of printed chintz fabrics for quiltmaking in Charleston during the late eighteenth and early nineteenth centuries. By the 1850s, however, chintzes had been gradually supplanted by smaller-figured printed fabrics for both clothing and quilts.[12] The use of chintz in a quilt in 1853 may indicate a lag between the changing fashions of the city and those of upcountry settlements. Still, the type of fabric selected, the cost, and the substantial lengths of uncut yardage needed for a whole-cloth quilt reflect a desire for a quilt that would stand out from the ordinary.

Although the chintz fabric in the Bensons' quilt connects it with Charleston fashions, the style of the quilt is quite different. Rather than cutting out the individual floral wreath motifs and appliquéing them onto a plain background, the maker simply sewed the lengths of cloth together to make a whole-cloth top. The construction technique links this quilt structurally to the whole-cloth quilts and comforts characteristic of the backcountry in the late eighteenth and early

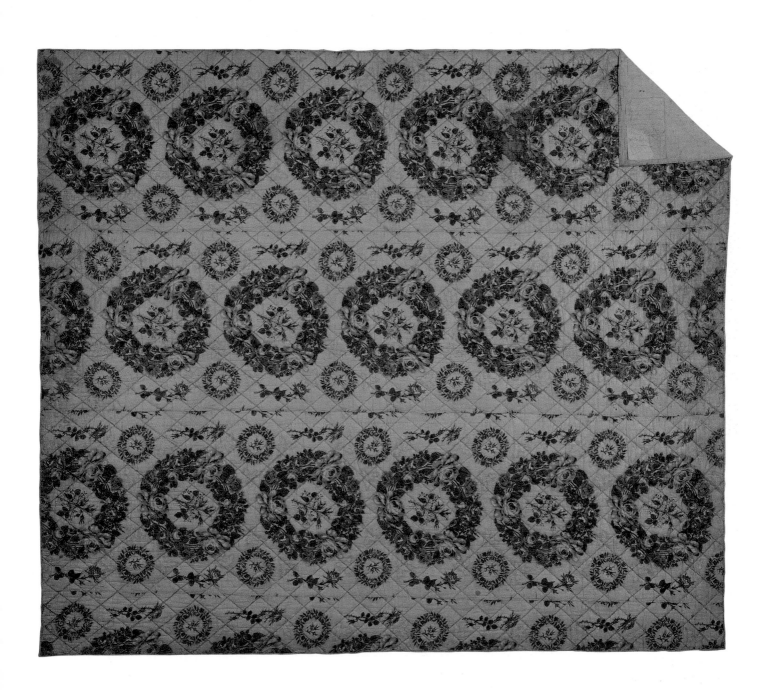

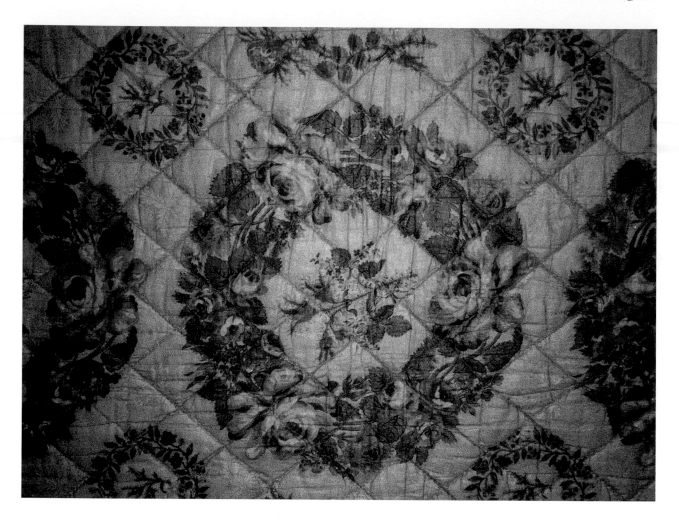

Plate 4. Whole-cloth chintz quilt—detail. According to Florence Montgomery, this particular fabric is typical of the chintzes produced in England in the 1840s, which "show an impressionistic shading of flowers achieved with a limited number of colors and characteristic dotted backgrounds in black or blue" (*Printed Textiles,* 312).

nineteenth centuries. The resulting quilt combines the elegance of imported chintz fabric with the traditional construction style of the local area. It contains elements of both traditions but is typical of neither. Other whole-cloth chintz quilts survive from this era, but they are rare.

The quilt was filled with a moderately thick cotton batting, in contrast with the thinly padded chintz appliqué quilts of the lowcountry during the same era. For the backing, the maker chose a fine, plain cotton sheeting, the product of a factory rather than of home manufacture. She quilted the three layers in a simple, overall diagonal crosshatch. The chalk-like material she used to mark the quilting lines remains visible, an indication that the quilt has never been washed.

The information handed down by Mary Black is not specific about the maker of the quilt; however, it is probable that Rosa's mother made it, whether alone or with help from family members or household slaves. The simple crosshatch quilting design could have been accomplished in a relatively short time, suggesting that Nancy Miller Benson chose not to take this as an opportunity to display

fine handwork. She may have had only a short time to complete the quilting, or perhaps she was busy with the care of her own small children in addition to the wedding preparations. The printed chintz fabric represented a departure from the more familiar plain white whole-cloth quilts, and the maker may have had no models to suggest how it should be quilted. Consequently she chose to finish it more in the manner of a comfort, with thick batting and simple stitching, than with a carefully crafted design typical of white whole-cloth quilts.

The quilt presented to Rosa by her parents reflects a high degree of concern for fine materials and a lack of interest in exhibiting needlework skills. In keeping with its status as a material record of a significant family event, the quilt has been handed down with little evidence that it was ever used as a bedcover. Its function from the beginning was as a symbol of the Bensons' recognition of their daughter's rite of passage. Years later, when Mary Snoddy Black indicated which of her children were to receive which quilts, this one was designated for Mary Kate.

Rosa's Sunflower Quilt

"The Sunflower, pieced by Rosa Benson Snoddy for Rosa Black. The fancy design of stitches called the 'wine glass.'"

Rosa's Sunflower quilt stands in marked contrast with the chintz quilt presented by her parents. The chintz quilt represented the values of her parents' generation, emphasizing a connection to the fine fabrics and local styles of the early nineteenth century. Rosa's own quilt is both a testament to her artistry and skill and an example of her interest in new patterns and techniques of quiltmaking.

A close look at this whole-cloth chintz quilt reveals discoloration from a substance used to mark the quilting lines. The quilt was never washed.

The practice of making quilts from multiple repetitions of pieced or appliquéd blocks became popular during the second quarter of the nineteenth century. The style may have resulted from a melding of patchwork and quilting techniques from the British Isles with the decorative art traditions of German immigrants. Block-based patchwork patterns seem to have developed during the late eighteenth century and appeared first in the Delaware River Valley, including parts of Pennsylvania, New York, New Jersey, Maryland, and Delaware.[13] From there the style spread southward along the same migration route followed by German and Scots-Irish families a century earlier.[14] By the 1840s and 1850s, block-style patchwork had reached South Carolina.[15]

As the number and variety of patchwork patterns increased, quiltmakers sometimes identified them with descriptive or commemorative names. Both the patterns themselves and their names developed local and regional variations. The Sunflower pattern of Rosa's quilt bears a stylized resemblance to the structure of

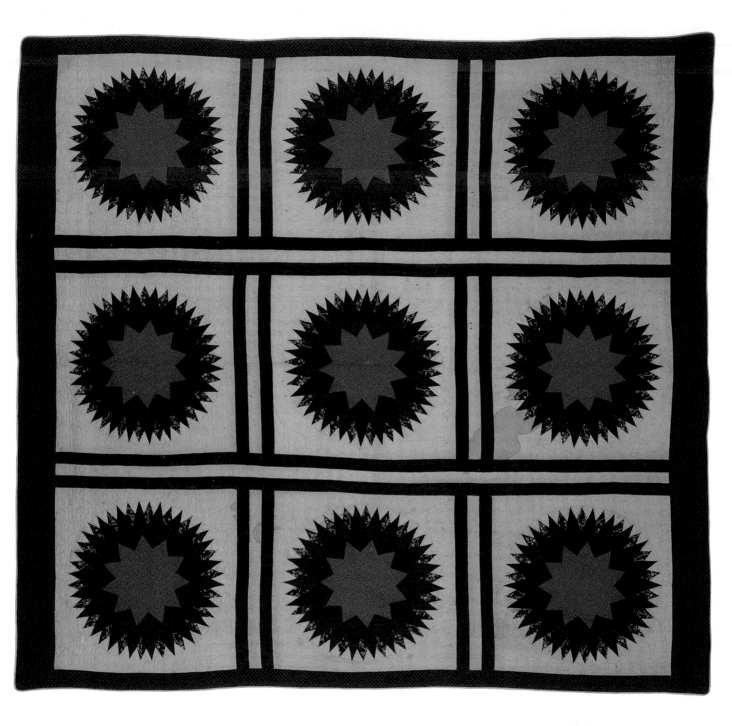

that flower. However, quiltmakers at other times and places have referred to similar patterns by such names as Sunburst, Mariners Compass, and Chips and Whetstones.[16] In the mid–nineteenth century, quilt patterns were circulated by direct contact, through the sharing of homemade paper patterns or by tracing the designs from existing quilts. Pattern names would not become more or less standardized until the late nineteenth century.

Elegant, large-figured floral chintz fabrics were generally not well suited to the geometry and crisp outlines of block patterns. Instead quiltmakers favored solid colors or small-figured prints of a type that came to be known generically as *calico*.[17] These fabrics could be cut into small pieces and juxtaposed effectively to form contrasting design elements. In addition to a wide range of fabrics imported from Europe, printed cotton fabrics manufactured in New England's textile mills were available. By 1836 American mills produced about 120 million yards of printed fabric annually.[18] The fabrics in Rosa's quilt might have come from old England or New England; they were available both in Charleston and in local stores.

S. N. Drummond, who was married to Samuel Snoddy's younger sister Ann, owned a local general store, probably in the Woodruff vicinity south of Spartanburg. At his death in 1856, the contents of the store were described in the inventory of his estate. This inventory included thousands of yards of dozens of different types of fabrics, including "353 yds shirting, bleached and unbleached," at seven cents per yard; "24 yds Kentucky jeans" [a sturdy, twilled cloth, often used for trousers], at fifteen cents per yard, and "20 yds opera flannel," at forty cents per yard. Of particular interest to quiltmakers, the inventory included "592 yards Callico (various prints)" at ten cents per yard.[19]

Rosa's fabrics included a green ground printed with a tiny floral sprig in black, a yellow ground printed with small paisley figures in dull red, a solid red, and a dark blue with larger floral figures. Red and green formed the most popular color combination for quilts throughout the country during the mid–nineteenth century, with small amounts of other colors added for details.[20] Instead of adhering strictly to this formula, however, Rosa chose to highlight the bright yellow by using it for the center circle in each block. As a result the red, green, and blue recede in contrast with the yellow centers, and the quilt is particularly bright compared with other quilts of this period.

In contrast with the simple needlework of the chintz quilt presented by her parents, Rosa used this quilt to show off her superb needlework skills. Each of the points ends precisely and cleanly right where it is intended, and she carefully pieced each circular Sunflower design into the background square. She quilted the center of each pieced sunflower in a close crosshatch, outlined each of the radiating triangles with stitches, then filled in those triangles with further concentric lines of "echo" quilting. The "wine glass" quilting design that fills the background is also called "tea cup" quilting. The two different names may reflect social-class distinctions, but it is also possible that the latter term was one adopted later during the temperance movement in the late nineteenth century.

LEFT Plate 5. "'The Sunflower,' pieced by Rosa Benson Snoddy for Rosa Black. The fancy design of stitches called the 'wine glass.'" Hand-pieced by Rosa Miller Benson, ca. 1850, 97 × 94 inches. Cotton fabrics, cotton batting, backed with plain white sheeting. Quilted by hand: figures outlined, overlapping circles, triple rows of diagonal lines in border. Applied straight-grain binding.

Plate 6. Sunflower quilt—
detail. Rosa's Sunflower
is similar to many other
mid-nineteenth-century
quilts. Instead of having
four, six, or twelve points
radiating out from the
center, however, Rosa's
pattern has *eleven* points.

The border, made from strips of a complementary red print, is quilted in diagonal lines. Instead of following the usual method of measuring and marking the width of the spaces between the quilting lines, however, Rosa simply quilted lines connecting the tiny yellow floral motifs printed on the fabric, grouping three lines together, then skipping one before repeating the quilted triplet. The practice of quilting "by the print" rather than by measurement may not be unique to Rosa Benson, but it has not been described prominently in published accounts of historic quilts.

Rosa's quilt is generally similar in pattern, color, and technique to many other mid-nineteenth-century quilts. However, it is apparently unique in one significant aspect. Most pieced patterns designed with a number of points radiating out from the center contain an even number of points—usually four, six, or multiples of those numbers. Rosa's Sunflower pattern, however, has *eleven* points around the center.[21] This was not an accident, as all the points are regular in size and shape, and each block is identical. The pattern was deliberately drafted with eleven points rather than the twelve that would have been much easier and more typical. We will never know why Rosa pieced her sunflowers with eleven points,

but the number might have held some particular significance. The most obvious suggestion is that she was commemorating the number of children her parents had produced, but she could also have given herself the challenge of drafting an irregular geometric figure.

The study of geometry was available to girls whose families could afford to pay for their education, and either Rosa herself or someone she knew drafted this design. There are no surviving records of Rosa's education. "Old-field schools," typically established by local farm families and held in unused cabins on worn-out land, provided boys and girls with a basic education and sometimes included plain sewing for the girls.[22] Such schools served the children of middling farmers, but the Bensons had the means to provide their eldest daughter with a better education.

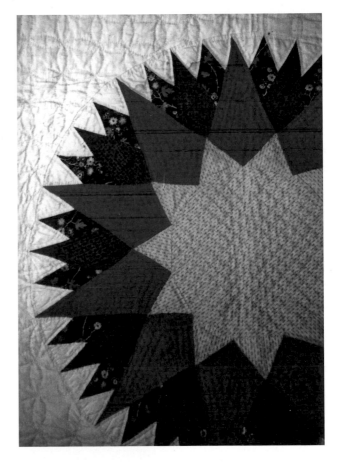

Rosa Benson quilted the background of her Sunflower quilt in a wineglass design. The overlapping circles could be drawn with a compass.

From 1820 to 1860 private academies for young women proliferated throughout the South, and those in the Spartanburg area "enjoyed a favorable reputation throughout the state."[23] The nearby Greenville Female Academy, which operated from 1819 until the 1850s, offered a curriculum in natural philosophy, chemistry, logic, moral philosophy, Latin, and Greek. In the 1830s modern languages and fancy needlework were added as electives.[24] Rosa's needlework skills, her familiarity with geometry, and her ability to play the piano are all attributes of an educated young woman, suggesting the influence of a female academy. Such an education was not intended to train young women for employment as teachers but to prepare them for their roles as preservers of the culture and gentility of Southern society.[25] Among well-to-do families, "an educated daughter was considered an asset to her family; education enhanced her social status and improved her prospects for marriage."[26]

Rosa Benson probably made her Sunflower quilt during the years between the completion of her education and her marriage. The construction and design of the quilt are consistent with those made during the 1840s and 1850s. If the number of points in the Sunflower pattern was actually related to the number of her siblings, she would have made it after the birth of baby sister Henrietta in 1850.[27] At the time of the United States census of 1850, Rosa, age twenty-four, was living in her family home, probably assisting her parents with the farm and family.

The two quilts were among the possessions Rosa brought with her to her new home. The whole-cloth chintz quilt represented her parents' values—fine,

In 1859 Samuel and Rosa Snoddy moved into a new home on their Jordan Creek farm. After Samuel's death in 1898, the house was no longer occupied by the family. It gradually deteriorated and was eventually torn down in the 1970s.

old-style materials put together without a great deal of unnecessary effort. Rosa's own quilt was symbolic of her preparedness for marriage—a demonstration of her domestic skill and artistry. As with many other mid-nineteenth-century brides, her quilts represented both her family's position and aspirations and also her own identity as an accomplished young woman. In the years that followed, raising her children during the difficult era of the Civil War, Rosa Benson Snoddy had to rely on both her family connections and her own strengths for her family's survival.

Samuel and Rosa's Family

Samuel and Rosa Snoddy set up housekeeping on Samuel's farm on Jordan Creek, where they reared their children. James Robert was born in 1854, followed two years later by Nancy Jane (apparently named after her grandmothers, Nancy Miller Benson and Jane Crawford Snoddy). An unnamed infant son was stillborn in 1858, and Mary Louisa Snoddy (later, Mary Black) was born on September 6, 1860.[28]

The 1860 Census showed the value of the Snoddy family's personal estate as $11,617, which included real estate valued at $5,000, and twelve slaves.[29] Samuel Snoddy was not an average Southerner, as most Southerners owned no slaves. However, he was an average slaveholder, for the vast majority of slaveholders owned fewer than twenty slaves. He was not one of the *planters,* defined as those who owned more than twenty slaves, but he belonged to a class of small slaveholders.[30] Samuel's twelve slaves included an adult man, 37, and woman, 28, who may have been a couple; four teenagers; and six children under the age of 12. The overlapping ages of the children suggest that they were not all the offspring of the two adults. Some of them were probably acquired by purchase.[31]

According to the 1860 Agricultural census, Samuel's farm included 200 acres of improved crop land and 650 acres of meadows, woodlands, and fallows. During the previous year the farm had produced a thousand bushels of "Indian" corn, two hundred bushels of wheat, forty bushels of oats, and nine of rye. These grains would have fed the household of seventeen people as well as the livestock, which included six horses, a mule, six milk cows, fourteen other cattle, seventy swine, and twenty-one sheep. In addition the farm produced forty bushels of peas and beans, twenty bushels of Irish potatoes, and fifty bushels of sweet potatoes.

The Snoddy household also produced 361 pounds of butter, more than twice the amount Samuel's household had churned in 1850, before his marriage. Rosa's influence is also evident in the production of thirty pounds of wool reported in 1860. In 1850 Samuel had owned no sheep, but Rosa's father, Silas Benson, owned fourteen sheep and a wool-carding mill. The Snoddy family produced seven bales of ginned cotton in 1860, which was sold for cash to pay taxes and to purchase clothing and commodities such as sugar, coffee, and salt.[32]

In 1860, the year that Mary Louisa Snoddy was born, her family lived a comfortable existence and were financially secure. Their material needs were met through their own labor and that of enslaved workers. Within a couple of years, however, the comfort and stability of the Snoddy family and their neighbors were overturned by the events of the Civil War.

The Impact of the Civil War

No Civil War battles were fought in the South Carolina upcountry, but the war had a profound impact on every aspect of daily life throughout the South, for the duration and for many years afterward. Following the fall of Fort Sumter in April 1861, South Carolinians were swept up in a wave of patriotic fervor for the new Confederacy and the prospect of war. The spirit of optimism overshadowed the sober reality that the resources of the agrarian Southern states were no match for those of the industrialized North. The Confederate victory at Manassas (Bull Run) on July 21, 1861, fueled Southern hopes for victory. At the same time, however, the heavy casualties on both sides demonstrated the severity of the conflict.

On August 9, 1861, in response to the sobering reality of the war, a group of Spartanburg women met to form a Soldier's Aid and Relief Association, which

The Bivings Factory, shown in an 1856 illustration, was one of the few Southern textile mills to sell yarn to individuals during the Civil War. Photograph courtesy of Clarence Crocker and Hub City Writers Project.

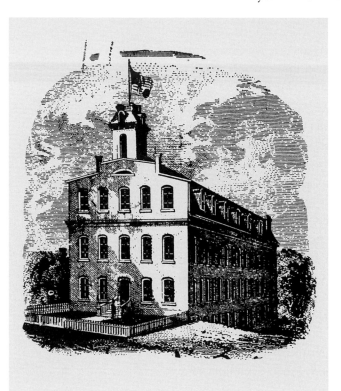

had as its objects "to provide garments, hospital stores and other comforts for our sick and wounded soldiers, and secondly, to furnish underclothing, socks and other articles needed by our soldiers in the field—these objects to be carried out by voluntary contributions of money, material and labor." That year the association collected dozens of pairs of socks and drawers and packed them in boxes to send to companies of South Carolina troops stationed in Virginia. Bedding items included blankets, sheets, and pillows, as well as comforts and counterpanes.[33]

Women in rural communities throughout the district also organized local relief societies. Many of the Snoddys' neighbors were involved with the Reidville association, which, in the fall of 1861, sent the following items to "the sick and wounded" in Virginia: "150 pillows, forty counterpanes, quilts, comforts, blankets, sixty-three pairs socks, a quantity of underclothing, pants, vests, mattresses, honey, brandy, vinegar, marmalade, lint [loose cotton fiber used as wound dressing] and bandages."[34] This is one of very few specific references to quilts in the relief records. Quilts sent to the troops during the early months of the war were often removed from family beds and trunks. In their initial enthusiasm to support the troops, women sometimes sacrificed impractical items such as fancy quilts and counterpanes instead of warmer blankets or comforts.[35] In other regions of the Confederacy, fine quilts were sometimes auctioned to raise money for the cause.[36]

When the Civil War erupted, Samuel Snoddy had already retired as colonel of the 36th Regiment of the state militia, and he remained at home with his family during the first two years of the war. In July 1863 the Confederate army suffered critical losses at Gettysburg and Vicksburg, and Charleston Harbor was under heavy siege. These events combined to deflate civilian morale.[37] In August, Samuel, then age forty-seven, enlisted and was appointed captain of Company F, 5th Regiment, South Carolina Volunteers, State Troops,[38] the equivalent of a reserve unit. Captain Snoddy was accompanied at camp by Spencer Snoddy, an enslaved mulatto manservant about eighteen years old.[39] Rosa, age thirty-seven, was left at home with Jimmy, age nine, Nancy, called "Sister," age seven, Mary, called "Sweet," age three, and the remaining slaves.

We are fortunate that seven of the letters Samuel and Rosa wrote to each other between 1863 and 1865 survive among family papers. These letters, three from Rosa and four from Samuel, provide insight on some of the details of their daily lives, at home and in camp, as well as their hopes and concerns. The 5th Regiment

was organized August 1, 1863, initially for a period of six months, and was stationed near Charleston during October.[40] In November the regiment was transferred to Camp Bonham, near Greenville, only about twenty miles from the Snoddy home. In a letter written on November 6, 1863, Samuel reported on the soldiers' efforts to deal with the lack of shelter. "We are today building tents, some are putting up cabbings [cabins], some rail pens, some brush tents, and some their blankets and some none at all. I have put up some forks [forked sticks] and covered it with boards and have tolerable comfortable quarters." On November 15 Captain Snoddy filled out a requisition form requesting six army tents "for the health and comfort of the troops and advancement of the public interests."[41] There is no indication whether or not requests were filled, but the Confederate army remained perennially undersupplied throughout the war.

On January 19, 1864, Rosa began a letter to Samuel with several sentences expressing her frustration on not having heard from him.[42] "This is the third letter I have not got any answer from you, yet all the rest of the women in the neighborhood gets letters regular." After several months of running the farm alone, Rosa's discomfort in her supervisory role is evident: "I am doing the best I know how but I don't know how you will like my management." Rosa described the work of the slaves, reporting that "the boys are still ditching, they are over half way in the big ditch now."[43]

In the same letter, Rosa reported to her husband that she had "sold a hundred and twelve or fourteen dollars worth of Cloth, Butter, and turkeys since you left." Supplies of fabric from Europe and New England were cut off by the War, and the yarn and fabrics produced by the few existing Southern textile mills were commandeered for army use.[44] Throughout the Southern states, women took looms and spinning wheels out from storage sheds and attics and put them to use. As existing garments wore out, they were replaced by a variety of locally woven cotton products called "Confederate homespun."[45] Those women who produced more than their own families needed found a ready market for their wares.

Four days before Rosa wrote her letter, another Spartanburg District farmer recorded a similar sale of cloth in his journal. David Golightly Harris (1824–1875) and his family lived on Buffalo Creek southeast of Spartanburg village and about twelve miles from the Snoddys. On January 15, 1864, Harris sold "three yards of jeans at $12 per yds" to a neighbor.[46] Like Samuel Snoddy, Harris was a small slaveholder, owning about five hundred acres and ten slaves. In the absence of additional documents from the Snoddy family, the journals of David Harris provide details of family life in Spartanburg County during the war and its aftermath. Harris and his wife Emily first set up a loom for their own use in May of 1862, then determined that they could make more cloth to sell.

The Harrises were fortunate to live near one of the few Southern cotton mills that continued to sell yarn for home use. On October 4, 1862, David Harris "Went to Bivings Factory to day, and by good luck and good management, I suceeded

in getting two more bunches of yarn. . . . Yarn is in great demand, and very scarse. It will be hard for us to cloth and feed ourselves the next year. We have now a good lot of home made cloth, several bunches of yarn, & wife is making cloth fast."[47] By April 1863, having made a profit of a hundred dollars, Harris recorded his concerns about his neighbors' reaction to the new venture and his own family's survival amid the prevailing economic uncertainties: "Wife & I are talking of making a large lot of cloth. I do not like to be called a speculator, but I want to make some thing to live upon. . . . None of us know what to do! We do not know whether to sell everything or keep every thing & sell nothing at any price."[48]

Rosa Snoddy did not express such concerns in her letters to Samuel, but she was clearly worried about her husband's welfare in camp. Further in her letter of January 19, 1864, she wrote, "I have not sold all my Cloth yet. I will send you some cloth and a box of provisions by Mr. Thomas Bomar, he said he would carry any thing I wanted him to carry." Her concern also extended to Samuel's manservant. "I also send some clothing for Spence. I send two pair of socks, which you can keep and give Spence your brown ones if they are not worn out and if they are give him the coarse ones, and you keep the fine ones." The thought of her husband's physical comfort then apparently triggered another anxious statement: "I want you to come home as soon as you can as I would be very glad to see you one more time."

In her final paragraph Rosa reported on the health of various friends and relatives. Rosa told Samuel, "I have just heard from your mother. She is as well as common." Ironically, Samuel's mother, Jane Crawford Snoddy, daughter of Patrick Crawford and widow of Isaac Snoddy, died the following day, January 20, 1864, at the age of eighty-four.[49]

According to army records, the 5th Regiment was mustered out on February 6, 1864; however, Captain Samuel Snoddy returned to service on June 13 the same year, this time joining the 1st S.C. State Troops, Company C.[50] Following the fall of Atlanta in August 1864, General Sherman's Union army cut a destructive swath through the Georgia countryside. Upon reaching Savannah in December, the Union troops rested, while South Carolinians braced for attack. With most of the regular Confederate army in defensive positions around Richmond, available state troops were called to block the advance of Union forces into South Carolina. In a letter dated December 2, 1864, Samuel reported that his company had left Greenville by train and took a circuitous route—through Augusta and Charleston—toward Savannah. They disembarked near Grahamville about midnight, marched for several miles, and joined a fierce battle in progress. Samuel's written letters reflect a speech pattern inherited from his Irish-born parents and grandparents and probably still prevalent in his neighborhood; he typically rendered "the" as "they." He described the horrors of battle:

> We were put in line of battle to meet they enemy and from they roar of cannon and musket I expected every minute that we would be attacked. Of all they

sights that I have seen, they sight on they field was they awfulest I ever saw. Negroes and white men shot in every direction, some mangled all to pieces, they ford of they creek was almost full of boddys. . . . I have not slept one hour at a time since I got here. My trunk and box is left at they depot four miles from here and I can't get time to go after them. We are fixing for another fight but don't know when it will come off.

A letter written by Samuel two months later from a camp near Combahee Ferry, some twenty or thirty miles from Grahamville, survives with one edge torn away, perhaps in Rosa's haste to open it. In the excerpts that follow, the missing words at the end of each line have been reconstructed in brackets. Dated January 31, the year is torn away, but the events took place in 1865. Captain Snoddy first described a harrowing engagement with the Union troops who had gained a foothold in the sea islands and were attempting to move inland. Following observations on the absence of effective leadership and his dread of further fighting, Samuel's thoughts returned to his family. Even in the midst of war, he was concerned about the children's education. "I would be glad to [know] where Laura is, and what she is going to do whether [she] is going to stay with you or not and if there will be [a chance] for the children to go to school this year. [They] must go if any chance." At the time of the 1860 census, Laura Snoddy, the orphaned daughter of Samuel's brother John, had been living with her aunt and uncle, Nancy and A. J. Daniel, as a teacher for their children. Laura was in her early twenties at the time Rosa encouraged her to set up a similar school for the Snoddy children and those of their neighbors.

Rosa shared her husband's concern about their children's education. In a letter written two months earlier, but obviously delayed in transit, she told her husband "Sweet says to tell you she has bin to school too days, played with the little girls." On Christmas Day 1864, Rosa wrote again, reporting, "Laura has gone home to stay two or three weeks." These statements suggest that Laura boarded with Rosa while teaching her children and had returned to the Daniels for a holiday visit.

In a postscript to his January 31 letter, Samuel addressed his son: "Jimmy you must write to me and tell me [what] sister and sweet is doing every day [and] what they talk about of nights [how many] potatoes they roast and how many they give Amanda & Cora, how many times [they] eat of a day." In addition to revealing Samuel's devotion to his children, this passage also indicates a general concern for the family having enough food for themselves and for the two women who must have been enslaved house servants. His letter refers not to Irish potatoes but to sweet potatoes, which were a staple crop for winter storage.[51] Samuel's company was ordered to evacuate Combahee Ferry on February 4 and to march northward. They reached Cheraw on February 27, and Fayetteville, North Carolina, by early March.[52] Samuel's final letter, from a camp near Smithfield, North Carolina, echoed the weariness and despair of the remaining Confederate soldiers:

Camp near Smithfield, NC, March 25 [1865]

My dear wife and children, I seat my self to inform you I am well and have been so all most all they time. We have seen hard times since I heard from [you]. We have been retreating for they last six weeks and fighting every day or two. On last Sunday there was as hard fighting as has been since they war. It lasted three days and nights. We fell back on Wednesday and fought again. Our battalion was engaged in it they balls fell thick all around me. I did not think of one thing else but about my sweet little children who is absent from me. I expect there will be another fight in a few days about this place. You must not be worry about me, they reason I have not rote you before we were cut off from all communication. Captn Earl is sending one man home and it may be you will get this. While I am writing they guns has commenced firing again. Jimmy you must be a good Boy and mind your ma. Sister, you must not forget me and be good. Sweet, I may never see you again but I love you as good as ever and would like to be with all one time more. My dear wife, I never have realized what pleasure is until now, to be kept away from my family and live camp life is what I don't want ever to do any more. If I never see you again do the best for my children. It may be possible I will get home again but it don't look like it now. I will close.

Farewell, S. M. Snoddy

In spite of the pessimistic tone of his last letter, Capt. Samuel Snoddy did come home. On April 12, 1865, three days after Confederate general Robert E. Lee surrendered at Appomattox, Samuel's company marched to Raleigh in hopes of boarding a train but "could get no transportation." According to company records kept by 2nd Lieutenant J. F. Sloan, "We like to have had a mutiny." The next day, April 13, the company started marching home, a distance of some 250 miles, and on April 25, they were officially "furloughed."[53]

Samuel survived the war and the long walk home, but many others were not so lucky. Some twenty thousand South Carolina men were killed, roughly one-third of the young adult white male population.[54] The extended Snoddy family lost two young men. Lt. Robert A. Snoddy, age twenty-four, the son of Samuel's cousin Captain John, died near Knoxville of wounds received on November 16, 1864.[55] Pvt. John Crawford Snoddy, Laura's nineteen-year-old half brother, died of disease in Elmira Prison, New York, in 1865.[56] The Benson family lost one of their two sons. Rosa's brother Willis Alexander Benson spent the first two years of his service stationed in the Charleston area without engaging in fighting.[57] By February 1864 he had been promoted to captain, and in June of that year, his company was relocated to the trenches near Petersburg, Virginia. On June 18, 1864, Capt. Willis Benson, age thirty-three, was reported killed in a skirmish that killed or wounded more than half of his company. Benson left his widow, Martha Jane Ballenger Benson, age twenty-eight, with three young children.[58]

Those who survived the war returned, weary and disheartened, to a home life that was very different from the one they had left. The Snoddy family left no documents relating to the years immediately following the Civil War, but, again, the journals of David Harris provide insights on the local postwar situation. On May 27, 1865, Harris wrote:

> It seems that our unfortunate country is drifting to ruin as fast as the Tide of Destruction can carry it. Our currency has entirely failed. No one will take a "Confederate dollar" for anything. . . . We have no money, consequently the prices have suddenly fallen flat. All trading is done by bartering. For everything that is sold, provision is demanded, & no one have provision to give. All is at a standstill & wondering what will be done next. All anxious to see, yet fearing to know.[59]

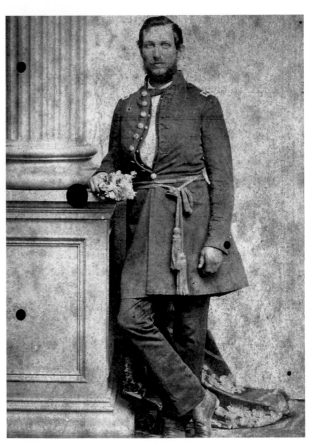

In 1860 the wealth of Spartanburg's citizens was valued at over $16 million, including the value of slaves. This figure plummeted to $4 million in 1870 as a result of the freeing of the district's 8,240 slaves.[60] Although the economy was in ruins, families like the Snoddys were more fortunate than some in owning land and having therefore the possibility of financial recovery. Upon their return home, Samuel Snoddy, David Harris, and other landowners faced the necessity of negotiating contracts with freedmen to perform farm work.

On June 5, 1865, David Harris attended "Sale Day," the public market held the first Monday of each month in Spartanburg. He heard the commander of the occupying army issue a proclamation freeing all the slaves, and commented, "I do not think it will have much effect." On June 14 Harris wrote, "There is much talk about the Negroes being free. Some have gone to the yankeys. I have heard mine say nothing on the subject." On August 14 he wrote, "A decree has gone forth from the Yankeys, that we must say to our negroes that they are free. If they stay with us, we are to pay them, & not drive them off nor correct them." The following day he reported, "I told my negroes they were all free & requested all to go. Ann has gone off, & the others have gone to work. . . . I fear much trouble & annoyance before we can get settled again."

Both whites and blacks had difficulty making the transition to wage labor. White farmers like Harris had work that needed to be done but no money to pay for it. Many blacks hoped that freedom would bring land ownership and were reluctant to enter labor contracts. The sharecropping and tenant system evolved

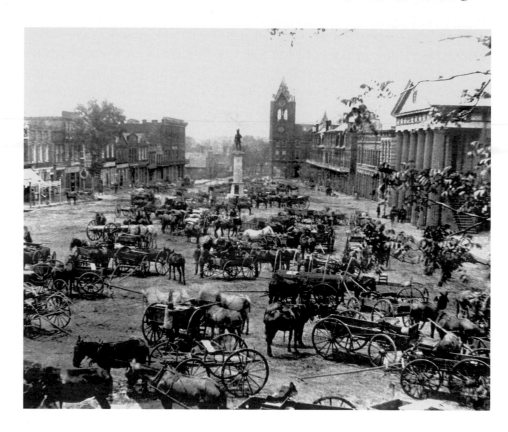

gradually as whites and blacks negotiated the terms of employment and land rent.[61] On November 5, 1865, David Harris recorded an arrangement with a man who had belonged to Harris's father: "To day Julius came to rent land of me. . . . Negroes seems anxious to rent land. I think some of them will make good tenants. At least I am willing to try some that I know to be good hands." Over the next five years, David Harris negotiated individual annual labor and land-rent contracts, with both black and white men.[62]

Many blacks left the area after emancipation, but as historian Walter Edgar has pointed out, "black Carolinians had a sense of place as strong as whites. By the spring of 1866, the majority of former slaves were living either on the plantation where they had previously labored or somewhere in the neighborhood."[63] It is not known how many of the slaves formerly owned by the extended Snoddy family chose to leave the farm and how many chose to stay. The 1870 census lists a number of black families named Snoddy living in the vicinity. Simpson Snoddy, a twenty-six-year-old black man, apparently lived on Samuel Snoddy's land as a sharecropper in 1870 and raised 90 bushels of corn on twenty-five acres. He owned neither horse nor mule to work his land, but he reported owning one hog and one sheep. Samuel's former manservant, Spencer Snoddy, age twenty-five, along with his wife Caroline, also twenty-five, and their two young children, were farming eighteen rented acres in the Beech Springs area in 1870. They owned

a milk cow and thirteen swine, and they reported production of one hundred bushels of corn and forty pounds of butter that year.[64]

The descendants of Mary Bomar (1840–1923) have determined that their ancestor lived as a slave at New Hope, the home of Isaac and Jane Crawford Snoddy, which was inherited by Samuel Miller Snoddy upon his mother's death in 1864. After the war Mary Bomar and other members of her family lived in tenant houses at New Hope and continued to work for members of the Snoddy family.[65]

Dilsey Snoddy

It is difficult to trace the lives and family relationships of individual African Americans through nineteenth-century historical documents. Prewar census records list the age and sex of slaves but provide no names. Probate records sometimes mention slaves by name but rarely include other details. Slaves changed hands through inheritance, and families were frequently broken up through sales. Through a combination of sources, however, it is possible to follow some of the events in the life of a woman named Dilsey Snoddy.

John Snoddy, who arrived from Ireland in 1773, owned eighteen slaves at the time he made his will in 1806. John's will transferred ownership of a "boy Bill and girl Dilsey" to his son Isaac, indicating that these slaves were already in his possession. When John's estate was probated in 1808, Dilsey, age eighteen, was valued at $400. This made her one of the most valuable slaves in the estate, along with a man named George ($482.50), and a woman Fan and her child Ransom ($500). Dilsey's attributed value strongly suggests that she was a house servant rather than a field hand.

When Isaac made his will in 1842, Dilsey was not listed among the named slaves bequeathed to his children; instead she remained part of the life estate left to his widow, Jane. On May 7, 1858, Dilsey and two other slaves "after being satisfactorily examined by session were received as members" of Nazareth Church.[66] When Jane Crawford Snoddy died in 1864, the inventory recorded fifteen slaves, including a "Negro woman Dilce (old)," appraised at $50, compared with $2,500 for a man named Jim. Samuel's portion of the estate included both Dilsey and Jim, along with livestock, blacksmith tools, furniture, and various produce.[67] Although Dilsey changed hands several times during her life, she remained within the Snoddy family and was never sold away from her home.

As a house slave, Dilsey may have been engaged in sewing for the white Snoddy family. The ability to do fine needlework was among the most highly regarded skills influencing the value of a slave. Women like Dilsey sometimes made quilts under the direction of their white mistresses. There is also evidence that slaves sometimes made quilts and comforts for their own use.[68] The individual circumstances of enslaved families varied widely, but few had access to the time, tools, or materials to make decorative bedcovers for themselves.[69]

Following emancipation Dilsey Snoddy remained in Beech Springs. The 1870 Census recorded her at age eighty; she was living with a mulatto farmer, Pompey

Vernon, age seventy-four; Sudy Vernon, age forty-five, who "keeps house"; and Emma Vernon, age ten. Her relationship with the Vernon family is unclear, but Dilsey survived a long life under slavery to emerge a free woman near its end. Freedom did not bring the opportunities for land ownership and prosperity that blacks had envisioned, and many continued to work with little change in their economic status.

The Snoddy Family and Reconstruction

The 1870 agricultural census provides some indication of the unsettled farm economy of the period. Samuel Snoddy reported paying out $100 in wages the previous year, presumably to newly freed laborers. He reported that he had only twenty acres in production, four hundred acres of woodland, and nine hundred acres of other unimproved land. The cash value of his land was $2,800, slightly less than the value of his land in 1850. This comparison is misleading, however, as he owned almost twice as many acres in 1870 as in 1850. Samuel produced only thirty bushels of corn in 1870, twenty bushels of sweet potatoes, and a single bale of cotton. Still, Rosa's remaining thirteen sheep produced thirty pounds of wool.

The decade following the Civil War was characterized by economic collapse, social upheaval, and political revolution. As farmers struggled to reclaim overgrown fields, replace lost livestock and worn-out equipment, and relearn their interracial relationships, a nationwide depression in 1873 wiped out what economic recovery had been made.[70] For those who lived through the Civil War and Reconstruction, the era was a turning point that remained a significant influence throughout their lives.

Rosa's two quilts survived the war safely, but many other antebellum quilts did not. During the patriotic fervor in the early months of the war, some families sent fine but impractical quilts to their husbands and sons in camp. A general shortage of blankets called other heirloom quilts into use at home. Many homes in the path of the Union army had been looted and burned, and an unknown number of quilts were stolen or destroyed.[71]

With the same hard work and determination he applied to his farm before the war, S. M. Snoddy set about to reestablish the financial well-being and security of his family. His neighbors continued to refer to him by his prewar militia rank of colonel, both as a sign of respect and to distinguish him from cousins with the same name. According to Landrum, "Col. Snoddy kept himself well posted on all the current news of the day. He was an honest and upright citizen and a progressive farmer. He was a good neighbor, hospitable in his home, was a kind husband and affectionate father. . . . He bestowed his attention on his farm, garden, etc. He was especially devoted to the culture of select flowering plants and trees, and his home was beautiful and attractive."[72]

The Snoddys weathered the war with their home and possessions intact, and this circumstance provided them with the material basis to rebuild their lives. For Mary her mother's quilts and other heirlooms would continue to serve as

reminders of the family's history and connections and would reinforce a strong local identity and an understanding of her place within her family and community. Growing up in the shadow of the war and Reconstruction instilled in Mary the values that would guide her life in future years and that would be reflected in the quilts that she and her female relatives created. ❧

"THE SPIRIT OF KINDNESS AND GENEROSITY"

Mary Snoddy's Childhood and Education, 1860s–1880s

MARY LOUISA SNODDY'S experiences as a child shaped her character as a young woman and guided her quiltmaking. Her earliest memories of home and family were influenced by the Civil War. Her father's long absences, her mother's preoccupation with farm management, the family's concerns about having adequate food and money, and a general atmosphere of uncertainty in the neighborhood certainly left their imprint on children of the era. The oddly complementary characteristics of frugality and generosity attributed to Mary as an adult were in evidence in her girlhood, and the quilts made by Mary, her mother, and her sister during this period demonstrate these values as well.

"Sweet"

Mary's childhood nickname, "Sweet," suggests that the agreeable temperament for which she was known in adulthood was present from her early years. As the youngest of three children, she did not share the burden of responsibility carried by her brother Jimmy as eldest child and only son. The four-year gap between the births of Mary and Nancy Jane (called "Sister" or "Nannie") emphasized Mary's role as the baby of the family. The combination of late birth order and a sweet temperament seems to have provided Mary with an attractive social persona, which allowed her to make friends easily.

It is possible that Mary's lifelong reputation for being kind and generous may have contributed to friction in Mary's relationship with her sister. Photographs

of the two sisters in their teens, wearing identical dresses, show both girls with serious expressions, as was customary for portraiture at the time. However, Nannie's neutral face features the downturned mouth characteristic of women in the Benson family, allowing her expression to be interpreted as sour. Although Mary's expression is similarly unsmiling, her mouth has less of a downward curve. It seems likely that Nannie developed an early jealousy for her younger, prettier, sweet-natured sister, which no doubt contributed to some of the later difficulties that occurred within the family.

Mary Louisa Snoddy, ca. 1875.

Mary seems to have learned from her family that affluence brings with it the responsibility for sharing with one's less fortunate neighbors. Recollections of her grandfather Isaac Snoddy described his generosity in inviting his neighbors, rich and poor, to the wedding of his daughter Margaret.[1] In a eulogy written in 1927, following the death of Mary Snoddy Black, Boyce R. Pollard, a long-time friend, wrote that Mary's maternal grandfather, Silas Benson, "always invited his patrons to dine with him if they were at his mills when the clock struck 12, and hundreds of plain men partook of his unlimited hospitality."[2] Describing Colonel Snoddy as "generous and kind," Pollard wrote: "Surrounding him after the War Between the States were a number of poor widows and orphans and it was his wife's great pleasure to kill and cook squirrels and chickens and many delicacies and send to their neighbors, especially when there was sickness in their homes."[3]

Mary's sweet character as a child was remembered in an oral account by Richard Tinsley, whose family lived on the Snoddy farm for many generations, during and after slavery. Many years later, Mary's grandson Sam Orr Black Jr. recalled hearing Tinsley describe his grandmother's childhood participation in bringing food to the field workers, a story that included an alternative etymology for Mary's nickname:

> I used to like to sit down and talk with Uncle Rich. He lived up at the farm, and he would talk about the old days. He and his mother were out in the fields, as slaves, picking cotton, and he said that one of the sisters every day would bring them lunch, Nancy and grandmother. They called her Miss Sweetie, cause she always brought them something sweet to hand after they'd finish eating dinner.[4]

According to Pollard, the girl who would later become Mary Black "rightly inherited the spirit of kindness and generosity and the poorer boys and girls in her school and community were often invited by her to visit in her home and were given free range in the 20-acre apple and peach orchard."[5] Pollard's fond

51

*James Robert Snoddy,
ca. 1875.*

eulogy also provides information about Mary's early education and describes a passing fad of the era:

> The poorer girls and boys in her school, the school of her childhood, the old "log-house," half a mile north of H. A. Wingo's home, were often treated to cake and custards from her oven-filled school dinner basket. At that time, 50 years ago, the "memory button string" was a great fad in the rural schools. And, Oh! How fresh it all comes back to me—the great number of buttons on Miss "Sweetie's" string. Every child in school gave a button and today I can see the heavy string of "friendship" buttons around her plump white neck. Yes, we all loved her and she loved us, and she never showed a preference for any of us except to give a little more attention to the poor ones among us.[6]

Southern Textbooks

Two schoolbooks from the era have survived in the Snoddy family to indicate what the children studied. A tattered copy of *The Southern Reader, Book Second,* published in Charleston in 1841, includes short readings in history and natural history, poetry, and fictional vignettes, each with a wordlist for spelling exercises. The book's preface states the book's philosophy:

> No apology need be offered for confining the historical portion almost entirely to incidents connected with the history of the South. Believing that the first lessons given to children, in this department of their studies, should be *home history,* and having but a limited space for such lessons, the author has not been willing to seek, in the history of other sections of the country, for less familiar anecdotes of patriotism and bravery.[7]

Mary's older brother Jimmy apparently used this book during the war as it includes a handwritten inscription in pencil: "Mr. James Snoddy's book was presented by his Cousin Laura Snoddy." For a poem, "Song of Marion's Men," commemorating the exploits of South Carolina's Revolutionary War hero Francis Marion, Jimmy crossed out every instance of "Marion" and substituted "Beauregard," a popular Confederate general. In the same poem he further substituted "Potomac" for "Santee" and "Northern" for "English." At the top of several pages, he inscribed the names of notable Confederates, giving two of them promotions: "Gen. Lee of Va, Gen. Davis of Miss, Gen. Snoddy of S.C." It is likely that as Mary learned to read, she also read this book and internalized a pride in her Southern heritage.

The second surviving schoolbook is *Our Own School Arithmetic,* by S. Lander, published in 1863. This text also offers a Southern slant, being "perhaps the first

Arithmetic whose authorship and publication belong exclusively to the Confederate States."[8] Chapters present basic arithmetic concepts in a straightforward manner, followed by lists of "Promiscuous [i.e., mixed] Problems," which include the following examples that reflect aspects of the Southern experience during the war:

> Bought 16yd. of calico at 15ct., 7yd. of gingham at 15ct., 9yd. of flannel at 68ct., and 25yd. of domestics at 10ct.; paid 16bu. of corn at 68ct.; how much is still due?

> A grocer having brandy worth $1 a gallon, wishes to mix it with water so that he can sell the mixture at 80ct. a gallon. In what proportions must he mix them?

> A man owns $10475 in real estate, $3850 in slaves, $4095 in good notes, and $1415 in cash; what is the value of his whole estate?

> If 5 white men can do as much work as 7 negroes, how many days of 10hr. each will be required for 25 negroes to do a piece of work which 30 white men can do in 10 days of 9hr. each?

> A man dying wills to one son $2000, to an other son $1500, and to his daughter $1250; but after paying his debts his executor has in his hands only $3000. How much should he pay to each legatee?

> How many steps of 28in. each, does a soldier take in marching 5 miles?

> There are 1000 men besieged in a town with provisions for 5 weeks, allowing each man 16 ounces a day. If they are reinforced by 500 more and no relief can be afforded till the end of 8 weeks, how many ounces must be given daily to each man?

> The Mecklenburg Declaration of Independence was made May 20, 1775; North Carolina unanimously seceded from the United States May 20, 1861; how many days elapsed between these two great events?[9]

This small, hardbound book has been protected by a homemade cloth cover, carefully cut, folded, and held together by a web of large stitches in a heavy thread. The fabric, now faded, is a chocolate-colored printed calico, typical of the fabrics manufactured by New England textile mills in the mid-nineteenth century and widely used for both dresses and quilts.[10] Inscribed in ink in a splotchy, inexpert manner on the flyleaf is "Miss Mary Snoddy's book, May 16, 1872." Eleven-year-old Mary may have been practicing with both pen and needle in making this book her own. Thanks to Mary's protective cover, the arithmetic book survives in remarkably good condition.

Mary's early education included musical instruction as well as arithmetic. Vocal and instrumental music formed an essential element in the genteel home during the mid-nineteenth century. A popular Victorian adage stated that "a home is incomplete without a piano."[11] As with the other spiritual features of the home, the provision of music was a woman's responsibility. Most girls in middle-class families developed some competence with the piano. "As the primary musical instrument, the piano became symbolic not only of the virtues attributed to music but also of home and family life, middle-class respectability, and woman's particular place and duty. The glorification of the piano became a moral institution."[12] Rosa and Samuel had a piano in their home, and both their daughters learned to play it.

A surviving copy of Ferd. Beyer's *School for the Piano-Forte,* "designed for the exclusive use of Young Students, and Dedicated to Mothers of Families," was found in the family home. This large-format instruction book, printed in New York in 1871, offered "the principles of music in 106 examples, studies, gamuts, exercises, and choice easy pieces."[13] The text was printed in English, French, and German, suggesting that a music lesson might be combined with language study. A penciled note in Mary's handwriting, "me in youth," appears at the top of one page. Penciled numbers and reminders have been added throughout the book, an indication that the book was indeed used for instruction. It is likely that either Mary's mother, Rosa Benson Snoddy, or Cousin Laura Snoddy supervised Mary's musical instruction. Mary's lifelong interest in music, particularly in the piano, seems to have developed early.

In 1876, while a student at Wellford High School, Mary wrote an essay entitled "Truth." According to sixteen-year-old Mary, "Truth in every sense of the word is all important. It alone will give character to an individual, more than anything else. To be truthful is a richer inheritance than mines of gold and silver." The essay expresses the certainty and confidence common to many youthful writers, but Mary seems to have held to such values throughout her life.

Williamston Female College

It is unclear how many years Mary went to local schools. In 1878, however, she was a student at Williamston Female College, some thirty miles from home. It is also unclear how she chose this particular school, as the Reidville Female College was not only much closer to home but was also run by the Reverend R. H. Reid, the minister at Nazareth Presbyterian Church and the man who performed her parents' marriage. Mary may have preferred the philosophy or the curriculum at Williamston, or, perhaps, like many seventeen-year-olds, she simply wanted to go to a school a little farther from home. In 1876 the Danville-Richmond Railroad laid a track through Beech Springs, and a new town called Wellford developed around the new depot and water tower.[14] Mary could catch the train in Wellford and transfer in Greenville to go to Williamston.

Williamston Female College developed from unlikely beginnings. Dr. Samuel Lander (the same "S. Lander" who authored *Our Own Arithmetic*) had taught in

North Carolina and served as a professor at the Spartanburg Female College before deciding to return to the pastorate. In 1871 Lander arrived in the small town of Williamston, accompanied by his wife and seven children, to serve as the new Methodist preacher. As there was no available housing, the Lander family moved into a vacant hotel building. Within two months the Landers had hired teachers and recruited thirty-six students for a girls' school.[15] The privately operated college proved remarkably successful. In 1904, when it outgrew the Williamston facility, the college was relocated to Greenwood, South Carolina, where it still operates as Lander University. According to Samuel Lander, the object of the school was "to furnish at low rates, to those young ladies who desire it, a thorough education, as far as its course extends, giving them opportunity, encouragement, and assistance, to lay deep and well the foundation, and erect thereon, with care and patience, the beauteous superstructure of accurate scholarship, combined in symmetrical proportions with physical vigor, cultivated manners, and sanctified affections."[16]

The Williamston curriculum featured a "One-Study" plan, allowing students to focus on one department for a five-week period. The four departments were Mathematics, Natural Sciences, Latin, and Belles-Lettres. Although himself a Methodist minister, Lander stressed that the school was "strictly non-sectarian, . . . and, while it will be our constant effort to induce the ungodly to embrace Christianity, no one will be allowed to join any branch of the Church without the approval of her parents."[17] As to discipline, Lander stated the aim that "the government of the Institution shall be that of a well ordered Christian family. No espionage is practiced; but, instead, every practicable effort is made to cultivate mutual confidence between teachers and pupils."[18]

Lander's educational philosophy is further reflected in his requirement that each student read "privately every day a prescribed number of pages in some approved book of acknowledged merit and practical value."[19] The college also emphasized musical instruction: "Our pupils all receive stated lessons, free of charge, in the science of Vocal Music, with especial reference to cultivation and practice of sacred song. . . . We regard Instrumental Music, not as a mere expensive luxury, but as a very valuable study for the cultivation of the mind, and as an economical instrumentality for making home attractive, and for cultivating harmony and happiness in the family circle." Instruments specified for this edifying experience were "the Piano-Forte, the Guitar, the Reed Organ, and the Orchestra Bells."[20]

Physical education included a twice-daily routine of "light calisthenic exercises, under the inspiring stimulus of a stirring march." The school offered students the use of a piece of gymnastic equipment, "Dr. Johnson's Health-Lift, under the immediate supervision of a prudent lady teacher, securing them from any injurious effects which might accrue from its excessive use." Students were also encouraged to take regular walks to the mineral spring, or "occasional romps in the play-ground," as "protection against the enervating tendency of a sedentary life."[21]

Williamston alumnae from the early years later recalled Lander's participation in the prescribed outings:

Early in the morning the signal was given, and a happy group assembled at the front door, all eager for the morning walk with the beloved president. Arriving at the spring, each partook of the sparkling water; but more enjoyable still was the sparkle of wit, as story after story, or incident, was recounted to the listening girls. Wherever one saw Dr. Lander outside of school hours, he was surrounded by a group of girls, all fascinated by the easy style with which he dispensed his unending fund of story and anecdote.[22]

Mary was enrolled in the Collegiate Department for the spring session, which ran from early February until June 20, 1878. It is not clear when she first entered, as the college's "semi-annual plan" allowed students to enroll either spring or fall.[23] A single surviving letter from Mary to her father offers a glimpse into the concerns of a seventeen-year-old schoolgirl, including family, health, studies, clothing, religious activities, and her classmates. It also reveals much about Mary's attitudes about herself, her family, and others:

Williamston S.C.
May 15th, 1878

Dear Pa,

I received your postal this morning, also one from Jimmie saying ma was no better, but I guess you were at home at last. [Correction in original.] I hope she will be well in a few days. You didn't say how your back was, suppose it must be better. I also received a tolerably long letter from Sis this morning. She says cousin Maggie doesn't go about much.[24] Gus has managed to get her out to ride once. I am somewhat surprised at her. She need not wait for pleasure to come to her, if she does, it will not be apt to make its appearance.

I have been quite sick for sometime. I feel better this week. The people had the picnic on last Saturday.[25] Think it was nearly a failure. Very few attended. Mr. Lander made a speech for them.

Mathematics will soon be over. Friday is the last day. I won't grade out by a half bushel. Very few in our class will manage to get out. I haven't learned any thing this Section. I was so irregular in my studies. My Arithmetic was nothing of importance. I ought to have been in interest or something of that kind. But I had to do what Mr. Lander said. There are so many contrary girls. I would like for him to have a better opinion of me.

I will be glad to see my clothes coming. I would like to have the express paid on it at Wellford. That is, if you can arrange it so. Then it will be less trouble to me especially. Mr. Lander gets enough without that. I haven't but two pairs of summer stockings. Shall I get them here? Or will you get them at Wellford. I will have to have a piece or two of ribbon but I will send off and get them where I can get them cheaper. If you get this before you leave home, send my slippers and the pink bows I had last summer. If you don't get it in time, it won't matter much. I ought to have written this last week, but was sick and forgot it.

There were two Presbyterian ministers here last Saturday and Sunday. Both from Due West.[26] They preached some splendid sermons. The older was named

Mr. Pearson. The young man was a Mr. Brownlee, just through college. He is going to preach for them the rest of the year. He preaches splendidly. Has a good education. Two school girls joined on Sunday.

Miss Hattie is in bed today. She has sore throat. She suffered all night and all day today. We couldn't sleep any scarcely last night. I thought she would choke. All she could do to breathe.

Carrie Parrott received a box from home two weeks ago with several new calicos and a beautiful white dress, gaiters, & etc. Three large cakes and several other things. Tell you what, we eat in a hurry.

As I have nothing to interest you, I will close.

Your daughter,
Mary Snoddy

Mary's letter contains many clues to her character and her relationships, and a close reading offers a better understanding of the attitudes of Victorian girlhood. Many of her comments share a common theme of *approbation*—that is, she was concerned with giving and receiving the approval of others.[27] Mary wanted Mr. Lander to "have a better opinion" of her than of other "contrary girls," and she did not wish either him or her father to be inconvenienced by her need for her summer clothing.

Not only was she concerned about the approval of others, but she offered or withheld her own commendation toward others. She expressed surprise at the behavior of Maggie Drummond, suggesting that her cousin "need not wait for pleasure to come to her" as a result of whatever situation she was facing. Mary approved of the "splendid sermons" preached by the visiting ministers and offered two new church members as support for her opinion.

Like most young women, Mary expressed an interest in clothing. She was sufficiently impressed with the "beautiful white dress" received by her classmate to mention it in her letter two weeks later. But her concern for fashion was tempered by frugality in stating that she would buy the ribbons she needed where she could "get them cheaper."

A common theme in nineteenth-century letters and diaries was a preoccupation with health. In an era without refrigeration or sterilization, people frequently experienced the physical effects of food or water contamination. Mary demonstrated a rather stoic attitude toward illness. She matter-of-factly reported her own recovery from an unspecified sickness, and she expressed hope for improvement for her mother's malady and for her father's back. She described the respiratory difficulty of Miss Hattie, who was probably some sort of houseparent, in objective terms, without overt expression of sympathy or condemnation for keeping the girls awake.

Perhaps most puzzling of all for modern readers is Mary's attitude toward her school work. She admitted to being "irregular" in her studies and suggested that "very few" in her class would "grade out." The meaning of Mary's further statements about her difficulty with mathematics are unclear: "My Arithmetic was nothing of importance. I ought to have been in interest or something like that."

She may have meant that she would have preferred to study practical aspects of accounting, that is, interest rates, rather than a more general approach to arithmetic, or perhaps she was merely admitting a lack of curiosity or dedication.

Mary accepted responsibility for her own shortcomings, but in her letter there is no indication that she felt much incentive to excel in her studies. Indeed Samuel Lander's stated mission to give young ladies "opportunity, encouragement, and assistance, . . . with care and patience," to achieve "scholarship, combined in symmetrical proportions with physical vigor, cultivated manners, and sanctified affections" reflected society's expectations for his students. Just as in her mother's day, a girl such as Mary did not expect to use her education other than to serve as the moral guardian for her future family.[28] A young Southern woman who was serious about higher education had no prospects beyond emulating her female teachers, and even this role was not thought suitable for a proper young lady in the 1870s.

Mary Snoddy may not have succeeded in learning mathematics, but her experience at Williamston contributed to the development of her adult character. By chance she was present for one of the most memorable events of the college's early history, the "calico commencement" of 1878. According to one recollection "The class of 1878 decided to be economical and wear calico on their graduation day. The idea became popular and the whole school dressed in calico. Yet the general opinion was that no girls had ever looked prettier."[29] Lander himself referred to the event later that year, adding that "a rule prescribing calico for their Sunday wear would be hailed with delight by the majority of our pupils, many of whom, even without the rule, usually wear dresses of this material."[30]

Silk dresses were the norm for special occasions for fashionable ladies of the era, and calico was considered appropriate only for everyday wear or for those less fortunate. The decision to wear plain dress for an official ceremony would have run counter to prevailing custom. Within the culture of the college, however, the students were encouraged to avoid pretension and display. "Our students have no use for costly clothing, and but little temptation to desire it. Our village is small, and free from the tyranny of fashion. . . . We encourage plain, neat attire; and we forbid the wearing of any jewelry, other than a breastpin. Whatever clothing is good enough for home will answer every purpose here."[31]

There is no record that Mary Snoddy graduated from Williamston Female College, but her term of study there seems to have deepened some of the values and interests she had already begun to cultivate. Mary may have continued her piano studies at Williamston. She may also have availed herself of opportunities for vocal training, as she is remembered as possessing a lovely singing voice.

At some point in her youth, Mary wrote a schoolgirl poem of three verses that reveals a facility with language, a sweet temperament, and a joyous devotion. The meter is somewhat irregular but lilting, and she may well have intended it to be sung:

> Now raise aloud your voices, Rejoicing as brothers,
> Each hand within another's, And love in each heart;

Sing thus with joyful music, to smooth the path before us,
Friendship is watching o'er us, Let every fear depart.

Now raise aloud your voices, Loud swell a joyous song,
For naught but blithesome smiles, Beam out from 'mid the throng;
And many stars have shone, Upon our happy road,
Let every heart breathe praise, To our maker and our God.

Now raise aloud your voices, Away with grief and care,
The youthful heart should know, No thought of dark despair;
But ever meekly bend, to Him who reigns on high,
As sweet rose blossoms bow, When zephyrs wander by.

<div align="right">Mary Snoddy[32]</div>

Mary joined the Presbyterian Church while attending Williamston, then, about two years later, on May 9, 1880, she transferred to Nazareth, where she presented "a certificate of membership from the church at Williamston and was admitted to the fellowship of the church." A few months earlier, on August 30, 1879, her sister Nancy had appeared before the session of Nazareth Church and "after having made a satisfactory profession of faith in the Lord Jesus Christ," was admitted "to the Sealing Ordinance of the Lord's Supper."[33] The Snoddy girls probably attended church at times during their childhood at Nazareth, Mt. Zion Baptist (with their mother's relatives), or other local churches with their friends, but they did not become church members until this time.

The Tulip Quilt

"Made by Mary Louisa Snoddy Black—
'The Tulip' design. Cousin Theresa Snoddy helped quilt it."

At some point in her early womanhood, either before or after her Williamston schooling, Mary Snoddy made a Tulip quilt. The Tulip was one of the most popular appliqué patterns in the upcountry of both Carolinas during the 1870s, and the color scheme and arrangement of Mary's quilt are typical of the region and the era.[34] The quilt is constructed of twenty identical blocks of a very large single tulip motif. Each tulip blossom has five points and is attached to a stem having two small leaves. Compared with other appliquéd floral patterns, these "Carolina" Tulip quilts are particularly big and bold, rather than graceful and delicate. Since there were no published quilt patterns available at this time, patterns were passed from one quiltmaker to another. One could borrow the paper templates, sketch the pattern by sight, or trace the shapes from a finished quilt.

Mary's color scheme of red, green, and orange is typical for appliqué quilts of the region in this era. Although quiltmakers in other parts of the country favored printed fabrics at this time, solid colors were more common in inland parts of the southern states. The particular shades of red and green were produced by early chemical dyes. Before the development of aniline dyes in 1859, all fabric dyes were produced from animal, vegetable, or mineral products. The brownish-red and bluish-green produced by chemical dyes are characteristic of quilts made in

OVERLEAF **Plate 7. "Made by Mary Louisa Snoddy Black—'The Tulip' design. Cousin Theresa Snoddy helped quilt it." Hand-appliquéd by Mary Louisa Snoddy, ca. 1880, 97 × 93 inches. Blocks joined by machine. Solid-color cotton fabrics, thin cotton batting, backed with fine white cotton stamped "Granite Shirtings." Quilted by Mary Snoddy and Theresa Snoddy: figures outlined, hanging diamonds, triple diagonal lines in sashing. Straight-grain binding applied by machine.**

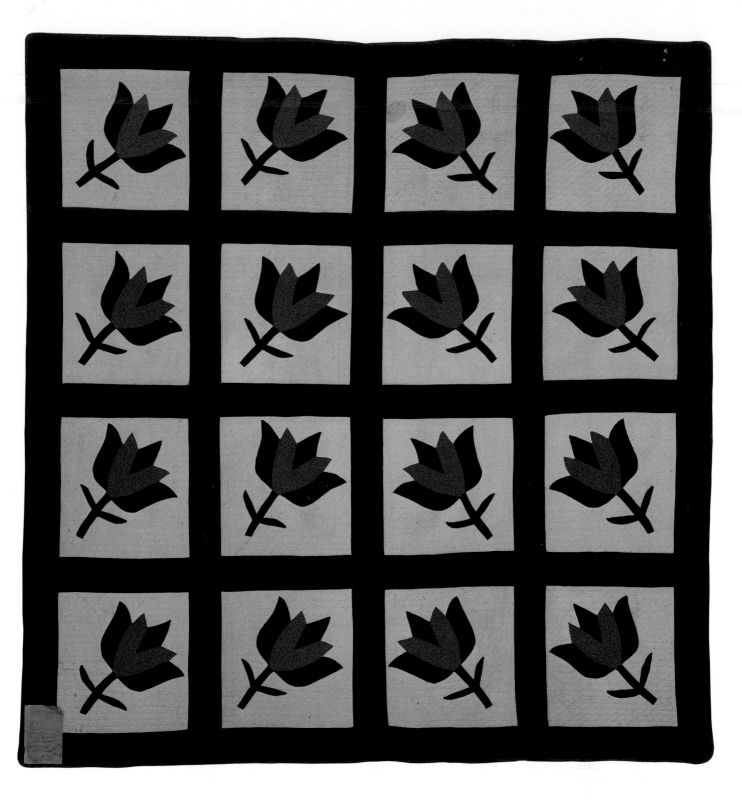

the Carolinas during the 1870s, and these subdued shades contrast vividly with the vibrant reds and yellowish greens found in quilts prior to the era.[35] Chrome orange, a mineral dye, was frequently used as an accent in red and green quilts in the mid-nineteenth century.[36]

Mary's quilt is also typical of southern quilts of the era in that the blocks are set solidly within a grid of wide fabric strips, called "sashing."[37] She quilted around the edges of the appliquéd motifs and added further rows to echo the contours of the larger pieces. The background is quilted in "hanging diamonds," that is, rows of horizontal lines crossed with rows of diagonal lines, and the sashing and border are quilted diagonally. The edges of the quilt are bound with a strip of green fabric.

Mary appliquéd the tulip motifs by hand, but she joined the blocks and sashing using a sewing machine. The binding is inexpertly attached with a single row of machine stitching. We do not know when the Snoddy family bought their sewing machine or what brand they had, but sewing machines were widely used in this era. An ad for J. K. White, a local store, in the *Spartanburg Herald* on May 19, 1875, offered "Singer's celebrated sewing machines, the cheapest and the best sewing machine, for sale on easy terms." In the same issue, McK. Johnstone advertised his cleaning and repair service: "Bring in your sewing machines and have them made good as new."[38]

ABOVE Plate 8. Tulip quilt—detail. For this quilt, Mary chose one of the most popular appliqué patterns in the upcountry of both Carolinas during the 1870s. Compared with other appliquéd floral patterns, these "Carolina" Tulip quilts are particularly big and bold, rather than graceful and delicate.

BELOW *The binding of Mary's Tulip quilt was applied using a sewing machine, apparently by someone unaccustomed to its operation.*

The fabric on the back of the Tulip quilt is a fine plain white cotton, stamped with the words "Granite Shirtings." The Graniteville mill, near Aiken, was the first South Carolina textile mill to successfully develop a national market for its products.[39] Southern mills produced primarily plain fabrics for most of the nineteenth century. The shirting Mary chose to back her quilt was a finer and comparatively more expensive fabric than the sheetings that were more often used for quilt backings in South Carolina throughout the nineteenth century.

The hand-written label on this quilt indicates that Cousin Theresa Snoddy helped Mary with the quilting. Theresa Rebecca Snoddy was Laura's younger sister (both girls the orphaned daughters of Col. Snoddy's brother John). In 1870 Theresa, age twenty-five, was still living with her uncle and aunt, A. J. and Nancy Snoddy Daniel, who had four sons still at home. Some time later, Theresa married a man named Wingo and had two sons, Benjamin and Asa.

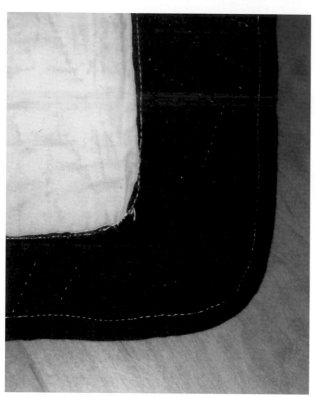

FACING Plate 9. "Mrs. N. J. Coan made this. Mother had dress like brown piece. Ma like gray + white but Auntie like blue + brown." Hand-pieced by Nancy Jane Snoddy, ca. 1880, 92 × 82 inches. Cross pattern. Printed cotton fabrics, cotton batting, backed with pink floral border print. Quilted all over in shallow diagonal clamshells. Applied bias binding of printed fabric.

Sister Nannie's Cross Quilt

"Mrs. N. J. Coan made this. Mother had dress like brown piece. Ma like gray + white but Auntie like blue + brown."

Mary's sister, Nannie, made a quilt alternating simple blocks of diagonal crosses with unpieced blocks. We don't know by what name, if any, this pattern was called at the time; but it was later published under a number of names, including A Snowflake, Cross Stitch, and Old Italian Block.[40] Nannie combined a large number of different printed fabrics in her quilt. The dark prints forming the crosses are primarily brown shades; the light background prints vary widely in hue. The variety in the pieced blocks contrasts with the consistent use of a delicate pink print for the unpieced blocks. The pink fabric was originally manufactured with a printed floral border, and this floral strip was removed and placed separately as the border for the quilt. The quilt is backed with the same pink print with the floral border intact. So, although the quilt blocks make use of small amounts of many different fabrics, the plain blocks, border, and backing required the purchase of many yards of the pink print. Nannie chose an all-over quilting design of shallow clamshells set on the diagonal, and she cut the binding strips on the bias from a brown and blue floral print.

The label for this quilt provides information about the color preferences in the family: "Ma like gray & white but Auntie like blue & brown." The reference to "Ma" here and elsewhere refers to Mary's mother, Rosa Benson Snoddy; Mary's own children always referred to her as "Mother." The form of Nannie's name on this label reflects her widowed state at the time the labels were written, as it was

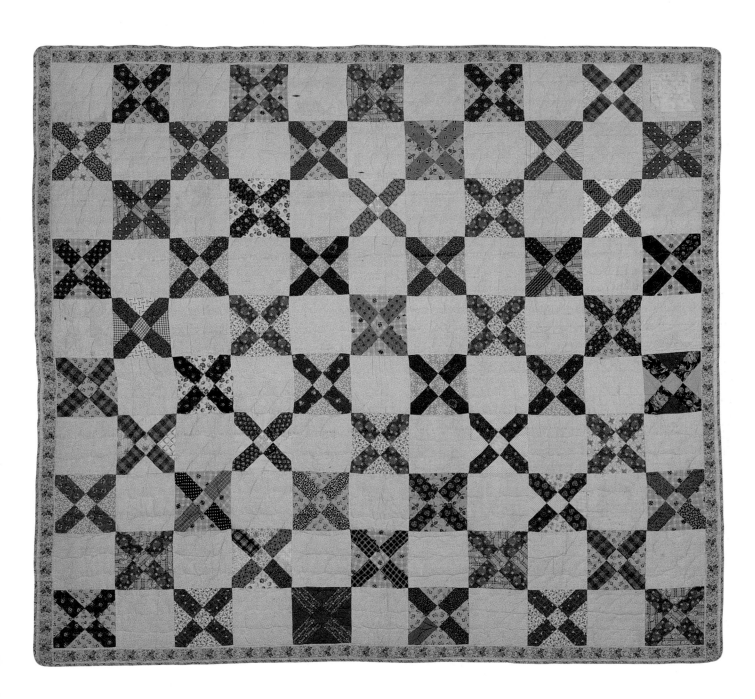

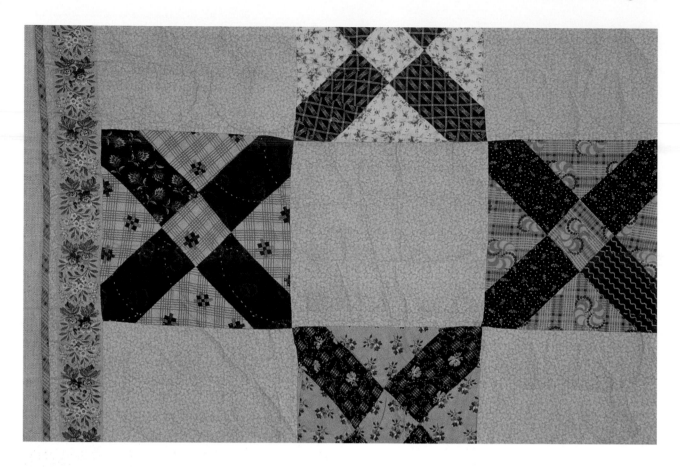

Plate 10. Cross quilt—
detail. Nannie Snoddy's
name for this simple
block pattern is un-
known, but it was later
published under a number
of names, including A
Snowflake, Cross Stitch,
and Old Italian Block.

customary for widows to use their own initials rather than those of their late hus-
bands. Nannie was not married in the 1870s or 1880s when she made this quilt.
The use of this official form, rather than "Sister" or "Nannie," may be an indica-
tion of the thin surface of civility that overlay ill feelings within the family later.
The label does not indicate how this quilt was transferred from Nannie to Mary.
It may have been a gift at her wedding or a later occasion.

Rosa's Log Cabin Quilt

*"Log Cabin design. Pieced by grandma Snoddy at home. Mother carried
it when she went to housekeeping. Made before Mother married."*

The Log Cabin pattern first developed in the 1860s as a technique for wool or
silk patchwork, but it quickly achieved wide popularity and was reproduced in
cottons as well.[41] Quilters of later generations assumed incorrectly from the rus-
tic name that the pattern had originated among early settlers on the frontier. A
writer in 1935 stated flatly that "No Colonial home was complete without one
or more" quilts of the Log Cabin pattern.[42] In the nineteenth century, the Log
Cabin pattern was constructed as a form of "pressed" patchwork, in which fab-
ric strips were sewn, one at a time, to a foundation square of fabric, then pressed
back over the seam, building the pattern outward from the center.

Log Cabin quilts can be made from a limited number of fabrics, but quilt-makers more often took advantage of the pattern's versatility to incorporate a variety of fabrics. As long as the majority of darker fabrics are separated along the diagonal from lighter fabrics, the resulting blocks can be arranged to form a dozen or more different visual effects. In this example the light and dark blocks are arranged to form a "checkerboard" design.

Rosa's Log Cabin incorporates a large number of different printed fabrics. The dark palette is limited primarily to shades of brown; the light fabrics include a variety of printed shirtings and dress fabrics. Quiltmakers often choose a single, bright fabric for the small center squares in all the blocks, but Rosa did not differentiate the center from the other dark fabrics. A single, narrow border of printed fabric frames the quilt, the edge is bound with alternating pieces of two different brown prints, and the fabric on the back is a lively printed stripe. The lines of quilting stitches simply outline the pieced "logs."

Many of the printed fabrics in Rosa's Log Cabin also appear in Nannie's Cross quilt, which also relies on a light/dark contrast to show off its pattern. Mother and daughters seem to have drawn from a common stockpile of fabric pieces, which would have included new yardage, remnants from clothing construction, and occasional recycled garments. In contrast Mary does not seem to have drawn from the same fabric collection for her Save All quilt (discussed in the Introduction), which was made during the same period. In that quilt Mary also used a variety of brown prints, but these are not duplicated in the quilts made by her mother and sister.

Rosa and her daughters had access to a ready abundance of fabrics for their dresses and their quilts. Printed cottons were plentiful and popular during the 1870s and 1880s. New England textile mills produced an almost endless variety of prints to supply consumers' desires for novelty. Small figured dress prints were the most popular style, accounting for the majority of the approximately one thousand different patterns produced by a typical company each year. Agents for these companies marketed fabrics throughout the United States and beyond.[43] In 1875 F. N. Walker, a Spartanburg merchant, advertised that he had "just returned from the North with an attractive line of SEASONABLE GOODS bought at the lowest prices and selected with unusual care. His LADIES' DRESS GOODS are of the latest and best styles, and purchased with a view to economy, beauty, and elegance."[44]

Although it would have been much quicker to sew quilt pieces together on the sewing machine, Rosa and her daughters typically pieced their quilts by hand

BELOW *Nannie Snoddy cut off the floral striped border from the pink fabric in her quilt blocks and used the long strips for the border of her quilt. The same fabric, with the printed border still in place, forms the quilt backing.*

OVERLEAF **Plate 11. "Log cabin design. Pieced by grandma Snoddy at home. Mother carried it when she went to housekeeping. Made before Mother married." Hand-pieced by Rosa Benson Snoddy, ca. 1880, 91 × 82 inches. Printed cotton fabrics, thin cotton batting, backed with printed striped fabric. Quilted by hand following pieced seams, thread color matches top. Applied straight-grain binding of two different fabrics.**

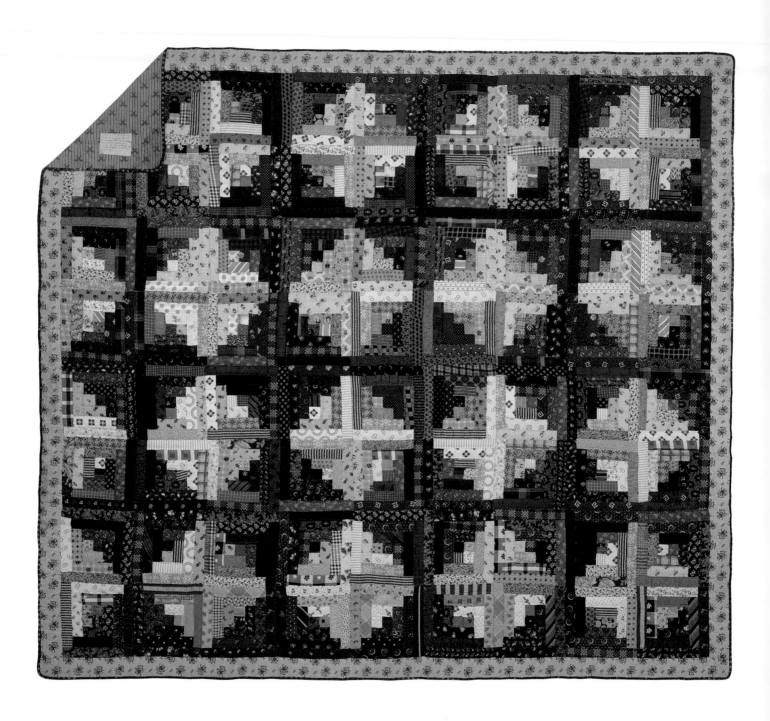

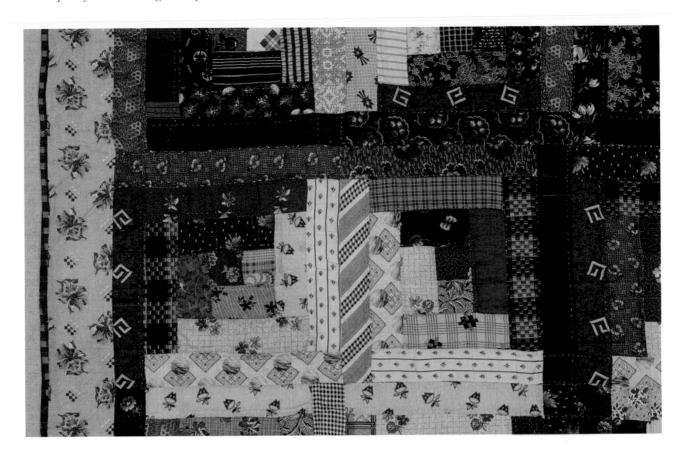

during this period. The machine work on Mary's appliquéd Tulip quilt indicates that the family had access to a sewing machine at this time, so the handwork on these pieced quilts indicates an intentional choice. To understand this preference for handwork, it is useful to examine the ways home architecture, social relations, and women's needlework intersected during the decade of the 1880s.

Mid-nineteenth-century homes included a formal parlor, sometimes described by social historians as a "sacred" space, where weddings, funerals, and other public events were held.[45] In addition larger houses, such as the one built by Colonel Snoddy before his marriage, would also include some sort of sitting room intended for the family's private use. Material culture researchers frequently refer to county probate records, which not only inventoried and appraised household furnishings but occasionally indicated the location of items within the house. The late-nineteenth-century inventory of the estate of Harriet Evins of Spartanburg County is particularly detailed, and the parlor and sitting room furnishings demonstrate the difference in the traditional functions of these rooms. The furniture in the parlor included a square rosewood piano, a "mahogany stand for bric-a-brac," a marble-topped mahogany table, two large upholstered rosewood sofas, two large chairs and five smaller chairs covered in the same material, and unspecified bric-a-brac. In contrast the furniture in the sitting room included, among

ABOVE **Plate 12. Log Cabin quilt—detail. Rosa incorporated a large number of different printed fabrics. The dark palette is limited primarily to shades of brown; the light fabrics include a variety of printed shirtings and dress fabrics. Quiltmakers often choose a single, bright fabric for the small center squares in all the blocks, but Rosa did not differentiate the center from the other dark fabrics.**

BELOW *Rosa Benson chose a lively printed stripe as the backing for her Log Cabin quilt.*

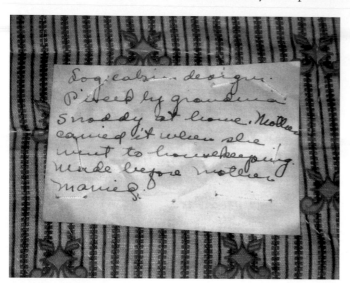

FACING Plate 13. "Aunt Narcissus Benson's quilt. She gave Mrs. H. R. Black." Zigzag pattern hand-pieced by Narcissa Benson, ca. 1880, 86 × 75 inches. Printed cotton fabrics, cotton batting, backed with woven striped fabric. Quilted by hand in wave design following pieced seams. Applied straight-grain binding of brown fabric.

other items, a walnut writing table, two bookcases with glass doors, one lot of about a hundred books "including cyclopedias and books of influence," one mahogany upholstered sofa, three wooden rocking chairs, and a sewing machine.[46] The furnishings and their placement in this house were typical for the nineteenth century. The parlor furniture was made of richer materials and included the piano for entertaining guests. The cozier sitting room was used by the family for reading and sewing.

Compared with the Evins estate, the household inventory of Mary's maternal grandparents is much less detailed but nonetheless revealing. When Silas Benson died in 1875, the officials conducting the inventory chose to provide a single appraisal figure for the contents of each of the nine rooms rather than itemizing the individual objects. They evaluated the "sewing machine and other furniture in sitting room" at $125, the highest total for any room. The "furniture in parlor" was the next highest, at $70; the "contents in kitchen," $60; and three bedrooms at $50 each. The parlor may have been the most elegantly furnished and formal room in the house, but the presence of the sewing machine ballooned the value of the sitting room's contents.[47]

Typically a family would gather in the sitting room in the evening, drawing close together to share the light of an oil or kerosene lamp. Reading was a popular activity, but instead of reading individually and silently, the family was likely to listen to someone reading aloud. Typically the man of the house would read aloud, while women engaged in some form of sewing or handwork. If no men were present, the women would take turns reading.[48] Hand sewing was a quiet, communal activity. The use of a sewing machine during these evening gatherings would probably have been seen as disruptive in more traditional households. Women may have been more likely to use sewing machines during the day and to save hand sewing for evenings.

Women of the late Victorian era were generally competent in a number of textile skills, so piecing quilt blocks by hand may have been one of several handwork activities, along with knitting, crochet, and embroidery. Women's needlework performed an important function in the late Victorian era:

> To an extent we may find difficult to understand today, the woman's sphere was valued or respected, and women did have an important role. They served as the guardians of positive moral values, and as counter-forces to the dubious forces of the outside. Everything that a woman did could affect the well-being of her family. Needlework was seen as a proper womanly activity, one that was suitable for the home environment and beneficial to its residents.[49]

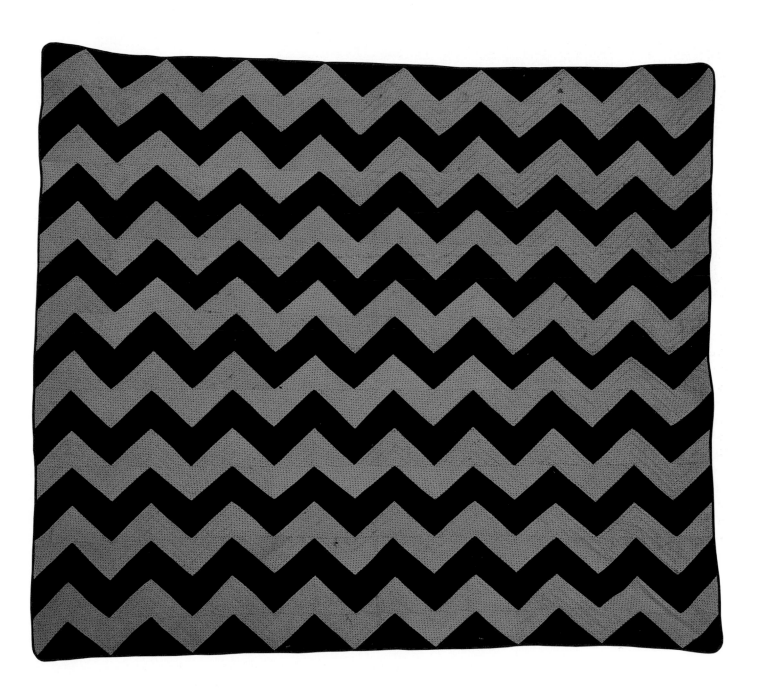

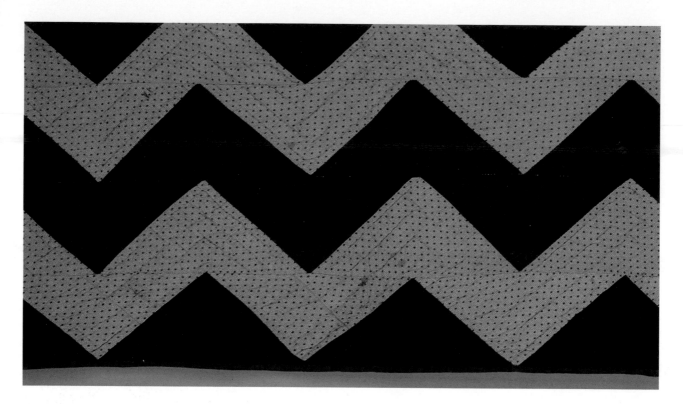

Plate 14. Zigzag quilt—
detail. Narcissa Benson
used only two different
fabrics to make this strik-
ing quilt. The stark con-
trast of the two fabrics
and the large scale of the
triangles results in a very
bold quilt, perhaps not a
style typically associated
with a middle-aged,
unmarried woman
of the Victorian era.

Women made frequent visits with relatives, sometimes for several days at a time, and they carried handwork in order to keep their hands occupied during these visits. In southern rural communities, women's friendships were largely influenced by kinship networks. One's closest neighbors were likely to include relatives and in-laws of various degrees. Mary and Nannie would have had frequent contact with their Benson and Snoddy relatives living in the area, and they probably pieced quilts, embroidered, crocheted, or knitted while visiting family and friends.

The complex web of extended families provided support in times of difficulty. In 1878 Rosa's sister Margaret Benson Nesbitt died at the age of thirty-five, leaving three small children. By 1880 the three children were living in Wellford with their unmarried aunt, Narcissa Benson, age fifty. In a will executed before her own death in 1881, Narcissa bequeathed to each of these children $100 and "a nice bedquilt and counterpane."[50]

Aunt Narcissa's Quilt

"Aunt Narcissus Benson's quilt. She gave Mrs. H. R. Black."

Mary Snoddy also received a quilt from Narcissa Benson. This gift was not named in Narcissa's will, so it may have been presented before the maker's death. Unlike the other family quilts from this era that are made of repeated blocks, Narcissa's quilt was constructed in long strips of triangles, forming a zigzag design.[51] She used only two different fabrics—a solid dark red (similar to the red in Mary's Tulip) and a delicate print of five-pointed stars in red and brown superimposed over

a pale yellow grid printed on white. The stark contrast of the two fabrics and the large scale of the triangles results in a very bold quilt, perhaps not a style typically associated with a middle-aged, unmarried woman of the Victorian era. Like the quilts made by Rosa and her daughters, Narcissa's quilt was pieced by hand. She quilted it in parallel rows of stitches, following the angles of the zigzag to form a wave design. She matched the color of the quilting thread to the fabric color, red thread on the red, and white thread on the light print.

Narcissa clearly had sufficient fabric to complete her quilt top without substitutions, but she exercised economy on the back where it was less visible. The backing fabric, a brown-and-yellow stripe, appears to have been recycled from an earlier use. She sewed together three lengths of the 25-inch-wide fabric, but that apparently proved insufficient. Along one long edge, a number of short pieces are joined to augment the width, and one of these has a small irregular patch, suggesting mending of some previous damage. The backing was still too short, as there are additional long narrow strips pieced in on both shorter ends. Narcissa chose new materials for the visible front of the quilt and recycled fabric for the generally unseen back. The juxtaposition of public and private faces in the quilt seems to mirror the distinction between the formal parlor and the more humble sitting room of the Victorian home.

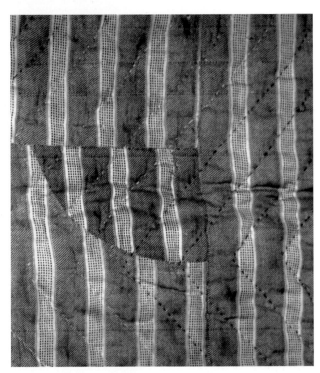

Narcissa exercised economy on the back of her quilt, using a brown and yellow stripe recycled from an earlier use. She joined a number of short pieces, some of which include patches of the same material.

The Snoddy Family in the 1880s

In 1880 the Snoddy family consisted of Samuel, Rosa, and their two unmarried daughters, Nannie, age twenty-four, and Mary, age twenty. Doc Wilkie, a twenty-one-year-old black laborer, was also enumerated with the family. James Robert Snoddy, called "J.R.," had attended Moore's Business School in Atlanta in 1876,[52] and, in December of that year, at the age of twenty-two, he married Mary Jane Richardson. The couple lived at New Hope, the former homeplace of his grandfather Isaac Snoddy, where J.R. farmed, ran a sawmill, and conducted various other business operations.

During this time J.R. seems to have taken on some of the financial business for other family members, including his father. The income of farm families was highly seasonal; cotton, the premier cash crop, was harvested and generally sold at the end of the year. Even farmers who owned hundreds of acres of land, including Colonel Snoddy, typically operated on credit during the year and settled their debts after they sold their cotton in the fall. In contrast J.R. conducted much of his business transactions in cash, and he frequently advanced cash to family members during the growing season.

In 1878 J. R. Snoddy started keeping an account book to record the orders of his sawmill customers and the distributions of cotton seed and supplies to his

RIGHT *The structure in this twentieth-century photograph is identified as "Cora's house," which stood in the field behind the Snoddy homeplace. Cora was the wife of Doc Wilkie, who worked for Colonel Snoddy's family after the war. The house is typical of the cabins occupied by slaves and, later, tenants and sharecroppers throughout the South.*

BELOW *The economy of the South, before and after the Civil War, was based on the production of cotton. This photograph was taken in the 1930s, probably in Spartanburg County; harvesting cotton remained a manual task at that time. U.S. Soil Conservation Service Collection, Spartanburg County Regional Museum.*

In 1885 J. R. and Mary Jane Snoddy moved into their new home at New Hope, the farm that had belonged to Isaac Snoddy. The house is still occupied by J.R.'s great-grandson.

tenants and sharecroppers. In 1885 J.R. and Mary Jane moved into a new house, and this domestic change seems to have spurred the gradual addition of personal journal entries to his account records. The journals reflect the complexities of daily farm and community life, and, in the absence of other surviving documents of this era, they provide what few details are available about the lives of Mary and her family during the 1890s.[53]

On September 13, 1888, J.R. noted "Pd Ma for Sweet to go to Baltimore $15.00." Personal items are scarce among J.R.'s entries during the first decade of his journal, and this was J.R.'s first mention of his sister Mary. Although the reason for Mary's trip was not given, it seems certain that it had to do with her engagement to Dr. H. R. Black, who had graduated from the University of Maryland School of Medicine in 1883.[54]

At age twenty-eight, Mary Louisa Snoddy was preparing to leave her parents and sister to establish a home and family of her own. Her childhood during the Civil War, her sweet temperament, her love of music, her education and religious values, all are aspects of the character that continued to govern her life and to influence her family and community in the ensuing years. The beauty and skill of her quilts are also testaments to her accomplishments as a young woman of the Victorian era. Late in her life the quilts made by family members during this period would serve as reminders of this preparatory stage in her life and of her own role within her extended family. ❦

"PAID SWEET TO GET SEWING MACHINE"

Marriage and Family in Wellford, 1890s

D URING THE FINAL DECADE of the nineteenth century, Mary's life revolved around her husband and their growing family in Wellford. Mary and other women in the community continued to make quilts, but, as locally manufactured fabrics became available the functions of their quilts gradually changed. During this era, quilts were no longer important markers of the family's affluence or the primary indicators of the maker's domestic accomplishments. Instead of functioning in public spheres, where their value was acknowledged by both men and women, quilts came to be circulated primarily among networks of women. As the significance of quilts as testaments to a woman's needlework skills declined, quilts of the late nineteenth century often reflected the work of more than one maker.

A Family Wedding

On January 2, 1889, Mary Louisa Snoddy married Dr. Hugh Ratchford Black (generally known as H. R. Black), in the parlor of her father's home. The Reverend R. H. Reid performed the ceremony, as he had for Mary's parents. Colonel Snoddy, now age seventy-three, and Rosa, age sixty-two, no doubt invited friends and family. With many relatives living nearby, the gathering would have been sizable. "Sister" Nannie, age thirty-two, was still single and living at home, and brother J.R., age thirty-four, and his wife Mary Jane, age thirty-three, certainly would have been there.[1] Rosa's parents and two of her sisters, Margaret and Narcissa, had died. Her other five sisters were married and living in the area, although the youngest, Henrietta, died seven weeks after the wedding. Rosa's surviving brother, John

Miller Benson, and his family were close neighbors, as was their sister-in-law, Confederate widow Martha Benson.

Colonel Snoddy's family would have been represented by his youngest sister Nancy Daniel, a widow sixty-eight years old. His only other surviving sibling was Mary Hoy, age seventy-six, who was living in Pontuloc County, Mississippi. Among his nieces Theresa Snoddy Wingo still lived in the area, but her sister, Laura, had married, moved away, or died, as no further details of her life are

known. The wedding provided an occasion for the extended family, friends, and neighbors to gather together. Most of them had known Mary all her life, but her new husband was a relative newcomer to the area and, according to his biographer, "one of the most eligible bachelors in the community."[2]

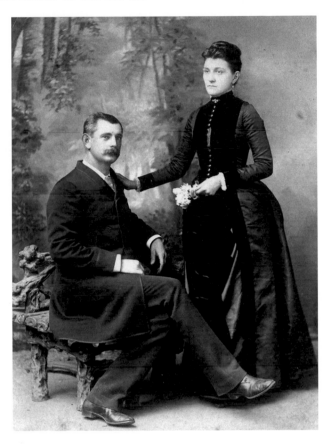

Hugh Ratchford Black was born December 4, 1856, in Cleveland County, North Carolina. His great-great-grandparents Robert and Agnes Black had emigrated from Ireland after the American Revolution; they landed in Charleston and moved on to York County, South Carolina. Their great-grandson Jefferson Black married Eliza Borders in 1850, and this couple settled on a farm across the state line in Cleveland County, North Carolina. Hugh Ratchford was the fourth child and second son of Jefferson and Eliza Black's nine children.

According to historian Dr. Lewis Jones, the family's "farming atmosphere" provided the young Hugh Black with "a rude introduction to medicine. In the course of cutting wood he received a severe cut on his arm, which was repaired by his farmer-father with three stitches taken with a darning needle." Following early schooling in "old field schools," Hugh attended a military academy in nearby Kings Mountain. After a six-month stint as a schoolteacher, he decided to study medicine. He entered the University of Maryland in 1880 and graduated in 1883.[3] In 1884 Dr. Black mounted his horse and headed for South Carolina to set up a medical practice. His brother, Thomas, and Thomas's wife followed in a buggy carrying Dr. Black's trunk. After a few months at Ballenger's Mill, he relocated to the nearby town of Wellford, where he boarded with the family of Rufus N. and Margaret McClain, who operated a dry goods store.[4]

The Black family had been associated with the Associate Reformed Presbyterian (A.R.P.) Church for many generations.[5] Although H.R.'s mother, Eliza Borders Black, remained a devout Baptist after her marriage, H.R. followed his father into the A.R.P. church. After his arrival in Wellford, Dr. Black became an active member of the local A.R.P. congregation and served as an elder.[6]

A New Church in Wellford

The Wellford A.R.P. church was formed in 1883, and that year some fifty members of the Nazareth congregation transferred their membership to the new church.[7] Members of the Snoddy family were apparently among them. J. R. Snoddy's journal entries indicate that, beginning in 1887, he helped locate the site and provided lumber, nails, hardware, and plastering supplies for a new church building, including a donation of walnut lumber for the pulpit. He also "planted shade trees" at the new church.[8]

It is possible that the Snoddy family and others left Nazareth in opposition to some controversial innovation in the worship service, or they simply may have found the new church to be a better fit with their personal convictions. The A.R.P. church shared the same roots in Scottish Calvinism with the mainstream United Presbyterian tradition, but the two branches diverged over certain doctrinal issues. Aside from doctrine A.R.P. churches are perceived as generally more conservative than other Presbyterian churches.

Fundamental in the early years of both the A.R.P. and mainstream Presbyterian churches was an adherence to singing biblical renditions of the psalms in worship. After many years and much debate, church officials approved the use of psalms that been recast in regular, more "singable" metrical forms, but they still rejected hymns that were merely of "human composure."[9] The differences between the old and new versions may seem insignificant more than a century later, but the selection and inclusion of the new versions were reportedly the result of "much time and prayer and close study" by the Presbyterian General Assembly and its committees.[10] The more conservative A.R.P. congregations were generally slower to adopt the new versions than mainstream Presbyterians, and this may have been one of the issues that influenced the shift in membership.

While records of the Wellford A.R.P. church have not survived, two copies of *The Book of Psalms* used at that time are still owned by descendants of the Snoddy family. Published in 1871, the book presents the psalms—texts only, without tunes—in numerical order, each with an older metrical version in "Common Meter," and one or more new versions in other meters. One of the copies of the book is inscribed in pencil on the flyleaf: "By H. R. Black, Wellford, S.C. To Mrs. H. R. Black." The date, "June 18, 1889," was added separately in what appears to be a different hand. The second copy is inscribed in ink "Miss Nannie Snoddy, Wellford, S.C., July 7th, '89." Of the two copies, Mary's is more worn, missing the preface and the back cover. Nannie's received, perhaps, either more care or less use.

Not only did the A.R.P. limit church singing to psalms at this time, but they also excluded the use of musical instruments such as the piano or organ, which some other congregations, including Nazareth, had adopted for worship. The ban on instruments and hymns of "human composure" did not extend beyond worship services, however. Church members were not forbidden to play musical instruments or to sing hymns or popular songs outside the church.

Music and Courtship

Many young people of this era played instruments, and instrumental music was associated with sentimentality, romance, and courtship. According to cultural historian Craig H. Roell, "In the Victorian home, music and playing the piano allowed expression that was otherwise frowned upon.... In this way music could be a liberating experience for women. Playing the piano was also an important part of Victorian courtship. The girl who could sit at the piano and sing sentimental songs and hymns to gentlemen callers was at least popular and at best had a greater chance of a good marriage and happy home. The piano—symbol of Victorian morality and respectability—naturally lent itself to romance, serenade, and betrothal."[12]

According to Dr. Jones, H. R. Black "played the guitar and several of his friends played violins, so that they had many a good time together."[13] Both Mary Snoddy and H. R. Black were accomplished musicians, and these two young people may have found opportunities during their courtship to exchange glances while singing popular sentimental songs. "In nineteenth-century homes, hymns and parlor songs were often heard and performed. Hymns, sung primarily in Protestant households, reinforced notions of morality and of the home as a sacred unit. Full of sentiment and romantic idealism, parlor songs often focused on themes such as family, motherhood, and home. Their messages were of purity, happiness, and stability."[14]

Mary and Dr. H. R. Black

After their marriage Mary and H. R. Black set up housekeeping in Wellford. In 1889 Dr. Black purchased a lot of 5¾ acres, "bounded by land of the negro Presbyterian church [and] the new schoolhouse lot" for $230.[15] As a country physician, Dr. Black made house calls in a horse and buggy over a wide area of the surrounding countryside. During his first five years of practice, he reportedly collected only five hundred dollars in cash. As his rural patients were primarily farmers, they typically paid him in the fall when they sold their crops.[16] At other times of the year, Dr. Black probably accepted farm produce as payment for services.

The Blacks supplemented their income by farming, contracting with tenants on part of Colonel Snoddy's land. On December 4, 1890, J.R. "Sent Sweet 15 Bus[hels] cotton seed," indicating that the Blacks were directly involved in raising cotton. The extended Snoddy and Benson families, like their neighbors, operated a complex but informal exchange of goods and services, sometimes for cash, sometimes as gifts, barter, or loans. A couple of months after the wedding, J.R. "Sent Sweet Table and Tray," which may have been wedding presents or items he had ordered for her. On October 3, 1889, J.R. "Pd D. P. Posey Sweet acct. 9.80." Other entries indicate that D. P. Posey was a dressmaker, and J.R. may well have stepped in to pay the bill for his sister's wedding dress made earlier that year. J.R.'s notation on March 20, 1891, is of particular interest to a study of Mary's quilts, as on that day he wrote, "Paid Sweet to get Sewing Machine, 18.00." Until this

*J. R. and Mary Jane Richard-
son Snoddy had two surviving
sons, Samuel Miller Snoddy
("Dolly"), born in 1890,
and Harry, born in 1892.*

time, Mary could have arranged to use her mother's machine, but having one's own sewing machine was by this time a landmark event in a woman's life.

On February 11, 1890, Mary Snoddy Black gave birth to her first child, who was named Samuel Orr Black.[17] Two months later a son was born to J.R. and Mary R. Snoddy (their first surviving child after thirteen years of marriage) and named Samuel Miller Snoddy, after his grandfather. Perhaps to avoid confusion when referring to these young cousins, Mary's son was always referred to as "Sam Orr," while J.R.'s son became known within the family as "Dolly."

In 1892 a second set of male cousins arrived: Harry Snoddy in February, and Hugh Snoddy Black in October. Two years later, on February 11 1894, J.R. "Spent Day Sam Orr Black birthday dinner." Less than two weeks later, his wife Mary R. Snoddy gave birth to a son, Wiles Miller, who lived only three days. On May 29 of the same year, a daughter was born to Mary and H. R. Black and named Rosa after her maternal grandmother. The young cousins, particularly the four boys, developed close friendships that continued through adulthood.

During 1897 Sister Nannie visited J.R. with increasing frequency. On November 11 J.R. "Pd Sis yesterday to get things 40.00;" and three weeks later "Pd Mrs. Bain to make Sis Dress 9.00." These preparations culminated on December 7, 1897, when "Sis & D. M. Coan married at 2½ pm." At the time of her marriage, Nannie was forty-one years old, and her new husband was fifty-five. The Coan family were neighbors, and, like the Snoddys, they were descendants of the original Scots-Irish settlers to the area. Nannie Snoddy and Dr. David M. Coan were also second cousins. The groom was descended from Isaac Snoddy's Irish-born sister, Mary Snoddy (1755–1823), and her husband Andrew Coan.

In June 1898 J.R. noted "Pa sick," and during the following weeks he frequently spent the day or night at the home of his eighty-three-year-old father. He did not remain idle; on July 2, he wrote: "Spend day at Pa. Paint kitchen floor. Build Wagon Shed. Spend night at Pa." A few days later, "Pa send me to see M. Foster abt his will," and on July 13, "Pa had stroke Paralysis." Col. Samuel M. Snoddy died on July 27, 1898, and was buried the following day at Nazareth.

J.R.'s journal indicates that Colonel Snoddy made a will, but the estate did not go through the county probate process. No copy of the will survives, and the details are now unknown. During the following months, Rosa, her children, and their spouses met repeatedly to negotiate the settlement of the estate. These meetings were apparently contentious at times. After one series of almost daily

meetings, J.R. reported on September 9, 1898, "Sweet agrees to abide by Pa's request," and on October 31, "Mr. Coan Report Sister will take all the Property she can get."

On December 17 J.R. recorded that R. E. Foster had been engaged to "cry sale of SMS," and on December 20, the day after the sale, J.R. came home with "a few old Rellicks." On December 22, "Ma brake up House Keeping & go to Sweets." The personal property had been disposed of, but the disputed settlement of the land took much longer. On March 1, 1899, J.R. "Went to Mr Coans with Dr Black & got a fierce going over by Sister."

On March 27, 1899, Rosa and the three children filed a document, "Articles of Agreement between and among the heirs at law and distributors of Col. Samuel M. Snoddy, . . . to partition his real estate and to settle and to adjust the other matters herein referred to, in order to save the costs of going into Court to do so, and for other good and sufficient considerations." This action was filed, not through the Court of Equity, which governed probate, but through the Register of Deeds, which governed land transactions. Each of the four heirs was represented by a commissioner, who as a group authorized a survey and divided the land among the heirs. Rosa and the children then executed a series of deeds, conveying their shares so that each of them owned a piece of land individually. As a result Rosa received 595 acres; J.R., 465 acres (including New Hope but excluding the value of improvements he had made); Nannie, 391 acres; and Mary, 495 acres.[18] Nannie's share of acreage was smaller, but it included the family home.

In addition Rosa filed a deed conveying "all of undivided interest in real estate of S. M. Snoddy" to J.R. and Mary but not to Nannie. Rosa retained the "right to use and control" the land "during her life and to collect rents and profits."[19] The deeds form an incomplete record of the negotiations that produced them, but it is clear that Sister Nannie Coan was at odds with the others regarding the settlement. Although the family soon resumed its pattern of visiting and exchanging goods and services, bitter feelings remained to surface much later.

Life in Wellford at the Turn of the Century

We have few records of Mary's activities during this period, but her brother's journals reflect events and interests shared by the family and the Wellford community during this transitional period at the end of the nineteenth century. The area surrounding Wellford remained agricultural, but by the 1890s, it was no longer an isolated rural community. The railroad linked farmers to Spartanburg and beyond, and new technologies transformed Wellford and other rural communities.

Col. Samuel Miller Snoddy died on July 27, 1898, at the age of eighty-two.

Mary's brother, J. R. Snoddy, was a successful businessman who participated in a wide range of local affairs during his lifetime. His first wife, Mary Richardson Snoddy, died in 1900, and in 1903 J.R. married Elizabeth Rogers, the twenty-four-year-old daughter of a neighbor. She gave birth to James Rogers Snoddy on September 27, 1904, and died two weeks later. Throughout his childhood young James was called "Baby" by the family; and his father continued to refer to him by this nickname at times into adulthood. J.R.'s journal entries during the years he raised his sons are filled with notations of frequent visiting among various members of his extended family, including in-laws from both marriages, various Benson and Snoddy cousins and their children, as well as neighbors and friends.

In addition to his farm and his family, J.R. also engaged in personal recreational pursuits. He went bear hunting in the North Carolina mountains. He played in a string band with Simp Coan, E. Wilson, and Joe Ballenger. A notation of the purchase of "violin strings" suggests that his instrument was the fiddle. Music was not his only diversion. On April 29, 1898, he "Built Alligator pen," and on May 16, he "Brought Alligators home." This novel experiment seems to have failed, as on August 22, he noted "Two Alligators dead."

In March 1892 J.R. became closely involved in "Meetings & work to set up telephones" in the Wellford area. Months of journal entries detailing the installation of posts and wires culminated on March 11, 1893, when "Dolly talk on Telephone 1st time." J.R. had built his home near the site of his grandfather Isaac's stagecoach inn, situated on the main road running northeast to southwest. The location continued to serve as a hub for travel in all directions, and J.R. recorded many notations regarding work to lay out, maintain, or relocate both roads and railroads serving the growing local population as well as travelers between Spartanburg and Greenville. In 1908 J.R. Snoddy became the first person in the Wellford area to own an automobile.[20]

J.R.'s interest in new technology also included photography. He frequently hired photographers to take pictures of his parents, his sons, his new house, the old homeplace of his great-grandfather John Snoddy, and an old walnut tree in the yard. He typically ordered multiple prints to share with relatives and neighbors. On March 25, 1905, J.R. hired a photographer named Barnhardt to take a group picture of his mother and surviving aunts, followed by "Dinner for all and a Good time." Descendants in the family still have copies of the photograph of Rosa Snoddy and her sisters, Frances High, Harriet Roe, Marinda Burnett, and Mary DeBard, taken at New Hope that day. Amused by the dour facial expressions and severe black dresses, they refer to the women in the picture as "the biddies."

LEFT *By the 1890s Wellford was no longer an isolated community. The railroad linked residents to Spartanburg and the rest of the country. The man to the left of the post is Dr. H. R. Black.*

BELOW *After the death of his first wife, J. R. Snoddy married Elizabeth Rogers in 1903. She died the following year, two weeks after the birth of their son.*

The Textile Industry in Spartanburg County

J. R. Snoddy's involvement with local business included the rapidly expanding textile industry. The success of the Bivings Factory and other early textile mills during the Civil War had demonstrated the potential for the development of textile manufacturing in Spartanburg County. Early settlers such as Silas Benson had built their flour mills on the shoals of the Pacolet, Tyger, and Enoree rivers and their tributaries. From the 1870s into the early twentieth century, many of these rural sites were transformed by the construction of multistory cotton mills and their attendant villages.

J. R. Snoddy was a shareholder in the Pacolet Manufacturing Company, which was organized in 1882 by a group of local investors headed by John H. Montgomery. In 1884 the three-story mill with its 12,000 spindles and 328 looms was surrounded by a newly created village of sixty-two houses and several boardinghouses for the five hundred employees, called "operatives." The Pacolet company built two more factories at the same location in 1888 and 1894, for a total of 57,000 spindles and 2,190 looms.[21]

The regularity of the semiannual dividend check of $75.00 from Pacolet encouraged J.R. to invest in other factory ventures. On April 27, 1894, he noted "Selected Tucapau mill site by Greene, Converse, & Fleming."[22] The mill site on the Middle Tyger River was only some two miles from the Snoddy

LEFT *James Rogers Snoddy ("Baby") with his new bicycle in front of the family home, New Hope, ca. 1910.*

BELOW *The surviving Benson sisters: Rosa Snoddy (left), Frances High, Harriet Roe, Marinda Burnett, and Mary DeBard. Photographed at New Hope, March 25, 1905.*

home at New Hope, and J.R.'s sawmill supplied the lumber for the mill construction. His journal notes lumber deliveries to Tucapau on at least six occasions between May and September 1894. Construction of the four-story brick mill went apace, and on April 12, 1895, J.R. noted "Heard Tucapau Bell 1st time," referring to the signals that structured the operatives' work day.

Tucapau opened as a calico mill, with 10,000 spindles and 320 looms. "The automatic Draper looms were the first of their kind ever installed in a Southern factory, and people came from all over to watch them work."[23] As a stockholder J.R. took a particular interest in the workings of this very local factory, and he served on the auditors committee with two other men.[24] On September 11, 1896, J.R. entered into a different relationship with the mill: "Let Tucapau have 6 B/C [bales of cotton]." During 1898 J.R. and his tenants sold a total of thirteen bales of cotton to the mill. The sales were spread out through the year, as J.R.'s financial diversification allowed him to hold back part of his crop for more favorable prices rather than sell it all immediately at harvest.

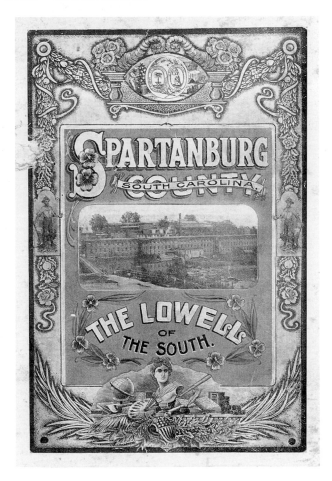

Spartanburg promoters distributed this brochure among investors in New England in 1899. Courtesy of the Spartanburg County Regional Museum.

The proximity of the Tucapau mill had another influence on J.R.'s business relationships. All factories needed workers, and as the mills were usually built in sparsely populated areas, the companies actively recruited workers from among farm families. Tenants and sharecroppers were already a mobile lot. At the end of each growing season many families moved from one farm to another, in search of more productive land, more favorable terms, or better living quarters. Textile mills promised regular hours, cash wages, and newly built houses, and these amenities appealed to many tenant farmers. On January 9, 1899, J.R. noted the departure of one of his renters: "Jno [John] Phillips moove [*sic*] to Tucapau." Subsequent entries record the movement of farm workers to and from various mill villages, suggesting that some landless families alternated between the risks, rigors, and relative freedom of farming and the comparatively well-paid confinement of factory work.[25]

In 1899 J. R. Snoddy established the Wellford Ginnery. This factory replaced the older gins and screw-type cotton presses used on individual farms and allowed for more efficient seed removal and more tightly compressed bales.[26] On September 2, 1899, the five directors met to elect T. E. Moore as president and J. R. Snoddy as treasurer and gin manager. During September, J. R. supervised the raising of the smokestack and the delivery and installation of the machinery. On September 26 he wrote "Gin 1st B/C at Wellford Ginnery."

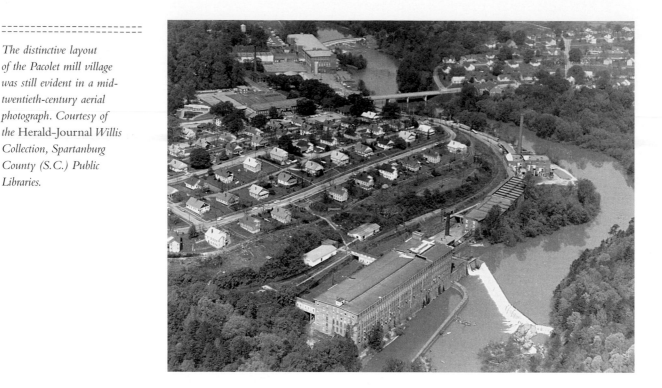

The ginning operation apparently formed the basis for the development of the Wellford Cotton Mill. By 1905 the small mill was in operation with thirty-six looms, "producing terry towels and quilts."[27] The nature of these "quilts" is not known; they were most likely white "Marseilles" bedspreads, woven by a process that imitated the stitched and puffed designs of whole-cloth quilts. Marseilles bedspreads were very popular during the nineteenth century, and simpler, lighter versions continued to be available at local stores or through Sears, Roebuck & Co. in the early twentieth century.[28]

J.R. occasionally noted that he had given towels, blankets, and cloth to various family members, and these may have been products of the Wellford factory. The early products of Southern mills generally had been "coarse" or "plain" goods, such as sheetings. Later mills, including Tucapau, produced inexpensive cotton prints, offering an alternative to the products of New England mills. In addition to shipping their products elsewhere, mills operated outlet stores where they sold seconds and overruns to local customers at reduced prices.

At the same time that cotton fabrics became more affordable, local stores offered a growing volume and variety of ready-made clothing. Most rural families, however, continued to make much of their own clothing, particularly every-day shirts and dresses, at home from purchased fabric. Seamstresses accumulated scraps from clothing construction, and some of these remnants were made into quilts.

The ready availability of a variety of inexpensive fabrics led to a gradual shift in the public perception of quilts, not just in the Spartanburg area but in other

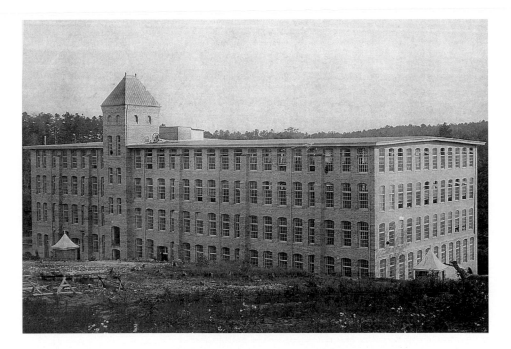

Tucapau Mills, 1895. Not only was J. R. Snoddy a stockholder in the Tucapau Mills, but his sawmill supplied the lumber for the building. Photograph courtesy of Junior West and Hub City Writers Project.

parts of the country. Earlier generations valued quilts in part because they were made from fine, expensive fabrics. Women making quilts from the newer, less expensive fabrics generally spent less time and energy in the process, and the quilts made in the 1890s generally demonstrate this gradual shift. Mary's quilts from this period include local fabrics, and they continued to reflect her relationships with female relatives and neighbors in the rural area surrounding Wellford.

The Shoofly Quilt

"Quilt made by mother probably after she moved to Wellford.
Strip around quilt was her dress."

Mary herself did not provide a name for this simple geometric design of squares and triangles, but the pattern is most frequently known as Shoofly.[29] Mary pieced her blocks from only two fabrics, a black-and-gray stripe printed with white daisies and a mottled pink and brown *ombre* (from the French *ombré,* meaning "shaded") print. The shading in the pink print produces soft stripes that, when cut up and pieced, create an irregular distribution of light and dark patches. The contrast between the two prints is subtle, resulting in a surface that is subdued in color and contrast, but lively in patterning.

The label reveals that the cotton border fabric was taken from one of Mary's dresses. It is possible that this bright, gay fabric had been appropriate for the dress of a young, single woman but was not considered suitable for a married woman. Converting the dress into a quilt prolonged the fabric's usefulness and preserved any sentimental or personal attachments associated with it. This fabric appears at first to be a simple pink-and-white plaid, but close inspection reveals a more complex pattern of yarn colors. A juxtaposition of red and white warp threads

OVERLEAF **Plate 15.** **"Quilt made by mother probably after she moved to Wellford. Strip around quilt was her dress." Hand-pieced by Mary Snoddy Black, ca. 1890, 92 × 77 inches. Shoofly pattern, maker's name unknown. Printed cotton fabrics, cotton batting, backed with brown and white woven check. Quilted by hand in diagonal parallel lines following pieced seams; border quilted in triple diagonal lines. Bound with bias strips of checked backing fabric.**

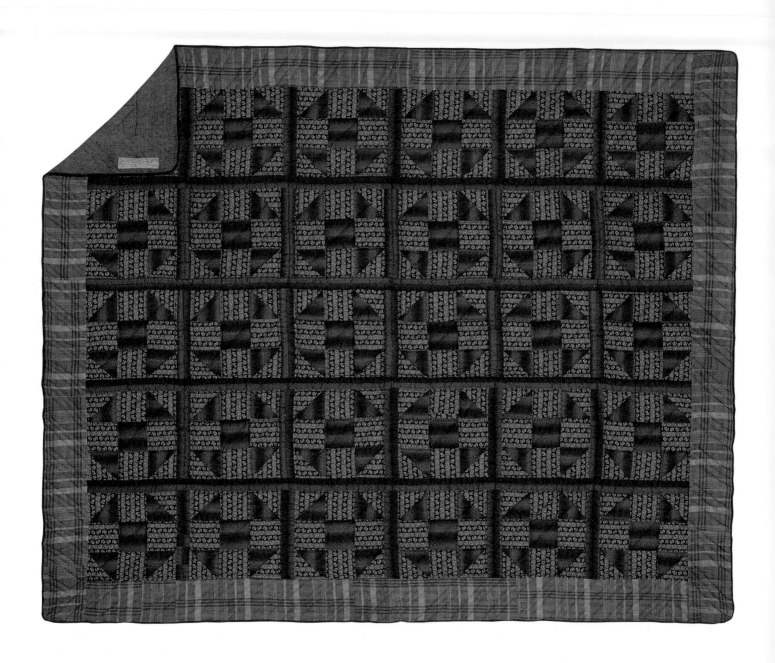

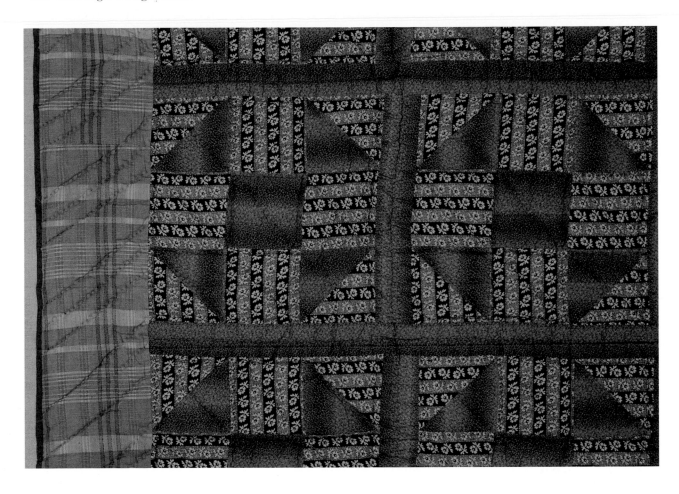

produces stripes of varying widths, crossed by an intricate and delicate pattern of stripes in blue and brown threads. The dress from this delicate fabric may indeed have been a special one.

The quilt is backed with a coarsely woven brown and white houndstooth check, an example of the "ginghams" produced widely by southern cotton mills during this period. These fabrics became known generically as "Alamance" plaids or ginghams, after the Alamance Cotton Factory in North Carolina.[30] Comparatively inexpensive, Alamance ginghams were widely used for household towels, aprons, and quilt backs.

Mary quilted the patchwork blocks in diagonal lines, but she quilted the sashing strips separately with three lengthwise parallel rows of stitches. The borders were quilted in diagonal lines grouped in "triplets" of three lines separated by unquilted spaces. Overall this is a simply constructed quilt made from rather elegant printed cotton fabrics. The needlework is all done by hand, which might suggest that it was made before 1891, when Mary's brother J.R. paid for her sewing machine. Alternatively Mary may have enjoyed this as a handwork project that could be done while sitting with her family in the evenings.

ABOVE Plate 16. Shoofly quilt—detail. Mary pieced this quilt from only two fabrics. The shading in the pink and brown ombre print produces soft stripes that, when cut up and pieced, create an irregular distribution of light and dark patches. The contrast between the two prints is subtle, resulting in a surface that is subdued in color but lively in patterning.

BELOW *Alamance ginghams were popular at the turn of the twentieth century for household textiles and quilt backs. Mary selected this plaid for the back of her Shoofly quilt.*

Cousin Mag's Churn Dash Quilt

"Quilt pieced by Cousin Mag and probably quilted by Miss Mary and Miss Lu. Mother's quilt."

A quilt from the same period introduces another quiltmaker, Cousin Mag Drummond. Margaret Drummond (1851–1927) was the daughter of Colonel Snoddy's sister Ann. In 1843 Ann Snoddy married S. N. Drummond, who owned a dry goods store, probably in the vicinity of Woodruff, southeast of Wellford. S. N.

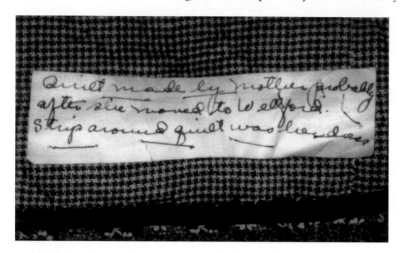

Drummond died in 1856, and three years later, Ann Snoddy Drummond married N. B. Davis. The 1860 census listed the family as Napoleon Bonaparte Davis, age twenty-three, a merchant with property valued at the impressive sum of $16,975; his wife Ann, age thirty-six; and her four children: Buena Vista Ann, age twelve; Margaret, age eight; Samuel, age six, and Jasper, age three.

Mag Drummond remained unmarried throughout her life. At the time of the 1870 census, she was nineteen years old and living in Greenville with her married

FACING Plate 17. "Quilt pieced by Cousin Mag and probably quilted by Miss Mary and Miss Lu. Mother's quilt." Churn Dash pattern, hand-pieced by Margaret Drummond, ca. 1895, 81 × 74 inches. Cotton fabrics, thick cotton batting, backed with a black on red printed striped fabric. Quilted by hand with black thread in discontinuous diagonal lines. Bound by turning backing to front.

sister, Buena Vista Westmoreland, who had a one-year-old daughter. J. R. Snoddy noted in his journal that Cousin Mag Drummond visited his home frequently over the years, often accompanied by Sister Nannie Coan. Following the deaths of each of J.R.'s wives, Cousin Mag was one of several relatives who spent an occasional day or two cleaning his house or sewing for his sons. J.R. made several notations over the years of giving her a few dollars from time to time, at least three pairs of shoes, and, once, a telescope.[31] The 1910 census enumerated her, at age fifty-nine, as living with the family of her brother Jasper. Ten years later, she was listed as a sixty-nine-year-old "servant" in the home of Frank Woodruff, in the town of Woodruff. On August 4, 1927, J. R. Snoddy noted "Cousin Mag died last night."

The quilt pieced by Cousin Mag was made in a popular pattern usually known as Churn Dash, Double Monkey Wrench, or Hole in the Barn Door.[32] Most often the triangles and squares forming the "dash" or "wrench" figures were formed from dark fabrics against a light ground, but this example reverses the contrast. Cousin Mag selected a variety of shirting stripes and dress prints, including some that appear in Mary's other family quilts. She alternated the pieced blocks with unpieced squares of black on red plaid. Two of the borders are of the same plaid fabric; the other two are cut from a similarly colored printed stripe, which was also used for the backing. Red and black prints were popular in quilts made during the 1890s in this area. While Mag pieced the quilt by hand, the borders were sewn on by machine, perhaps at the time the top was quilted.

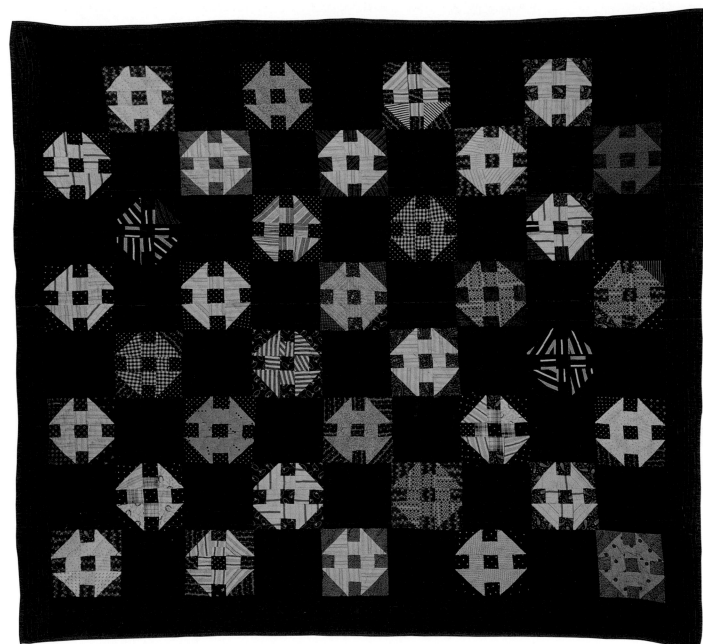

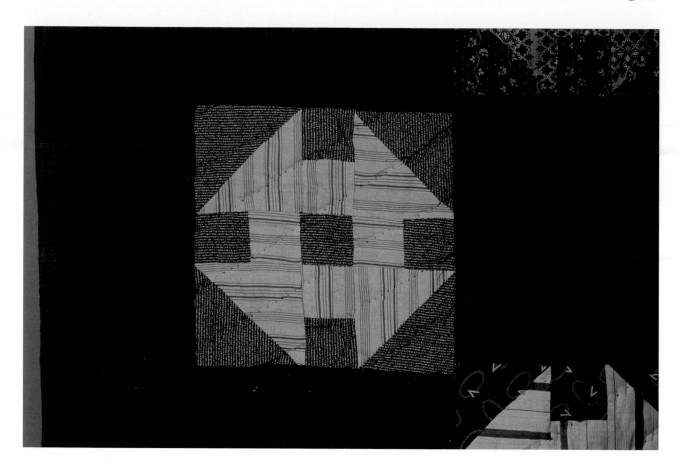

Plate 18. Churn Dash quilt—detail. We do not know Cousin Mag's name for this popular pattern, which is also known as Double Monkey Wrench or Hole in the Barn Door. In this example the figures are cut from light fabrics against a dark ground. Some of the fabrics in this quilt appear in Mary's other family quilts.

The quilt's label suggests that Mary acquired this piece from Cousin Mag as an unquilted top. It is possible that she paid for it as a way of helping out a less fortunate relative. As a single woman having no apparent employment skills, Mag Drummond may have supported herself by sewing and performing housekeeping tasks for a succession of friends and relatives. Mary later paid "Miss Mary and Miss Lu" to layer and quilt the top. The identities of these quilters are unknown. Single women and widows had few opportunities for earning income. (Factory work was considered unsuitable for women of middle-class families.) Women who did not receive a sufficient inheritance to maintain them frequently relied on the benevolence of family and friends. Many rural women raised and sold butter, eggs, and garden produce, or they quilted or sewed for hire.

Whatever their situation, Miss Mary and Miss Lu may have disagreed while quilting Cousin Mag's Churn Dash top. Although the quilting is done in diagonal lines, as are several of the later quilts, the lines in this quilt run in two opposing directions. It is as if the quilting was begun by a left-handed quilter on three sides, and the fourth side and the center were completed by a right-handed quilter. Perhaps the quilting design was seen as of little consequence. The quilting stitches are

less prominent against the dark fabrics of this quilt compared with the fine quilting clearly visible on earlier quilts, such as Rosa Snoddy's Sunflower.

The final element in the inscription is "Mother's Quilt," written in the same hand as the rest of the note but in ink at a different time. Several of the other quilt labels indicate which of Mary's children were the intended recipients, but, since all of the quilts belonged to Mary Black, it is not clear why this one is identified specifically as hers. Perhaps one of the daughters asked, "Who is this one for?" and Mother simply begged the question by saying, "Oh, this one is mine."

Basket of Chips Quilt

"Quilt pieced by mother—Design is basket of chips. Miss Mady Wingo brought pattern from Georgia. Pieced before Mother [married] but not quilted until after we moved from Converse St. to E. Main by a woman near Reidville. Small quilt."

One of the many quilt patterns representing baskets, this particular design was first published as Basket of Chips by *Comfort,* a periodical published in Augusta, Maine, between 1888 and 1942 and distributed nationally. *Comfort* was one of many periodicals that published drawings of quilt patterns during this period and offered the pattern templates through mail order.[33] While in Georgia, Mady Wingo may have copied the picture of the pattern from a magazine, ordered the commercial pattern, or traced it from an existing quilt made from the design. However she came by the design, the sharing of it was significant enough for Mary Black to recall the transaction, the pattern name, and the identity of the source some three decades later.

Except for quilters hired later, this is the only quilt in Mary's collection that involved someone outside the family. One might think that it would be a simple matter to trace an individual with a distinctive name like Mady Wingo through historic records. Actually, there were at least two unmarried women named Maiden Wingo living in the area in this period, and two others who acquired the name by marriage. The popularity of the name in this family must have created a certain amount of confusion!

Circumstantial evidence from estate records suggests that the woman in question was the daughter of Burrell and Delilah Wingo, born in 1840.[34] Burrell Wingo died in August 1878, and a sale of his household effects was held on September 27. Among family members and neighbors who purchased various items was "Miss Madie Wingo," who paid eighty cents for four jars, fifty cents for a cupboard, and $2.75 for "1 lot bedclothing."[35] Although the nature of the bedclothing was not specified for this particular sale, the lot may have included quilts. The form (if not the spelling) of the buyer's name is the same as that of the contributor of the quilt pattern. During the 1890s, when the pattern was likely to have

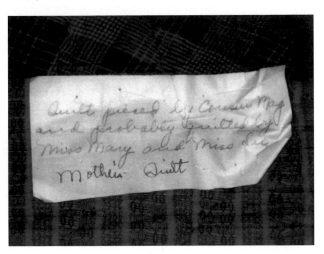

OVERLEAF **Plate 19. "Quilt pieced by mother—Design is basket of chips. Miss Mady Wingo brought pattern from Georgia. Pieced before Mother [married] but not quilted until after we moved from Converse St. to E. Main by a woman near Reidville. Small quilt." Hand-pieced by Mary Snoddy Black, ca. 1895, 86 × 78 inches. Cotton and linen fabrics, moderately thick cotton batting, backed with dark blue print. Quilted ca. 1917 in all-over design of diagonal lines. Applied binding, not cut on true bias, of gray and white striped fabric.**

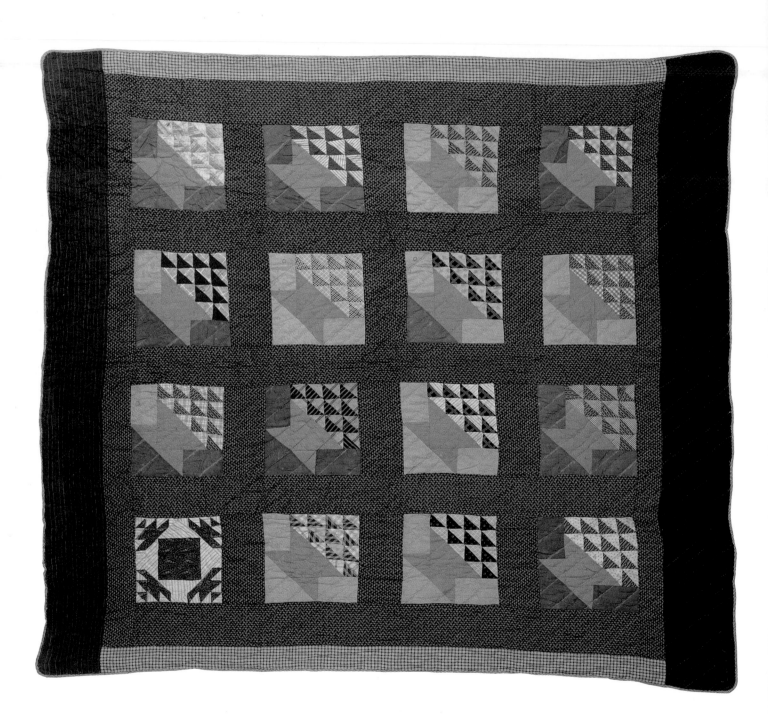

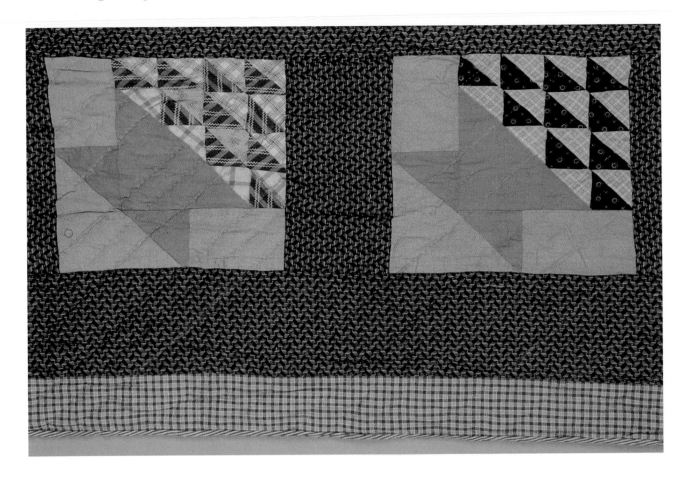

circulated, this Maiden Wingo was about fifty years old and more likely to have traveled to Georgia than her third cousin (once removed) of the same name, who would have been in her seventies.

The label on the quilt further states that it was "Pieced before Mother married"; however, this is unlikely. The word "married" in the inscription was inserted later in pencil to fill an obvious grammatical gap. The original concept might have been something else, such as "before she moved to Spartanburg." The fabrics and the way they are combined in this quilt suggest that it was made well after Mary's marriage in 1889. The construction of the top demonstrates a shift in direction and intention in the family's quiltmaking. Whether made from a limited number of different fabrics (Sunflower, Tulip, Shoofly) or constructed with a large number of different printed fabrics (Log Cabin and Save All), the earlier quilts in Mary's collection conveyed a visual sense of refinement due to the careful selection and juxtaposition of colors and the scale of printed figures. In contrast the Basket of Chips seems to have resulted more from an interest in using fabric already on hand than from a desire to create an object of great aesthetic appeal.

ABOVE **Plate 20. Basket of Chips quilt—detail. In contrast with the careful selection of colors and prints in the earlier quilts in Mary's collection, the Basket of Chips seems to have resulted more from an interest in using fabric already on hand than from a desire to create an object of great aesthetic appeal.**

BELOW *The label on the Basket of Chips quilt states that it was "pieced before Mother married," but the fabrics and style are later than 1889. The word "married" was inserted faintly in pencil to fill an obvious grammatical gap in the inscription.*

FACING Plate 21. Unlabled Flyfoot quilt, 85 × 83 inches. This pattern was popular before the ancient swastika symbol developed negative associations with the Nazi movement in the 1930s and 1940s. The top was probably made by Mary Snoddy Black or a female relative during the 1890s, and it was quilted after 1917. Cotton fabrics, thick cotton batting, backed with dark blue print.

The quilt includes fifteen blocks of the basket pattern; the sixteenth block is pieced from a different pattern entirely, featuring a large square in the center with smaller figures of pieced triangles in the four corners.[36] All of the pieces that form the baskets are cut from the same light solid green fabric. The "chips" are made from a variety of printed fabrics, generally selected to form a clear light-and-dark contrast. The pieces forming the ground behind the baskets are either tan or white, and three blocks contain pieces of both colors. The sashing strips between the blocks are unusually wide, 5½ inches. The wide borders on two sides are made from a red and black printed stripe, the same fabric that was used in the borders and backing of Cousin Mag's Churn Dash. The other two narrower borders are of a woven blue and brown Alamance gingham.

The visual evidence conveyed by this quilt suggests that Mary was motivated primarily by the novelty of a new pattern. She created the quilt blocks using fabric remnants on hand rather than purchasing new fabric according to a particular color scheme. Mary completed fifteen pieced baskets, not enough for a bed-sized quilt. She may have run out of one particular fabric, or she may have lost interest in piecing additional blocks. By incorporating the odd block, probably left over from another quilt, she had enough to make four even rows of four blocks each. Even by cutting wide sashing strips and adding multiple borders, she ended up with, as recorded in the final comment on the label, a "small quilt." The inscription indicates that it was quilted "by a woman near Reidville." This is one of several tops that remained unquilted until after 1917.

An Unlabeled Quilt

Of the sixteen quilts in Mary Black's collection, only one lacks a paper label. The quilt's pattern is one version of a graphic symbol widely distributed among many cultures. Unfortunately this ancient symbol, the swastika, was appropriated by the Nazi movement in Germany during the 1930s and 1940s; and in the minds of contemporary world citizens, it is indelibly associated with the atrocities of that era. For this reason, since the second quarter of the twentieth century, quiltmakers have generally avoided making quilts in this pattern, and owners of earlier quilts, including museums, have avoided displaying them.

Mary's name for this pattern is no longer known. The pattern has been published under at least sixteen different names.[37] The most familiar name, Flyfoot, is traceable to an architectural term, *fylfot,* which refers to a decorative device in the form of a swastika.[38] The pattern is based on an arrangement of triangles, one of a number of similar block designs that developed during the second half of the nineteenth century.

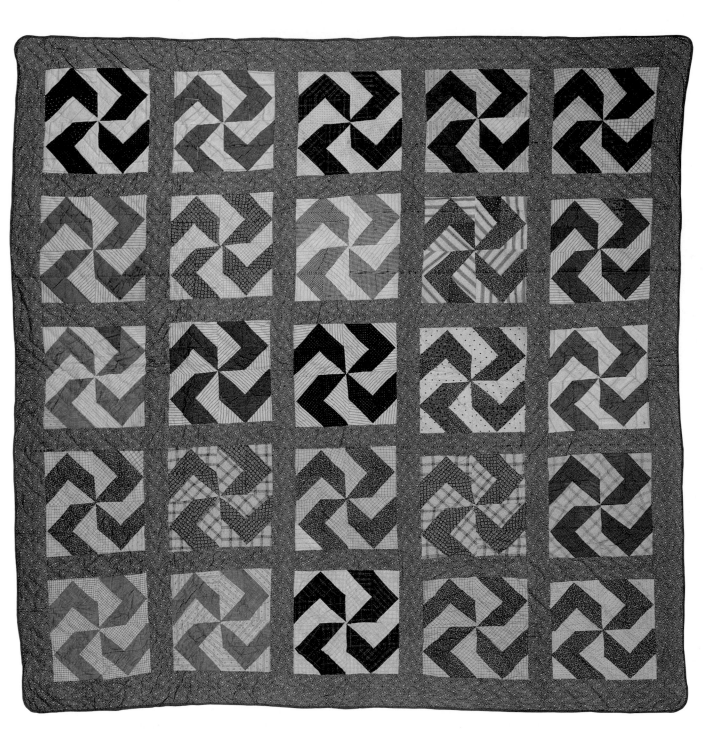

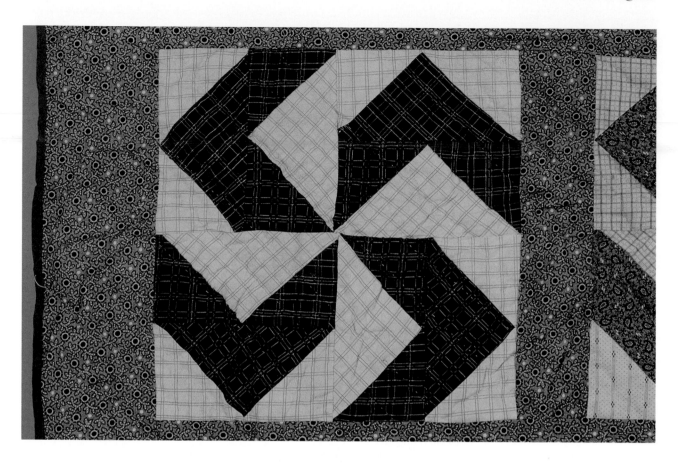

Plate 22. Flyfoot quilt—
detail. The fabrics in this
quilt are primarily dress
prints and men's shirtings,
suggesting that the top
was pieced of remnants
from family sewing. The
blocks are hand-pieced
but joined together by
machine.

The specific provenance for this quilt is unknown, but it was probably made by Mary herself or a female relative. Like the Basket of Chips, this quilt made use of a larger range of figured fabrics than the earlier family quilts. Although the maker created contrast in her placement of light and dark fabrics, she chose the colors from a wider palette than is displayed in the earlier quilts. The result is a less formal, more random appearance. From a practical standpoint, a married quilt-maker sewing for her husband and children had a different assortment of remnants than a young woman making and unmaking her own party dresses.

The dark fabrics are mostly dress prints, checks, and solids, probably from the maker's own dresses. The light fabrics in the quilt include several different shirting plaids, checks, and stripes. If Mary made this quilt, these would have been remnants from the shirts she made for her husband during the early years of their marriage. The gray print used in the sashing and borders is typical of dresses worn by adult women during this era. For any woman who adhered strictly to Victorian mourning customs, the gray print might have been an acceptable transition between black and everyday colors.

The Flyfoot blocks were pieced by hand but then joined to the sashing strips by machine. The quilt top, probably made in the 1890s, was among several that remained unquilted until some two decades later. This suggests that the maker was motivated more by the availability of materials and the desire to make use

of them by piecing them into a patchwork top than by the need to complete a bedquilt. Further, if Mary herself pieced this top, she may have found that hand piecing was more compatible with her role as mother to young children than setting up a quilting frame in her busy household. The humble nature of this quilt, its long-unfinished state, and, perhaps, the fact that it was overlooked during the labeling session might suggest that this was not a quilt having special significance due to a connection with a special event or relationship.

Changes in Quiltmaking in the 1890s

Of the quilts from this period, the simple but elegant Shoofly stands out. Early in her marriage Mary made it from the fabric from a dress, and it is reminiscent in both materials and style of the quilts she made while single. With this exception the quilts made during the 1890s reflect changes in the status of quilts generally and a corresponding shift in the goals of the quiltmaking process. Instead of serving as a vehicle for the display of fine fabrics, the later quilts appear to be *pattern*-driven. That is, the primary motivation for their inception was the desire to reproduce a particular pattern. The choice of fabrics was of secondary concern, and they were usually selected from those already on hand. The fabrics appear to be primarily remnants from making clothing, and some may be recycled from clothing that received little wear. Two exceptions may have been the many yards of red and black printed stripe for two borders and the back of Cousin Mag's Churn Dash and the brown and white Alamance gingham backing for Mary's Shoofly.

Mary apparently quilted the Shoofly herself and probably paid Miss Mary and Miss Lu to quilt Cousin Mag's Churn Dash soon after it was made. The other two tops remained unquilted for some two decades. This may have been an economic issue. As long as quilt tops remained unquilted, they cost the maker almost nothing but her time. Having them quilted typically required the purchase of backing fabric and cotton batting.

A significant aspect of Mary Black's quiltmaking from the late nineteenth century is the absence of a crazy quilt. The making of crazy quilts developed sometime in the late 1870s, and within a few years the practice had become an international obsession.[39] Crazy quilts from the closing decades of the nineteenth century were almost invariably constructed from fancy fabrics, usually silks, and heavily embellished with embroidery. Makers frequently purchased silk remnants from necktie manufacturers or traded fabric pieces with their friends so that their quilts would display an abundance of materials. Crazy quilts were generally made by women who attended to fashion trends, and there is some indication that they were made most frequently by young unmarried women or by older women no longer encumbered by childrearing.[40]

Perhaps it is not surprising that Mary did not participate in this popular needlework activity by making a crazy quilt. Mary had worn a brown silk dress for her wedding portrait, but her experience at Williamston had established, or reinforced, a preference for less opulent clothing. The dresses she recycled into quilts were of high-quality cotton fabrics. These reflected not the height of fashion but

*In the fall of 1896 J.R.
was involved in erecting a
new monument at Nazareth
Presbyterian Church to mark
the grave of Revolutionary War
ancestor Patrick Crawford.*

an interest in selecting good materials and using them effectively. Mary's religious affiliation with a comparatively conservative Protestant denomination and the financial needs of her new family may have been additional factors in determining the scope and intent of her quiltmaking activity at the close of the century.

Family and Memory

No documents survive to indicate Mary's attitudes toward her quilts. She probably did not think of them as a *collection* at that time. Her quilts would have been among a number of other possessions handed down in her family or acquired during her own life, including furniture, tableware, and jewelry. By the late

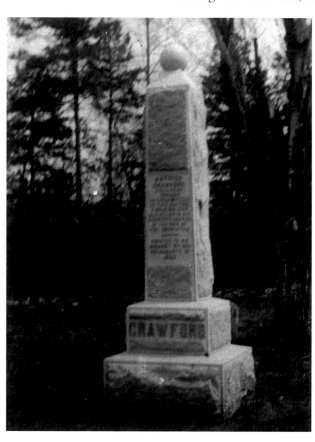

nineteenth century, quilts were no longer prominently displayed as evidence of wealth or as indicators of a woman's accomplishments. Old quilts, particularly those from the antebellum period, were seen as quaint relics of an earlier era. Quiltmaking was one of many forms of needlework that might occupy a woman's time and hands, but, except for crazy patchwork, it had become ordinary and unfashionable.

Mary's quilts included both revered relics and ordinary patchwork. Over time, however, all the quilts grew in importance as reminders of family identity and the reciprocal obligations of kinship. The language and traffic of quilts circulated in a private sphere among women, who recycled dresses, shared patterns, and paid other women to piece and to quilt. Quilts and household heirlooms served to commemorate and reinforce the private, domestic relationships important to women. Larger and more public family connections, however, required other forms of demonstration.

During the 1890s the extended Snoddy family participated in public celebrations of ancestral commemorations. On July 27, 1895, the descendants of Patrick Crawford held a reunion at Nazareth Church. In the days before the event, J. R. Snoddy butchered a pig for the event's barbecue supper and helped build a table. Among the orations requisite for such an occasion, Dr. H. R. Black gave a speech on the life of Mary's grandfather Isaac, and the Reverend R. H. Reid, age seventy-four, presented a tribute to Isaac's wife, Jane Crawford Snoddy.[41] This reunion seems to have fueled the family's desire to further honor Crawford's memory. In the fall of 1896, J.R. was involved in erecting a new monument to mark Crawford's grave at Nazareth.

Marking the grave, however, did not satisfy the family's desire to commemorate their ancestor. On June 6, 1897, J.R. recorded "Pa, Dolly & I went to see the spot 1st time where Patrick Crawford was killed During the War of 1776." Colonel Snoddy must have grown up knowing the location of the site of his grandfather's death, but he had not taken his children there before this time. On

August 26, 1897, J.R. "went to George Burnett & get deed for land for Crawford monument" and a month later "Erected Rock where Patrick Crawford fell in War of 1776 by Pa." Although J.R. inscribed the monument with his father's initials, he himself seems to have taken the major role in this effort.

J.R.'s interest in the family's history included documenting his father's legacy. On January 2, 1900, he "Pd Dr. Landrum Cash 10.00 for to insert Pa Photograph in his History." On December 24 of that year, he "Recd & Pd for 2 Books of Dr Landrum History of Sptbg Co." J. B.O. Landrum's *History of Spartanburg County* included biographical sketches of many of the area's old families and leading citizens, and a number of their descendants apparently paid Landrum to include photographs. The book continues to serve as an important source for the area's events and families a century after its initial publication.

On December 13, 1894, H. R. and Mary Black moved their growing family from Wellford to Spartanburg. The family moved a physical distance of only eight or ten miles, but the social setting was very different. In Spartanburg, Mary's neighbors included many like herself who were longtime rural residents newly relocated to town, as well as people who had come from elsewhere seeking opportunity in the growing city. Neighbors were no longer easily identified and classified by family lineage, based on generations of familiarity. In the city one's identity depended more on the outward appearance of one's home, clothing, and other trappings; and one's acquaintances were determined more by career choices and social aspirations than by kinship, habit, and proximity.

Although she no longer daily retraced the paths where her ancestors had walked, Mary maintained her connections with friends and family in Wellford. The family transported into town all their household possessions, among them, a number of family quilts. At this time Mary's quilts included her own Tulip, Save All, and Shoofly; her mother's Log Cabin; possibly Sister Nannie's Cross; and Aunt Narcissa's Zigzag. From her time in Wellford, she had also accumulated an unknown number of unquilted tops and unfinished blocks, including the Flyfoot, Cousin Mag's Churn Dash, and Basket of Chips. Separated from her home neighborhood, Mary nonetheless carried with her these tangible reminders of her identity as a member of an established community of family and friends. ✥

"LET OTHERS LIVE THE ROWDY LIFE"

The Black Family in Spartanburg,
1890s–1916

THE BLACK FAMILY'S move into Spartanburg at the end of the nineteenth century coincided with continuing changes in the functions of quilts and quiltmaking. Throughout the country, quiltmaking declined as modern, urban families developed a preference for factory-made bedspreads. This decline was followed, a couple of decades later, by renewed interest as part of the Colonial Revival movement in home furnishing. The impact of these national trends was moderated by the particular circumstances of Spartanburg and its population, and, in particular, by the lifestyle and position of the Black family.

Changes at the Turn of the Century

On December 13, 1894, H. R. and Mary Black and their three children moved from Wellford into Spartanburg. They were not alone; between 1890 and 1900, the population of Spartanburg doubled from 5,544 to 11,395.[1] Not just the town was growing; during the 1890s, the development of scattered textile mill villages swelled the population of the entire county. Spartanburg itself, as the county seat and principal market town, served as the hub for commercial activity and public service for the larger area. The old general stores and other small businesses in small towns such as Wellford, Woodruff, and Campobello gradually declined as rural residents patronized new specialty shops in Spartanburg.

A major factor in the family's move was to provide Dr. Black with access to better medical facilities. Although he continued to attend to patients in rural areas, the increasing sophistication of medical practice and equipment led to a need for a more professional office. As a physician H. R. Black was an innovator and a

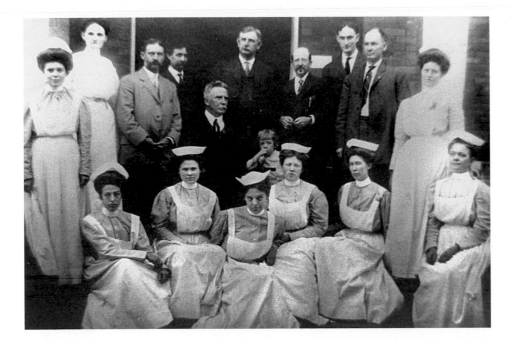

leader in the medical field. Throughout his career he traveled to medical centers for study and observation. In 1895 he was the first physician in South Carolina to perform a laryngeal intubation, a procedure that prevented deaths from diphtheria, one of the leading causes of children's deaths at the time. He is also credited with performing the first hysterectomy in the county and the first large skin graft in the state.[2]

The resources of an individual physician were limited, and Dr. Black was active in efforts to establish a hospital in Spartanburg. A 1902 editorial in the *Spartanburg Journal* expressed the changing attitudes of the times, favoring a centralized medical facility over home care: "It is a matter of frequent comment that Spartanburg has no city hospital. Two short-lived private hospitals have proved the great need and demand for an institution of this kind where both private and charity patients can be accommodated. Towns considerably smaller than ours have thriving hospitals where patients can get such attention and nursing as is often impossible even in the best homes."[3]

In 1904 H. R. Black and two other physicians, George W. Heinitsh and James L. Jefferies, purchased a house on North Dean Street and established the Spartanburg Hospital, "for the treatment of general diseases." The money for the building, $3,548.38, was provided by a loan from Mary Snoddy Black. The loan was formalized through a mortgage, specifying repayment within one year at 8 percent interest.[4] The new hospital, a frame building with an operating room and facilities for nine patients, was used for three years. With the help of additional stockholders, the doctors built a new brick hospital building on the same lot.[5]

With small children and a busy medical practice, the Blacks must have found it difficult to attend the A.R.P. Church in Wellford.[6] In 1902 a Spartanburg A.R.P.

*The original brick Spartanburg
Hospital building later became
the Georgia Cleveland Home
for elderly women. Photograph
courtesy of Linda Taylor Hud-
gins and the Hub City Writers
Project.*

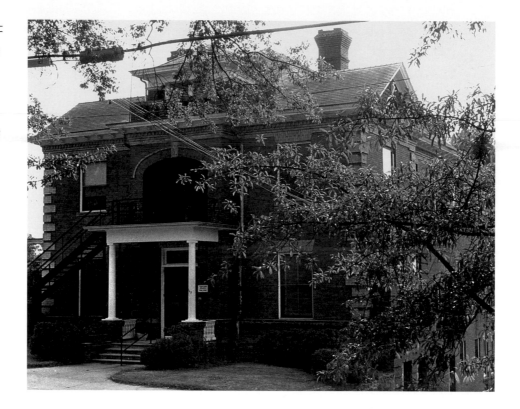

congregation held an inaugural service at the Spartanburg Business College. Among the twenty charter members were Mrs. Mary S. Black, Sam Orr Black, and Hugh S. Black. Although he had earlier served as an elder in the Wellford church, H. R. Black's name does not appear on this list. At first occasional services were led by visiting ministers, but in 1905 the church was officially organized under the pastorship of the Reverend A. J. Ranson. By 1908 the Spartanburg A.R.P. Church had purchased a lot and completed a building.[7] In 1910 the Spartanburg church had sixty communicants, with ten Sunday School teachers and sixty-five pupils.[8]

The Ladies' Aid

During the early twentieth century, church women in many Protestant denominations created formal organizations. These groups often organized initially to provide amenities for church buildings, and many of them expanded their interests to support mission work. A column in the *Spartanburg Journal* in 1902 reflects the situation:

> "Well, we'll have to get up an ice cream social," said the president of the Ladies' Aid Society. There was a debt hanging over the church that was "worrisome," and the pastor and trustees naturally turned to the women for help. The ice cream social was the first thing that suggested itself, because it was in the summertime. If it had been in the winter it would have been an oyster supper. But always it would have been the women who were expected to raise the debt.

... There are different names for the women's organizations according to the denominations. But it always amounts to the same thing in the long run, and, if statistics were at hand to show just how much money the women turn into the church coffers, it would undoubtedly be shown that without the women the trustees would come out of the little end of the financial horn at the end of the year.[9]

The Ladies' Aid Society of the Spartanburg A.R.P. church was formed on October 29, 1905, with its object "the furtherance of Christian life and effort among its members and elsewhere." Among the eight initial members were Mrs. H. R. Black, Mrs. N. J. Coan, and Kate Ranson, the pastor's wife. During its early years the society raised money for the church carpet "by chain letter, musicals held in homes, ice cream suppers, oyster supper, and a lecture." After minor expenses these events netted $25.05. By 1908 the group had acquired more experience in fundraising: a musical event netted $9.00, and serving ice cream on the courthouse grounds brought in $32.55. These funds were earmarked for a communion set.[10]

On February 9, 1906, society members voted to take thirty cents from their treasury to purchase the lining for a quilt they were making. Making and selling quilts was one of the ways groups of women have raised money for local causes from the mid–nineteenth century to the present time, and fundraising quilts were particularly popular in the decades before World War I. Some quilts were raffled, but Presbyterians and other churches considered this a form of gambling and typically auctioned quilts instead.[11] The Spartanburg ladies apparently offered their quilt for sale, but the minutes indicate that the group purchased it themselves: "It was finished—bought in by society and presented as a gift to the Ransons."

This brief notation in the minutes merely suggests the larger story. The secretary did not need to explain the reason for the gift, as that would have been obvious to the women involved. The Ransons had recently lost an infant son.[12] The gift of this quilt was probably an expression of both appreciation and sympathy for the thirty-two-year-old minister and his twenty-seven-year-old wife, Kate. For society members such as Mary Black and her sister Nannie Coan, who had grown up in the mid–nineteenth century, the gift of a quilt represented the resources and solidarity of women in a community.

When the group made the decision to present the quilt to the Ransons, they could have done so directly. Instead, without losing sight of their fundraising intention, they simply took up a collection within the group and "bought in" the quilt themselves.[13] Events sponsored by women's groups of the era were often organized in a theatrical manner, providing entertainment and opportunities for women to demonstrate their talents for public speaking and presentation in an acceptable manner.[14] It is possible that the simple notation in the society minutes understates a staged auction to surprise and honor the Ransons. As Kate Ranson was a member of the society, the other members would have taken delight in her unknowing work on a quilt that was destined for her. The further history of the quilt is unknown. After five years in Spartanburg, the Ransons moved on to another calling. The society's minutes for January 1910 indicate that the group "Met to

LEFT *From 1894 to 1917, the Black family lived in a large house on North Converse Street. The house no longer stands.*

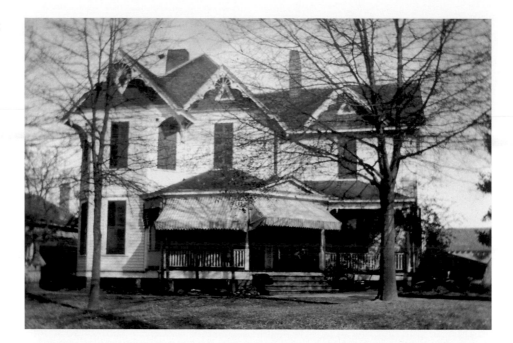

BELOW *The Black family, ca. 1906. From left to right, Sam Orr, Rosa, Dr. H. R., Hugh Snoddy, Paul, Mary Kate, and Mary Snoddy Black.*

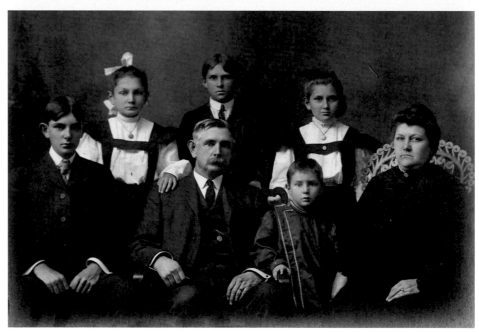

104

pray God's choicest blessing on Mr. And Mrs. Ranson, who are going as missionaries to the far away land of India."

For Kate Walker Ranson, missionary assignment was the fulfillment of a life-long ambition. In 1896 she had enrolled in the Women's College in Due West, South Carolina, part of Erskine College, supported by the A.R.P. Church. Her education was interrupted by her mother's illness and a subsequent family move to Texas. In 1900 she volunteered for mission work in Mexico, but her application arrived after an appointment had been made.[15] She married the recently widowed A. J. Ranson in 1903, and her husband came to share her zeal for mission work in spite of concerns for his health.[16]

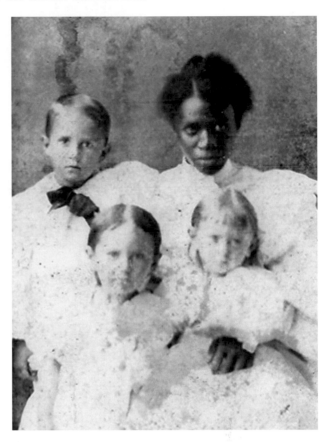

The missionary field was one of the few acceptable career options for adventurous women of the late nineteenth and early twentieth centuries. Women could become schoolteachers, but they were expected to retire when they married. There were few positions available at home to women with scholarly aspirations and religious leanings. On the other hand, when a woman reported that God had called her to volunteer for foreign mission work, church officials could hardly dispute the call.

When the Ransons departed for India in 1910, they left an older daughter, Mary, with relatives, but Kate carried their ten-month-old son, Arthur Jones Jr., with them. The Ransons had already lost two sons, in 1905 and 1908. It could not have been easy for Kate's friends to see her leave one child at home and carry an infant off on an admittedly dangerous assignment, and the women of the Spartanburg A.R.P. church might have questioned the propriety of Kate's missionary zeal in relation to her duties to her children.

Detailed church records do not indicate that the Spartanburg church provided any significant financial support to the mission in India. Nevertheless Kate Ranson later remembered Mary Black as a supportive friend and wrote a warm letter to daughter Rosa, recalling their time together in Spartanburg. Mary Black may not have shared Kate's aspirations to see the world and to experience hardship in the cause of her religious faith, but she seems to have offered the younger woman the same encouragement, support, and guidance she gave her own daughters.

Family Activities in Town and Country

From 1894 to 1917 the Black family lived in a large house on North Converse Street. Two more children were born to them, Mary Kate in 1896 and Paul in 1901. The 1900 census shows that they employed two live-in servants. One of these was Mary Dodd, the children's nurse, who appears with the three middle

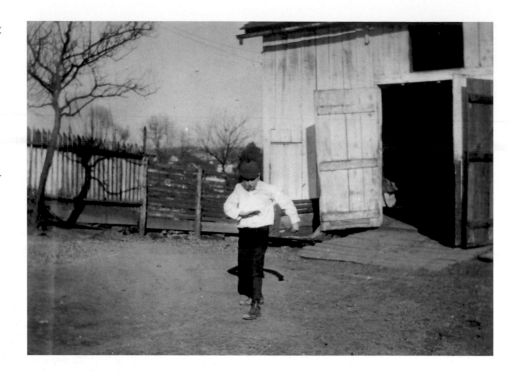

Paul Black in the backyard on Converse Street, ca. 1908. After they moved into town, the Black family maintained a vegetable garden and kept chickens and a cow.

BELOW *Nancy Jane Snoddy Coan also moved into Spartan-burg in 1906.*

children in a photographic portrait. Over the years, the family employed a number of individuals as servants. Sometime before 1913, Herbert Jenkins, age fifteen, was hired as a driver, and he quickly made himself indispensable, not only to H. R. Black but to the entire family. He remained with the Blacks for fifty-seven years, through three generations, until his death in 1962.[17] While other servants came and went, Herbert was considered "a part of the family."

The Black family maintained contact with relatives and friends back in Wellford. Although they kept a cow and poultry in the large lot behind their Spartanburg home, they also relied on the farm for meat and vegetables. On October 27, 1898, Mary's brother J.R. noted "Kill Beef & Divide with all," and on October 22, 1900, he "Carried Sweet Turkey, Eggs & chickens." In return Mary did some sewing for her brother's family, including making shirts for her nephews.[18]

Mary and her children visited her brother's home frequently. As the children became old enough to travel by themselves, they continued to visit their Snoddy cousins and often stayed for a couple of days at a time. They enjoyed hunting and fishing, and occasionally they helped out with farm work. On July 18, 1902, J.R. described a family visit in some detail: "Sam Orr & Team come to play Base Ball. Dollys score 37, Sam Orr score 10. Simp, Elbert, & Jno come and furnish

music for Game of Base Ball." The lopsided score suggests that the more experi-
enced "visitors" allowed Dolly's "home team" to win, as Sam Orr, at age twelve,
was already an accomplished baseball player.

The extended family shared not only their bounty and good times but
also their sorrows. In 1903 Sister Nannie's husband, Dr. David M.
Coan, died, and three years later Nannie Coan left her home in
Wellford and moved into Spartanburg. Nannie, Mary, and J.R.
were also concerned about their aging mother. Rosa Snoddy,
had given up her own home following the death of Colonel
Snoddy in 1898, and, for the remaining ten years of her
life, she lived alternately in the homes of her three chil-
dren and occasionally visited with other relatives. On
February 12, 1908, while at J.R.'s home, she tripped on
the carpet and broke her hip. She died six weeks later,
on March 25th, her eighty-second birthday. The *Spar-
tanburg Journal* reported that Rosa Snoddy was "a con-
sistent member of the Nazareth Presbyterian church,"
and the *Herald* stated that she was a member of the A.R.P.
church. Beyond this disagreement the obituaries pro-
claimed her, respectively, as a "life-long" and "faithful"
Christian. The Reverend A. J. Ranson, the A.R.P. minister,
conducted the service, and she was buried at Nazareth next
to her husband. Once again dissension rumbled among the sib-
lings about the division of Rosa's share of Colonel Snoddy's land,
and the negotiations and survey process continued through 1911.

As Mary's children reached their teens, their lives were very different from that
of their mother. At the same age, Mary had spent her evenings with her family,
sitting at home, sewing with her mother and sister, and listening to her father
read. Social occasions consisted of leisurely visits with friends for a day or two.
Mary's own children were part of the emerging youthful elite in Spartanburg
society and often spent evenings engaged in social activities with their friends.

The society column of the *Spartanburg Herald* published detailed descriptions
of elaborate parties, and Mary's children were frequently listed among the guests.
In August 1910 Rosa's friend Lucy Tolleson arrived from her new home in Ari-
zona to spend a week in Spartanburg, and Rosa, age sixteen, was among fourteen
young ladies who attended a farewell party for Lucy: "The porch was made very
attractive with rugs, pillows, and wicker chairs, and a spirited contest proved
exciting and entertaining during the afternoon. After the games were played a
dainty pink and white ice course was served."[19] Both Hugh, age eighteen, and
Mary Kate, age fourteen, were among some sixty guests invited two weeks later
to "the largest and most brilliant social event among the younger set this season,"
and Sam Orr, age twenty, attended a house party at the home of Mrs. Victor
Montgomery, where "dancing and cards were enjoyed" by nine young women,
ten young men and two young married couples.[20] During this period the four

older children appear to have engaged in an almost constant flurry of social events. Even with servants at home, Mary would have faced a steady stream of decisions and negotiations regarding schedules, messages, transportation, and clothing.

Mary's two older sons, Sam Orr and Hugh, were good students, and both boys attended Wofford College, a well-regarded local school, where they excelled at baseball.[21] In 1910 Sam Orr (first base) and Hugh (center field) participated in a baseball game to raise funds for a monument to Confederate soldiers. The teams were "composed of well-known young men of the city who have had experience in playing the great national game on college teams."[22] Sam Orr enthusiastically followed his father's footsteps and enrolled in Jefferson Medical College in Philadelphia in 1911. Hugh graduated from Wofford in 1913.

Daughter Rosa was an excellent student. Proud of her academic accomplishments, she kept all of her report cards from public school and college. In January 1908, midway through the eighth grade, she enrolled in Converse College. Converse did not sponsor a high school program, and Rosa's enrollment in a four-year college at the age of thirteen was unusual. Her report cards indicate that she excelled in mathematics, German, psychology, sociology, and physical training; and was proficient in history, chemistry, Bible, Latin, and piano. She graduated with a B.A. degree from Converse in 1913. Fewer records remain from this period to document the accomplishments of the two younger children, Mary Kate and Paul, but their activities and personalities emerge through a set of family letters written during Rosa's European tour.

In 1913 Rosa Black, age nineteen, became the first person in her family to travel outside the United States. She was part of a group organized by Markell Private Tours of Birmingham, Alabama. The tour, "arranged for those who wish to see the best of Europe during an ordinary vacation period," ran from June 12 to August 24, beginning and ending with steamship passage through New York. The itinerary included well-known cities and sites in Italy, Switzerland, Germany, the Netherlands, Belgium, France, England, and Scotland. The cost of the tour, including passage, land transportation, lodging at first-class hotels, food, and admission fees, was $725.[23] This was a considerable sum for the family, but they clearly wanted Rosa to have this opportunity.

Rosa made the most of her travel experience. She recorded her adventures in an informal journal—first in a small pocket-sized notebook, then on a series of loose papers, cards, and hotel stationery. Her enthusiasm and wide interest in new places and her enjoyment of her fellow tourists are evident in her writings. This initial tour obviously whetted her appetite for world travel, which became an important part of her adult life.

Rosa's letters home were not retained by the family; however, Rosa kept the letters she received from family and friends while abroad. These letters are valuable because they are among the few surviving documents of personal communication among the family members. The letters describe events of daily life and reveal attitudes and concerns that distinguish the personalities of the individual family members. As a group the letters capture an imprint of the Black family's dynamics.

During the summer of 1913, Mary Black was worried about Rosa's health and well-being during her tour. The family apparently received word that Rosa was seasick for several days on her outgoing voyage, and thereafter their letters are sprinkled with questions about her health. Mary's concern was described in a letter to Rosa from Rosa's friend Emma Jennings: "Mrs. Black told me how sick you've been—Poor thing is just <u>so</u> worried about you."[24]

Mary maintained an interest in her daughter's clothing, appearance, and personal hygiene: "I found three or four pairs of your best drawers soiled on the shelf in your room. Also your best corset covers. Don't know why you didn't have them clean to take with you." Mary also offered frequent financial advice: "Spend your money profitably. Make it show for something. . . . I am sorry you took the pin Miss Bettie gave you. Better have a safety catch put on it. Ask what it will cost first. Ask that about everything."[25]

Mary's letters to Rosa included frequent admonitions about manners and deportment. "You be nice and not talk too much and laugh loud and be conspicuous. In other words act the lady. Don't forget what I have told you about the way people live on the ship. Show them you have been better raised. Show that you are a Christian. That will take you through. Let others live the rowdy life. Go to bed early and get rest so you will be able to stand the trip."[26]

During that summer there were a number of weddings among Rosa's friends. Mary alluded to proper protocol in a situation involving the marriage of a former beau: "Harry Armstrong wrote to know if you got <u>their</u> present. I wrote that

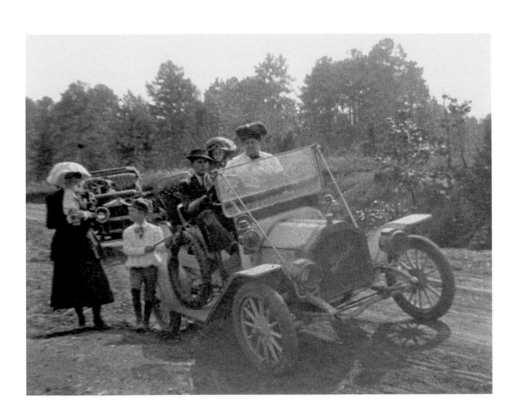

In 1913 Rosa Black (right) enjoyed a reunion with Lucy Tolleson, who was visiting from her new home in Arizona.

you did and you would write a note of thanks. Told you to do that several times before you left. He began it Dear <u>Miss</u> Rosa. Now you do the same stunt 'Mr. Armstrong.' You know he has a wife now—Be careful."[27]

Mary's letters included frequent references to the summer heat, especially in the kitchen. Hattie Cole, the family's cook, had to leave when her husband lost his job, and two other servants worked irregularly due to family illness. "The weather is something hot here. In the kitchen the thermometer is over 110. Now you see what a time I am having. Rindy is still out. . . . Eunice is here but . . . she doesn't come till after breakfast is cooked in the mornings. You know that doesn't suit me very much." The heat became worse a few days later, and Mary had to call on her inner strength to get through. "Friday the thermometer in my kitchen registered 120. How is that for hot weather. It was almost more than I could stand for. Thought several times I would have to give up. But there was nobody to relieve me so I had to endure it."[28]

In spite of the heat and the difficulty in hiring a replacement cook, Mary worked to process and preserve food, a continuation of the practices that she and others of her generation carried with them when they moved from the farm into town. Her letters frequently referred to these activities: "It is still hot and we are having lots of rain. Can't get to plant any more beans in garden. Have canned quite a good many beans and some tomatoes. Have had two meals of butterbeans." "I bought 33 chickens this morning. Killed three already. Will have two for supper." "I am putting up beans, tomatoes, peaches, and everything I can. Have canned some today. Tomorrow will make more jelly, have a good deal made and hardly know how I got it done."[29]

Mary's summer activities included sewing for the family. In her letters to Rosa, she revealed her motivation to be a concern for both economy and quality. "Had

a time getting Paul ready [for a trip to Chicago]. Am going in a few minutes and cut him out some night shirts. Am afraid his old ones won't last till he gets back. Didn't know they were so thin. Can make them so much cheaper and better material." During the hot summer, Mary also described various physical ailments: "Am having a time with my teeth. My face is so swollen it looks a sight. . . . I will have to close. My face is hurting me so badly. Wish the old teeth would fall out."[30]

Mary's sister Nannie, called "Auntie Coan" by the children, is revealed through her own letters to Rosa as well as in the correspondence of others. Nannie reported to Rosa that she had come to the aid of Mary's toothache. "Your mother had another risering [abscessed] tooth but I sent her a police [poultice] and it cut it short so she is OK now." Nannie herself reported having frequent "nervous spells," but she apparently felt well enough at times to sew for her niece. "I have been making Mary Kate a little simple white dress, and a muslin with a blue dot of some kind, both simple and pretty."[31]

Rosa's father, Dr. H. R. Black, was reported as very busy with his practice, including performing frequent surgical operations. He expressed concern about the economy: "Times are hard with us now sure." Nonetheless he regularly sent Rosa additional spending money. Early in the summer Rosa broached the possibility of extending her tour with a visit to Ireland, and her father's questions addressed the propriety of this action rather than the cost. "I am sending fifty more for your 'Ireland trip.' Now if you do not feel entirely able physically, don't undertake it. According to your letters you have already been sick enough, and there is no use to exhaust yourself. . . . Who is going with you on the 'Ireland trip'? You can't go by yourself."[32]

In addition to his busy medical practice, H. R. Black and his sons also took an active role in their farming operations; and it is clear that the family depended on

BELOW *Even after the Black family acquired an automobile, they still relied on "Old Joe" and the buggy. Hugh is the driver in this photograph.*

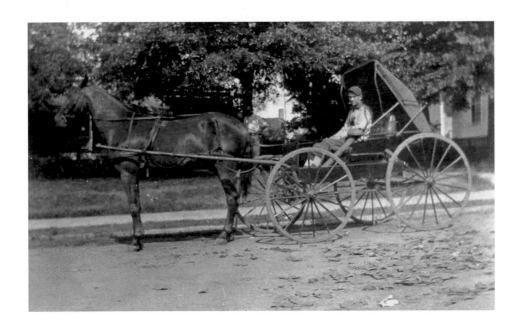

*After playing baseball at
Wofford College, Hugh had
to decide whether to become
a professional ballplayer or
to become a doctor like his
father*

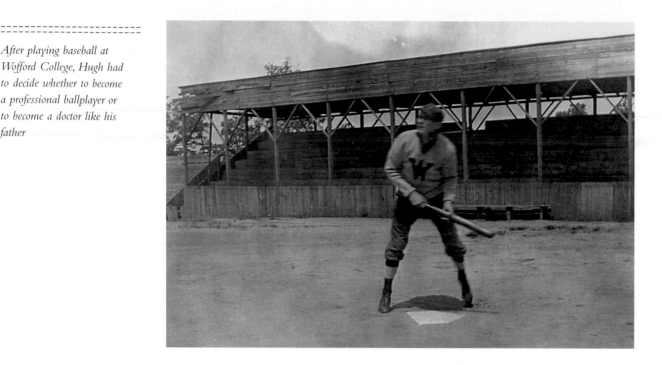

the sale of farm crops to supplement Dr. Black's medical income. Rosa's brother Hugh wrote, "The crops look very good and I am glad they do, for this is a hard year on father financially." Between house calls and farm visits, the family car got a lot of use, but fortunately they still kept the family horse. Mary wrote to Rosa: "Father and Hugh went to the country since dinner. The batteries went down on them or something went wrong. . . . Phoned for Paul to bring Joe & buggy. What would they do without Joe? The car has been giving lot of trouble lately."[33]

Sam Orr, at age twenty-three, was home from medical school for the summer. He had a temporary job working with the Pellagra Commission, which sponsored an investigation in Spartanburg.[34] "Sam is pecking away with the pellagra people. He seems to like it very much." His mother also reported to Rosa that he maintained an active social life. "Sam Orr is bruising around as usual. Can't stay away from Julia Calverts. Mabel Marler is there. You know how he is."[35]

The summer of 1913 was a turning point for Mary's son Hugh, age twenty. Having graduated from Wofford, he was faced with choosing a career direction. An excellent baseball player with a batting average of .700, he had an offer to join the Pittsburgh Pirates. However, his father expected him to become a doctor. He spent the summer playing baseball in South Carolina while pondering his future. Mary told Rosa: "Hugh is in Chester. I suppose he is playing ball. I want to write him this afternoon. He doesn't seem to want to hear from us so I shall not write much." Mary was clearly concerned about her second son, but allowed the quiet boy to work things out for himself: "Hugh came home Wednesday night and left again this morning. . . . Told him to write you this A.M., but I don't suppose he did. You know he is funny."[36]

By August, Hugh seems to have resigned himself to following the family pro-
fession. He wrote about his decision to Rosa: "I have just returned from Chester
where I have been playing ball and in the meantime having a great time. . . . I
have decided to study medicine at last." According to his nephew Sam Orr Jr.,
one evening Hugh had an emotional discussion with his father about his future,
then cried all night. In the morning he announced his decision to go to medical
school.[37]

That summer Mary Kate was a boy-crazy seventeen-year-old, and her letters
to Rosa enumerated her current interests. "I fell in love with Grover Page and
Fred Wetzell. . . . Am still liking Robert Medlock and
Ernest Jones. Am insane over Rutledge Osborne. Wal-
ter Sullivan is still nice. Have heard from Osce several
times. . . . There have been oceans of parties here this
summer." One beau was particularly devoted in his
attentions: "Medlock sent me three 'special deliveries'
last week. . . . Am kind of expecting another one
tomorrow, but take it from me, I don't send him any
—no, not a one. Medlock also sent me a three pound
box of candy last Monday by express—that's going
some, isn't it?"[38]

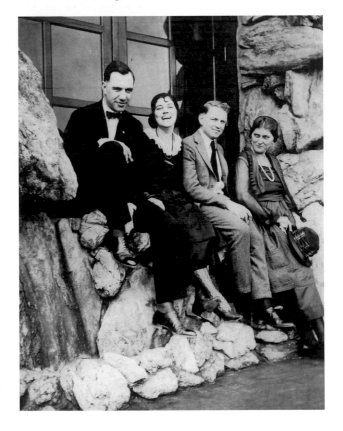

*Mary Kate (far right) enjoyed
socializing with her friends.
This photograph appears to
have been taken on an outing
to the Grove Park Inn in
Asheville, North Carolina.*

Mary was disturbed by Mary Kate's behavior. "She
has been getting special delivery letters nearly every
day and your father has told her she will be a talk for
the town. . . . If she doesn't stop some of this going on
she will be ruined. Sam Orr undertook to talk to her
yesterday and she became furious. She always does.
Nobody here that is any account notices her. She can-
not behave when she gets where boys are."[39]

For Paul, age twelve, the summer included a train
trip and the possibility of surgery on his arm. Mary
wrote, "Your father, Sam Orr, and Paul have gone to
the station. They are going with Paul to Dr. Murphy
in Chicago. Little fellow was very happy. He doesn't realize what is before him.
. . . Don't know but suspect he will have a pretty bad time. I dread it for him."
However, the doctor recommended that surgery be delayed. Mary Kate wrote
to Rosa: "Got letters from Paul, Sam Orr, and Father this A.M. saying that Paul's
arm can be fixed but it would have to be done when he is sixteen and a half years
old, because if done now, it might stop the growth of his arm." "Paul is at Uncle
Jimmie's now. He rings every day to know if his two bantams are still living."
Auntie Coan wrote, "Paul is running all around, but his mother is keeping him
at home more than she did for awhile. You never saw anyone grow faster than he
is now growing, and has a word for everybody as usual. I feel sorry for him, he
says they all go but I can't get to go anywhere. I told him his day would come
if he lived." Paul himself wrote in a childish scrawl, "Dear Rosa, I am eating

- -

Hugh, Rosa, and a friend out for a drive near an unidentified textile mill.

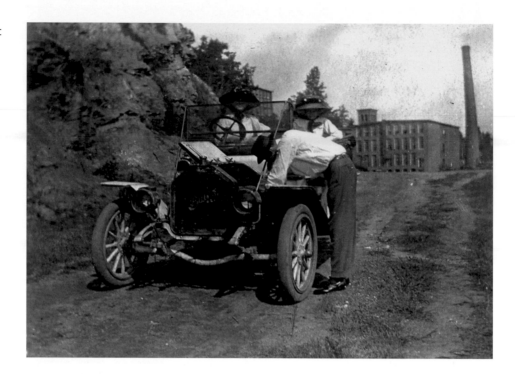

cake now. Mary Kate has gone on a camping trip. I run the automobile by myself all the time. I stay busy going with father all the time. I hope you are having a fine time. Old Joe is as mean as he can be. He ran with me twice yesterday. All are well. Your Bro. Paul Black."[40]

The letters also included requests and suggestions of things for Rosa to bring home to the family: "Sam Orr says bring him two pairs white dress gloves if you can get them cheap enough. . . . Paul says bring him a pony, and a cheap watch to carry every day and a 25 ct. knife. This is some boy." Mary singled out Herbert Jenkins, the family's all-around servant, as particularly deserving of a special gift from Rosa's trip. "By the way, be sure and get something for Herbert. If you have to get it in America then you won't have to pay duty on it. Want something pretty good for what would I do without him? . . . Can't bring everybody something, I know. But I like to praise the bridge that carries me over safely."[41]

Arriving back in New York, Rosa stopped off to visit friends in Germantown, Pennsylvania, before coming home. In a final letter Mary replied to Rosa's wish to buy a black coat to match a new dress. "How about having your blue coat dyed for general use. Guess yours is all wool. Don't see why it wouldn't take black alright. Do as you please about it. Thought you could save express if it could be done at once." Mary expressed further interest in her daughter's clothing, in particular, a newly fashionable garment that exposed one's legs. "Hope you didn't get a slit skirt as I understand they are all the rage."[42]

For women of Mary Black's generation, a European tour was a once-in-a-life-time experience, an indulgence she and her husband had provided for their daughter to culminate her education: "See all you can for I suspect this will be

your last trip."[43] For Rosa, however, this trip was just the beginning. Her adventure at age nineteen kindled a lifelong passion for world travel and encouraged similar aspirations in her younger sister Mary Kate. Mary Black's daughters clearly grew up in a different world than that of their parents. Still the stability and support of their family seem to have enabled them to explore their potential as new young women of the twentieth century in ways their mother could not have imagined.

Quilts in the Early Twentieth Century

The Black family had one foot in the city and one in the country. They participated in the social and economic affairs associated with living in town, but they cultivated a backyard garden, managed their farm in Wellford, and maintained close relations with rural family and friends. With a house full of active children, social activities, and church, Mary Black does not seem to have been directly involved in quiltmaking during this time. Living in town, the family was more subject to an interest in fashionable clothing and home furnishings. During the early twentieth century, using quilts as bedcovers would have been considered quaint and old-fashioned. New discoveries about germs and sanitation raised concerns about household cleanliness. Quilts were difficult to wash by hand, and as a consequence most families aired quilts occasionally rather than washing them. The newly available washing machines were no advantage, as the wringer system was not designed to handle the bulk of a quilt without damaging the stitching.

Instead of making and using quilts, middle-class families purchased blankets for warmth. A 1902 advertisement for the Bee Hive, a Spartanburg dry goods store, offered two grades of cotton blankets, at 48 cents and 98 cents, and "all Wool Blankets made in the South of southern wool by southern merchants. We sell the best all wool Elkin North Carolina Blanket made at $2.75 and the 10 × 4 at $2.45."[44]

For the decorative top bed covering, these same families preferred white spreads, either from the Sears & Roebuck catalog or from local stores. In 1910 Harris-Grimes, "Spartanburg's best department store," offered seven grades of "white quilts" for sale, ranging from 89 cents to $3.45 each. Although described as "quilts," these were actually factory-made textiles, and some of them may have been the products of local mills. After the dark colors, heavy fabrics, and elaborate decoration of the Victorian era, interiors in the new century tended to be lighter, airier, less cluttered, and easier to clean.

The Black family and their neighbors did not use quilts on their beds, but some women in the area continued to make quilts. Mary's own quiltmaking activity during this period seems to have been confined to her church group, in which the purposes were to participate in enjoyable communal work and to raise money for the church and its work. The church women's interest was in the *process* of quiltmaking, with less concern about the end-use of the finished quilt after it was sold. During the same period, however, other members of Mary's family were involved in various ways with quilts and quiltmaking.

J. R. Snoddy occasionally recorded in his journal paying various women to make clothing for his sons, and, during the summer of 1906, he also made a

FACING Plate 23. "The Handkerchief Quilt made by Rosa Benson Snoddy + she + Mag Drummond quilted it. For Paul to have." Machine-pieced by Rosa Benson Snoddy, ca. 1905, 84 × 78 inches. Cotton bandanna handkerchiefs with solid orange cotton sashing, cotton batting, backed with brown printed striped fabric. Binding is same orange fabric as sashing.

number of entries relating to quiltmaking. The entries include the following: May 22, 1906, "Carried Mrs. Davis Cotton for quilts"; June 12, "Carry Mrs. Davis Quilt Lining"; August 25, "Carry Mrs. Davis Quilt to Fix"; and September 11, "Pd Mrs. Davis to make Quilt." The entries describe quiltmaking steps in sequence, so it is possible that they refer to a single quilt. The reference to a "quilt to fix" is likely an unquilted top to be quilted, suggesting that Mrs. Davis was paid to do the quilting rather than to piece the top or perform repairs. Some quiltmakers worked "on the halves"; for instance, Mrs. Davis might have received cotton—i.e., batting—for two quilts, keeping half for her own use. J. R. Snoddy and his tenants all grew cotton during this time, and he could have held back enough of his crop to "carry" to Mrs. Davis. However, there were other sources of quilt batting. A classified ad in the *Spartanburg Journal* in 1902 proclaimed "Best filling for mattresses, cushions, comforts, pads, etc., is the short lint (called linters) re-ginned from cotton seed. For sale in rolls wrapped in paper at Spartanburg Oil Mills."[45]

Rosa Snoddy's Handkerchief Quilt

"The Handkerchief Quilt made by Rosa Benson Snoddy
+ she + Mag Drummond quilted it. For Paul to have."

Sometime before her death in 1908, Rosa Benson Snoddy made a quilt from nine identical red bandanna handkerchiefs, producing a quilt unlike any of the others in the collection. To someone such as Rosa, familiar with the typical block structure of American quilts, the printed design of each handkerchief resembled the format of a pieced block. The bright color, the agreeable figures, and the availability of multiple, identical repeats must have suggested the possibility of making the bandannas into a quilt.[46]

Bandannas have had a long history. Originally made from silk and tie-dyed to create decorative patterns in red or blue, these cloth squares were among the textiles imported from India in the eighteenth century. A fragment of a bandanna dating from about 1750, found at a Charleston archeological site, is the earliest documented evidence of the tens of thousands of bandannas imported into this country. By the late nineteenth century, bandannas manufactured in American factories were ubiquitous, and they are still among the most widely recognized textile products available.[47] Among the textile mills in Spartanburg County, the Clifton Manufacturing Company produced "sheetings, drills and print cloths, including red fancy bandanas used by railroad men."[48] Whether or not the handkerchiefs in Rosa's quilt were products of this local factory, similar products would have been widely available in local stores.

Rosa framed the somewhat rectangular bandannas with wide sashing strips and border of solid orange, in a shade characteristic of the mid-nineteenth century. Mary had used the same orange in her Tulip quilt thirty years earlier. The combination of bright red and bright yellow-orange produces an intense visual impact, in contrast with the subdued colors of the other family quilts from this era.

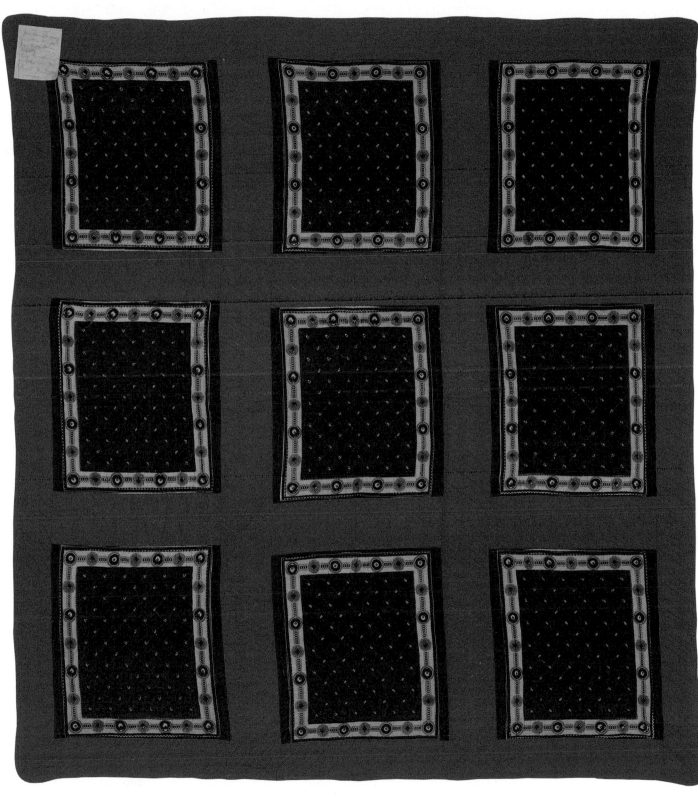

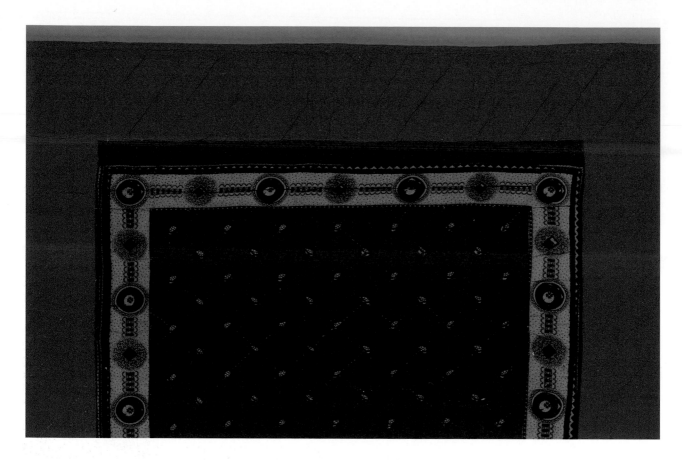

Plate 24. Handerkerchief quilt—detail. The central field of each bandanna is quilted in a diagonal crosshatch, and the crossing lines carefully intersect in each of the small printed turtle-shaped motifs distributed across the field. This method of quilting "by the print" of the fabric rather than marking arbitrary lines is the same technique that Rosa used a half-century earlier in quilting the border of her Sunflower quilt.

It was a quick and simple process to join the handkerchiefs and sashing strips with a sewing machine to make the small quilt top. When Rosa quilted it, however, she did not take a haphazard approach. In each of the bandannas, she quilted a line down the center of each figured white handkerchief border, and added parallel lines on either side. The central field of each bandanna is quilted in a diagonal crosshatch, and the crossing lines carefully intersect in each of the small printed turtle-shaped motifs distributed across the field. This method of quilting "by the print" of the fabric rather than marking arbitrary lines is the same technique that Rosa used a half-century earlier in quilting the border of her Sunflower quilt before her marriage. That she would take pains to closely quilt such a simple piece late in her life in a similar manner as in the masterpiece of her youth is, perhaps, a testament to her character and perseverance.

The orange strips surrounding the bandannas were quilted in triple rows of diagonal lines. These lines were not marked beforehand but quilted intuitively, as the distances among the triplets vary noticeably across the quilt. This may be the result of a desire to avoid leaving visible markings on the quilt as much as from a lack of attention to detail. For the back of the quilt, Rosa selected a fabric printed with narrow, brown and white stripes. The cotton batting is moderately thick, and the quilt edges were bound with a strip of the bright orange fabric.

Cousin Mag, who earlier pieced the Churn Dash quilt, was available to help her aunt Rosa Snoddy quilt this piece. The similarity of the quilting style to Rosa's earlier quilt indicates that the older woman remained in charge of the work. Paul Black was born in 1901, and it is quite likely that Rosa herself chose him as the recipient for this quilt. The bright colors, the association of the bandannas with railroad men, and the simplicity of its construction may have seemed appropriate for a small boy.

Nannie Coan's Christmas Gifts

Sister Nannie continued to make quilts during the early twentieth century. On December 24, 1914, J.R. recorded "Mrs. N.J. Coan send us all Xmas presents: JRS 1 quilt, SMS 1 quilt, Harry 1 quilt, JRS jr. 1 quilt, Robert 1 suit, & Mary 2 pins." (Robert, three years old, and Mary, twenty months, were the children of J.R.'s son Sam.) These gift quilts have not survived, but Nannie Coan may also have made quilts for the family of her sister Mary. Two crazy quilts made by Nannie are part of Mary's collection.

By 1900 highly embellished crazy quilts were no longer in vogue among urban fashion-setters, but women in rural areas had begun to practice a modified version of the technique. Instead of fine silks, rural quiltmakers used the fabrics at hand—wool and cotton remnants left from making family clothing. South Carolina crazy quilts from the early twentieth century were generally plain and made from humble fabrics. If embellished at all, they were embroidered with simpler motifs and fewer different kinds of stitches.[49]

Paul's Crazy Quilt

"Paul's Crazy Quilt—center pieced by Rosa Benson Snoddy during Civil War. Auntie made the rest of it. Quilted by her + Cousin Mag + Auntie."

One of Nannie's crazy quilts incorporates a piece of unfinished patchwork made by her mother, according to the label, "during the Civil War." The center of the quilt is a large six-pointed star pieced by hand from small fabric diamonds, a pattern that certainly predates the Civil War. However, the dyes that produced the red-brown and blue-green pieces in Rosa's pieced star are among the most recognizable of the chemical dyes that became widely available during the 1870s. It is quite likely that Rosa Snoddy pieced the star, but she would have done so in the decade after the war. She may have used the same red and green fabrics from which her daughter Mary cut the pieces for her Tulip quilt during this time. A distinctive imitation cross-stitch fabric used to fill in between the points of the star to make a circle also appears in both Rosa's Log Cabin and Nannie's Cross quilts. The brown print that cradles this circle-in-a-square is similar but not

BELOW *Rosa Snoddy quilted the central field of each bandanna such that the crossing lines carefully intersect in each of the small printed turtle-shaped motifs.*

OVERLEAF **Plate 25. "Paul's Crazy Quilt." Center pieced by Rosa Benson Snoddy during Civil War. Auntie made the rest of it. Quilted by her + Cousin Mag + Auntie." Center section hand-pieced by Rosa Benson Snoddy, ca. 1875. Remainder pieced by hand and machine by Nancy Snoddy Coan, ca. 1915, 91 × 91 inches. Printed cotton fabrics, thick cotton batting, backed with blue and tan plaid. Quilted by hand in irregular elbows and fans. Applied straight-grain binding of blue and white striped fabric.**

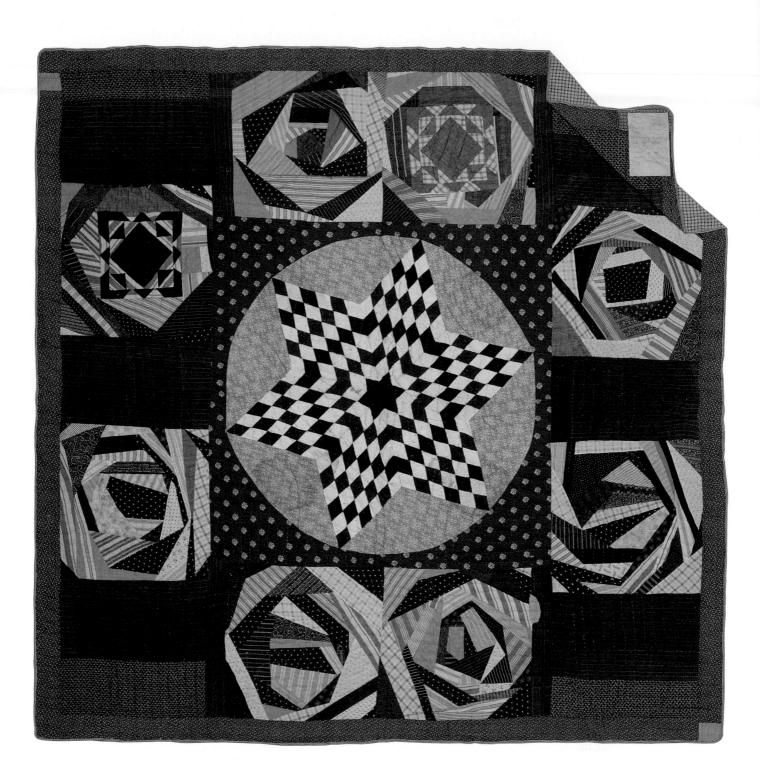

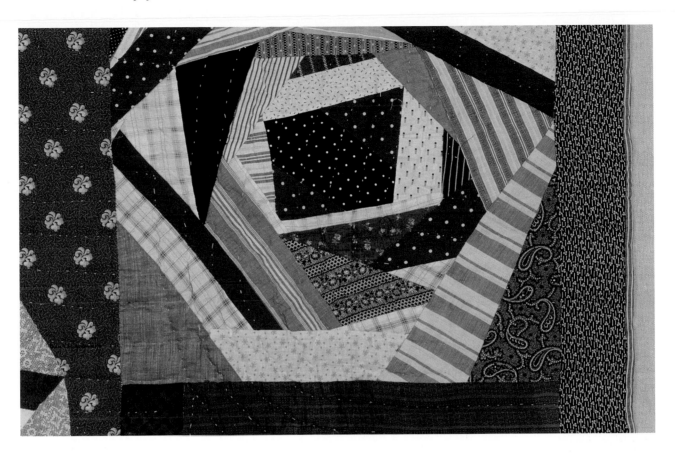

identical to prints in several of the early quilts made by the three women. Rosa most likely pieced the star and framed it in the brown square during the 1870s before setting it aside unfinished.

Nannie Coan probably found the unfinished star patchwork after Rosa's death in 1908, when the children went through their parents' household belongings. The label indicates that Nannie made the eight large crazy-pieced blocks arranged around the central star. Starting in the center of each 19-inch square of foundation fabric, Nannie worked outward, adding pieces by hand, until the foundation was covered. This technique is similar to the sew-and-fold technique in Log Cabin patchwork. Two of the blocks incorporate geometric pieced blocks, probably left over from another quilt.[50] In the other six blocks, the pieces were arranged with attention to an attractive distribution of lights and darks. Striped fabrics and red highlights provide additional visual interest.

The eight crazy-pieced blocks themselves may have been left over from one or more of Nannie's other quilts. Had they been created with the intention of combining them with Rosa's star, it is likely that more attention would have been given to sizing them appropriately. Twelve blocks would have framed the center completely, and Nannie would likely have made this number if she had envisioned this project from the start. Finally, although red fabrics appear in both the

ABOVE **Plate 26. Paul's Crazy quilt—detail. Starting in the center of each 19-inch foundation square, Nannie worked outward, adding pieces by machine, until the foundation was covered. This technique is similar to the sew-and-fold technique in Log Cabin patchwork. The irregularly shaped pieces were arranged with attention to an attractive distribution of lights and darks.**

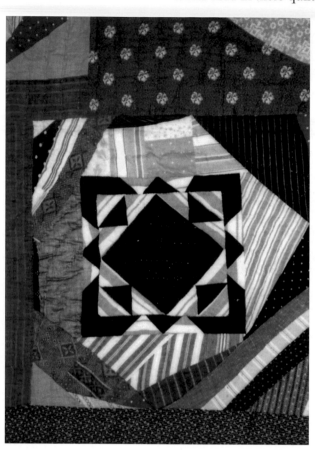

In Paul's Crazy quilt two of the blocks incorporate geometric pieced blocks, probably left over from another quilt.

star and the crazy blocks, there is no evidence of an attempt to coordinate the colors between the old and new parts of the quilt.

The eight blocks are arranged unevenly around the center star, and the spaces between them filled in with large pieces of the same striped red fabric as the backing and two borders of Cousin Mag's Churn Dash. The large amount of this fabric used in these quilts suggests that someone in the extended family may have purchased an entire bolt and shared it with others. The quilt is backed with blue and brown Alamance plaid.

The label indicates that the quilting was done by Auntie and Cousin Mag.[51] Working together, the two women quilted this top with close rows of stitches irregularly in "elbows," an angular variation of the more rounded "fan" quilting design. Fan quilting is one of the all-over designs that emerged during the late nineteenth century to become the most common quilting design for Southern utility quilts during the early twentieth century. The concentric arcs of the "fans" are comfortable for the quilter to perform, and the curved lines produce a pleasing counterpoint to geometric piecing.

The label identifies this piece as "Paul's Crazy Quilt," which suggests a more direct bequest than the other quilts whose labels name the recipient at the end. It is possible that Auntie Coan herself gave this quilt to Paul, perhaps as part of her Christmas gift-giving in 1914.

Auntie's Crazy Quilt

"Crazy quilt—Auntie made it.
Quilted at Ma's house by the family."

Mary Kate's transcription seems at first to indicate that this top was quilted at the home of Mary Black. However, Mary's children always referred to their parents as "Mother" and "Father." "Ma" was reserved for Nannie and Mary's mother, Rosa Snoddy. The label instead suggests that "Auntie Coan" set up the quilt frame in her childhood home and invited members of the extended family to quilt with her. After Rosa's death in 1908, the house otherwise remained unoccupied, and the children gradually removed furniture and other items after her estate was settled. This quilt may have been made around 1914, during the same time that Nannie made quilts for her brother's family.

Nannie Coan's crazy quilt consists of unembellished pieced blocks in a variety of cotton fabrics. While it would have been possible to make a visually interesting quilt with these fabrics, Nannie apparently chose to produce a rather uninspired jumble of lifeless shapes. She seems to have been more interested in fitting

large pieces of fabric together in an efficient manner than in creating a visually pleasing arrangement. The fabrics include dark and light prints peppered with a red solid, but no attempt was made to exploit these contrasting elements for an aesthetic effect. Some blocks are made from a single fabric or from only two or more large rectangles.

In contrast with this example of Nannie's work, the makers of crazy quilts typically arranged small pieces of fabric in an attractive placement, often producing diagonal lines to create visual interest and movement. Although this quilt contains several blocks with diagonals, their impact is negated by the preponderance of right angles. One block, located near the center of the quilt, is pieced in the form of a cross, but the visual impact of the red figure is muted by a lack of contrast with the printed stripe fabrics that form the ground within the block. Otherwise, the forty-two square blocks appear to be randomly placed. The quilt is framed with a border of rectangles. In one border the colors of the pieces follow a regular sequence of red, blue, and white, but this effort was not continued along the other three edges.

BELOW *The label on Paul's Crazy quilt indicates that Cousin Mag helped "Auntie Coan" with the quilting.*

Nannie's earlier Cross quilt demonstrates that she was quite capable of combining pattern and fabric in an aesthetically pleasing manner. Why, then, did she not approach this quilt with the same interest in creating beauty? She could have pieced it using the sewing machine if she was in a hurry to finish, yet she sewed the pieces together by hand. As she was making a number of quilts during this era, she may have decided at some point to vary her approach. She could have made a conscious decision to shift her emphasis from imposing a pattern on the fabric pieces to an attempt to arrange the existing remnants with a minimum of cutting and reshaping.

A less charitable interpretation is that Nannie might have intentionally created an unattractive quilt to give to her sister Mary. This would have satisfied the outward expression, if not the spirit, of the gift tradition. Family members were expected to give each other gifts, and to refuse to do so would reflect badly upon the non-giver. The gift of an intentionally ugly quilt would have been a spiteful gesture, but the recipient of such a gift could not complain without violating her role in the exchange. Nannie's actual motivations at the time are unknown, but the relations between Nannie and her siblings were strained by the conflict over the division of their parents' property in 1911.

Although the quilt as a whole lacks the appeal of others in the collection, it does serve as an album of fabrics available during the era. Two fabrics represent

OVERLEAF **Plate 27.** "Crazy quilt—Auntie made it. Quilted at Ma's house by the family." Hand-pieced by Nancy Snoddy Coan, ca. 1915, 90 × 78 inches. Cotton fabrics, thick cotton batting, dark blue print backing. Quilted in parallel diagonal lines. Bound by turning backing to front.

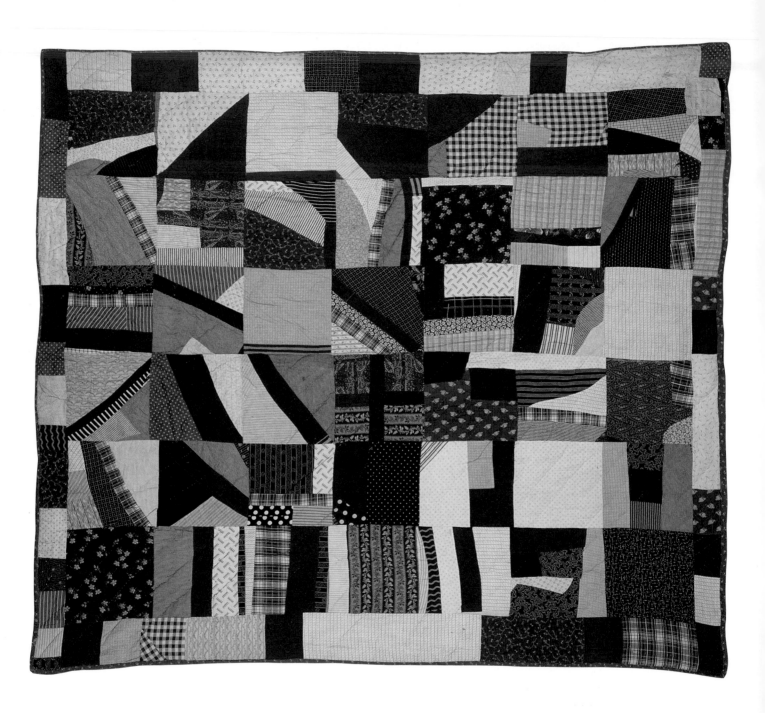

the pictorial "object prints" that were popular at the turn of the century: yellow and white anchors on a navy blue ground, and white dogs' heads encircled with hunting horns on cadet blue.[52] Elaborate floral prints on dark or medium grounds, a variety of white shirtings, and a number of plaids and stripes reflect a wide range of clothing remnants. The backing fabric is a cadet blue printed with white floral sprigs. The quilt is layered with a thick cotton batting. The quilting, a simple design of long, widely-spaced diagonal lines, would not have taken very long. If Nannie had been determined to construct and quilt a number of tops, one after the other in a short time, she could have accomplished this by keeping the quilting simple and getting help from family members when available.

The Colonial Revival

Nannie Snoddy Coan's quilt gifts to family members suggest an interest in reinforcing family connections. Her gifts seem intended to enhance her bonds with her nieces and nephews; and, by incorporating the patchwork of her mother, Rosa, and quilting the tops in the family homeplace, the quilts also linked these children with their grandmother. During the early twentieth century, there was a

ABOVE **Plate 28. Crazy quilt—detail.** Although this quilt lacks the visual appeal of others in the collection, it serves as an album of fabrics available during the era. Elaborate floral prints, object prints, a variety of shirtings, and a number of plaids and stripes reflect a wide range of clothing remnants.

widespread interest in exploring connections with America's past generations, which was expressed in the Colonial Revival, a movement that influenced architecture, home decoration, and historic preservation throughout the twentieth century.

For many Americans the Colonial Revival included a new appreciation of their country's preindustrial past. The movement was more of an attitude than a distinct style, and its inspiration extended beyond the actual period of colonization prior to the American Revolution. One writer for the *Ladies' Home Journal* described the Colonial Revival in this way: "Technically we can hardly call it a period, since it is merely a combination of period influences gathered together and used in a new world. 'Colonial,' as a term, may best describe an atmosphere, a correlation, which has been united by custom and by such changes as best met a new national ideal."[53]

The Colonial Revival was reflected in a renewed interest in quilts and in the process of quiltmaking. Thousands of American women ordered patterns and purchased new fabric to recreate the new quilts designed by Marie Webster and featured in the *Ladies' Home Journal*.[54] Making quilts "like our grandmothers did" was undertaken as a hobby by many women, particularly those whose families had lived in cities for generations. These modern quilts, however, owed more to the contemporary Art Deco movement than they did to actual historic quilts.[55]

Even though Mary Black subscribed to the *Ladies' Home Journal,* neither she nor members of her family participated in the new style of quiltmaking. However, Mary Black and her daughters did participate in another outgrowth of the Colonial Revival movement. In 1916 Mary and Rosa applied for membership in the National Society of the Daughters of the American Revolution, an organization founded in 1890, and open to any woman "who is of the age of eighteen years, and who is descended from a man or woman who, with unfailing loyalty, rendered material aid to the cause of Independence."[56] Rosa's application traces her lineage through her mother's father, Samuel Miller Snoddy, to his mother's father, Patrick Crawford. In the space provided for a narrative of the "ancestor's services in assisting in the establishment of American Independence," Rosa copied verbatim the description of the event recorded by J. B. O. Landrum in his *History of Spartanburg County.*

The following year Mary and Rosa applied for membership in the United Daughters of the Confederacy. This organization, founded in 1893, accepts as members "the widows, wives, mothers, sisters, nieces, grand nieces, and lineal descendants of such men as served honorably in the Confederate Army."[57] During this period there was a widespread interest in reunions of Confederate veterans and in erecting monuments to the Confederate dead in town squares throughout the South. The early quilts in Mary's collection, particularly the ones made before the Civil War, would have taken on increased importance as hallowed family heirlooms. Even the later quilts would have been perceived as old-fashioned and quaint reminders of bygone days, having great sentimental value but no real monetary worth.

Instead of making quilts influenced by the Colonial Revival movement during this period, Mary and Sister Nannie put their efforts into finishing work started earlier and making use of old fabric on hand. They may well have shared an interest in using quiltmaking to reinforce a connection to earlier generations, but for them the past was a more recent one. Unlike many of the women in eastern cities who were discovering the values of traditional quiltmaking for the first time, Mary and Nannie had grown up on a farm and had made quilts as young women. They may have had less interest in re-creating "grandmother's quilts" because they actually owned quilts made by their grandmother and other relatives.

From the time the family moved from Wellford into Spartanburg until the children reached adulthood, Mary Black juggled multiple responsibilities as wife to a busy doctor; mother of five active children; daughter, sister, aunt, niece, and cousin to extended family; supervisor to servants; charter member and supporter of her church and its women's group; and friend to long-time acquaintances in Wellford and new ones in Spartanburg. Quiltmaking was no longer a central activity in Mary's life, and there is no evidence that her daughters were ever involved in quiltmaking. As Mary's children became adults during her declining years, she remained an important influence in their lives during her lifetime and beyond. &

"HER FAITH, HER CHARITY, AND HER TALENT FOR MAKING FRIENDS"

Mary's Legacy to Family and Community, 1917–1996

I N 1917 THE BLACK FAMILY moved to a new house on East Main Street, which was considered "out in the country" at the time.[1] Scant evidence survives of Mary's own activities during the years leading up to her death in 1927. Her children were in the process of creating their own lives, still rooted within the family sphere yet reaching out into the larger world beyond. As the children grew into adulthood, traveled, married, and worked, the spacious house on East Main continued to serve as the family's geographic center for their own generation and the next. During this time quilts played a minor role for Mary, age fifty-seven, who devoted herself to supporting the careers of her husband and sons and to guiding her daughters to fulfill their roles as well-bred young women.

Mary's Children as Adults

In 1917, as Sam Orr was completing his final term at Jefferson, he married Miss Sallie Marvil, "one of the most popular and attractive members of Delaware society" and the granddaughter of a former governor of that state. While Sam Orr continued his studies at the Mayo Clinic, the couple lived in Rochester, Minnesota, where their daughter Shirley Marvil Black was born in 1918. They moved to Spartanburg in 1919 and lived with H.R. and Mary for a couple of months before moving into a rented house on Alabama Street. Their son, Sam Orr Jr., was born June 9, 1920.[2]

Having decided to forgo his athletic aspirations, Hugh Black committed himself to the medical profession. After graduation from Jefferson Medical College, he studied further at the Mayo Clinic, where he served as Dr. William Mayo's

medical assistant. In 1922 he returned to Spartanburg in 1922 to join his father and older brother in their practice.[3] He was remembered as a quiet man who rarely showed his emotions. In 1925 Hugh married Iris Burris, whose father owned a hospital in High Point, North Carolina. The Black and Burris families became very close and visited frequently. Dedicated to his medical career, Hugh nonetheless maintained a lifelong interest in baseball. According to his nephew, Sam Orr Black Jr., "Any time he went anywhere, he'd make a point of being in a big city to see the baseball game. He kept the *Sporting News* by his desk, read it every night, and he could tell you the batting average of every player."[4]

Rosa remained at her parents' home, traveled frequently, and never married. Sam Orr Jr. recalled: "I heard rumors that in her earlier life she had a man she was very much in love with, but what happened to that, I don't know. She'd have had no problem getting a husband if she'd wanted one." Her niece Marianna Black Habisreutinger also referred to this relationship: "As I understand it, she had a very nice friend who was at Camp Wadsworth, here in Spartanburg, during World War One. I never knew what happened to him, but she never married after that. Later there was a Dr. Fox in New York City who used to come down and visit her. But she never married Dr. Fox either."[5]

Mary Kate graduated from Converse in 1917, with a certificate in art.[6] For a number of years she served as the society editor for the *Spartanburg Herald*. As editor she was available daily from 3:00 to 4:30 P.M. to receive calls from local residents submitting items for the society page. Each of Mary Kate's daily columns opened with an inspirational poem, followed by notices of club meetings and church events, reviews of parties, and other local social items. In the summer of 1925, the paper sponsored a subscription promotion, and Mary Kate was among seventeen people who were rewarded with a tour of the western states by train. Mary Kate extended her travels with a visit to Hawaii, apparently as chaperone to a "Miss Beety," the winner of a beauty contest. In her travel journal, she recorded a constant and enthusiastic flow of sightseeing and flirtations.

Paul attended the local Hastoc School for Boys, then enrolled at Wofford College in 1920. According to his daughter Marianna, "When he was a student at Wofford, he had a horrible bout with nephritis and was in bed around two years. And after that, it was recommended that he get fresh air, so he never went back to Wofford." During this time Paul received treatment at the Mayo Clinic, and he spent several weeks in the local hospital in Spartanburg. He had developed a close relationship with his uncle J. R. Snoddy, who visited him frequently.[7] When he was well, Paul increasingly spent his time in Wellford, working on the family farm and sharing meals with his uncle and cousins.[8]

Paul Black loved farming and pursued it as his life's work. Increasingly he took responsibility for the supervision of the family's substantial agricultural holdings and took an active part in the labor of hauling logs, digging wells, killing hogs, and baling hay.[9] During the early 1920s the invasion of the boll weevil decimated cotton crops, and the Blacks were among the Spartanburg County farmers who planted peaches in place of cotton. Over the next decades peaches became the

The Mary Black Clinic opened in this building in 1925.

dominant agricultural product in the area, and Paul Black was active in agricultural associations and fairs at local, state, and regional levels.

In 1917 H. R. Black actively supported an effort to establish the first public, tax-supported hospital in Spartanburg. On September 29, 1921, the Spartanburg General Hospital opened its doors, and Dr. H. R. Black performed the first surgery in the new hospital. The patient was his son Paul, who was suffering from an infection in his right arm.[10]

After working to develop the public hospital, H. R. Black and his sons bought a piece of property at the corner of Oakland Avenue and East Main Street as the site for a new private clinic. On January 18, 1925, the Mary Black Hospital opened, named in honor of their wife and mother. Six patients were admitted that day. The following year the Doctors Black established the Mary Black School of Nursing in conjunction with the hospital to address the local need for skilled medical personnel.[11]

In addition to her involvement in the lives of her husband and children, Mary's interest in her family extended to both past and future generations. She had grown up knowing the history of her immediate ancestors, and membership in the D.A.R. and U.D.C. apparently spurred additional genealogical pursuits. In 1920 Rosa was away from home and apparently researching family history. On April 20 that year, Mary wrote Rosa a letter in response to her queries about family names. Mary reviewed what she knew about the family and expressed regret at not having paid more attention to these things earlier:

> Isaac Snoddy is my grandfather, your great grandfather. . . . The other Snod-
> dy I don't know anything of. Never heard of him. See where he is from if

possible. No doubt but he is a relative of ours. . . . I don't know the Benson ancestors. . . . Grandma Benson's people were closely related to the Millers, Montgomerys, Clevelands, Vernons, Bomars, but I cannot tell how. . . . Have heard my mother tell of these people but I never kept it in mind I'm sorry to say.[12]

Mary's grandchildren, Shirley Marvil Black Barre and Sam Orr Jr., remembered their grandmother as an affectionate and attentive woman. According to Shirley, "She was very religious, I do remember that. She was at church about every time the door was open." Sam added, "She wasn't what you'd call 'born-again religious'; she was born *with* it, and it was just her way of life. She wasn't overbearing with it or anything as I recall."

The grandchildren sometimes stayed overnight at their grandparents' house on Saturday night and accompanied Mary to church on Sunday. Shirley recalled, "I used to go with her when I was a little bitty thing. I remember sitting on her lap. I don't remember anything about what was going on, but we loved for her to take us to church." Sam Orr Jr. also recalled the comfort of her ample lap; "I sat there and thought how convenient it was to have these cushions. I didn't realize it was great big bosoms. I don't remember what we did when we got there, to tell you the truth. That's how little I was. I just have a recollection of how comfortable I was, and the smell of her powder."[13]

Mary's fondness for small children drew her to teach the junior Sunday School class for the Spartanburg A.R.P. Church. Miss Agnes Coleman, a longtime member and church historian, remembered Mary Black's lovely voice during congregational singing. Mary was also remembered for her generosity in charity work, although no records survive to indicate the nature or recipients of these contributions.

Unfinished Quilts

In the process of packing up and moving to the new house on East Main Street in 1917, Mary apparently found four unquilted patchwork tops made years earlier. At this point she had a number of options for dealing with the tops. Her deeply ingrained respect for the usefulness of things would not have allowed her to throw them away. By this time her church group may have moved on from making and auctioning quilts to other fundraising activities, but Mary could have given them away to some other charity. Or she could have simply found a new storage place for them in her large, dry basement.

Instead of any of these options, however, Mary decided that the quilts should be finished. Unquilted tops are flimsy and somewhat fragile. Compared with finished quilts, they have little value or potential for use. Mary may have briefly contemplated quilting them herself. Her new house was large, but it was elegantly furnished. The idea of setting up an old-fashioned quilting frame in the family sitting room would have been inconsistent with the décor of the home and inconvenient to the lifestyle of the inhabitants. Instead of trying to find the space and time to quilt the tops at home, she decided to pay someone else to do it.

Four quilt tops made earlier and quilted after 1917 are all backed with a dark blue fabric printed in a leaf design.

FACING Plate 29. "Quilt possibly pieced by Cousin Mag but quilted by woman near Mr. Gaston's on Reidville Road. Pieced after Mother married. Small quilt." Double Squares pattern, hand-pieced, probably by Margaret Drummond, ca. 1900, 91 × 76 inches. Cotton and linen fabrics, cotton batting, dark blue print backing. Quilted in triple rows of diagonal parallel lines. Applied bias binding of solid black fabric.

The identity of the quilter is unknown—perhaps Mary herself could not recall her name nearly a decade later when she described the quilts to her daughters. According to information on the quilt labels, the tops were quilted "after we moved from Converse St. to E. Main" by a woman living "near Mr. Gaston's on Reidville Road." Rural women had few options for earning money, and sewing and quilting for hire was one way single women and widows supported themselves. Mary would have taken the four tops, batting, and backing fabric to the quilter, then paid her when she picked them up. Some quilters charged by the number of spools of thread used in the quilting, but there is no record of how much Mary paid for the work.

The four tops included the Basket of Chips and the unlabeled Flyfoot described earlier, along with two additional tops, one pieced in a pattern called Double Squares and another that is a composite of three pieced patterns. All four of the finished quilts are backed with the same fabric, a dark blue print with a leaf motif. Although Mary's intention may have been simply to have the four humble tops completed, she nevertheless selected a finer fabric than what would have been minimally acceptable. The backing fabric is similar to the colors and prints popular in the late nineteenth century, and Mary may have selected the print because it reminded her of quilts from this earlier era. Backing the four quilt tops would have required a total of at least twenty-five yards of the 35-inch-wide blue fabric, and she probably purchased an entire bolt for the purpose.

The batting in all four quilts is moderately thick. During this period the Black family continued to grow cotton on their farm, and it is possible that some of this was reserved for the quilts. However, commercial cotton batting was readily available, inexpensive, and involved considerably less work. In these four quilts, cotton seeds remaining in the batting are palpable as small, hard lumps. Some quilt writers have suggested that seeds in quilt battings indicate that the cotton that was picked out and carded by hand instead of being ginned. In reality, however, hand-picked cotton typically contains fewer seeds than ginned cotton, and even some commercial battings contained cotton seeds. The presence or absence of seeds in

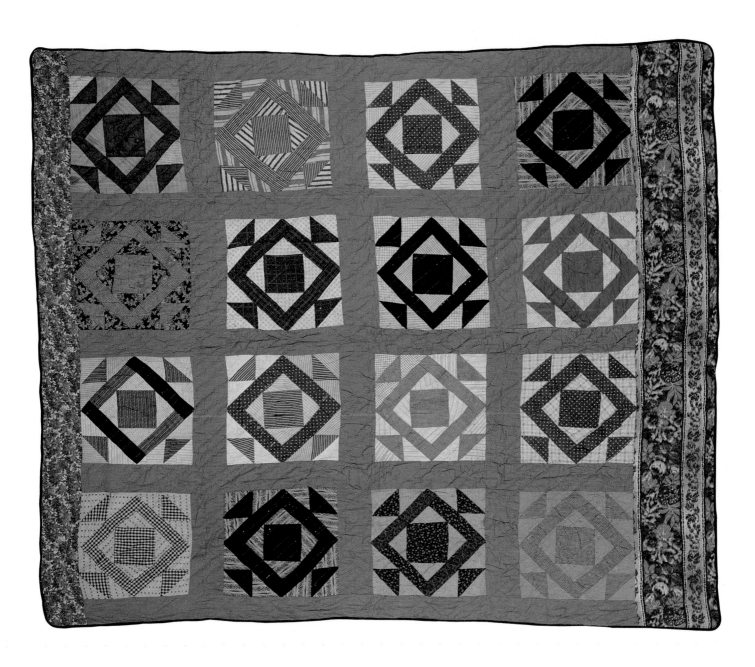

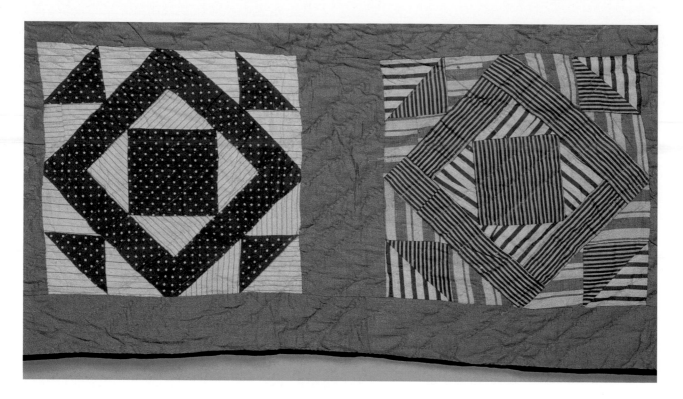

Plate 30. Double Squares quilt—detail. Like the Flyfoot and the Basket of Chips, this quilt is pieced from a wide range of colors and prints, producing a random visual impression. The fabrics are remnants of shirtings, dress fabrics, and home-decorating prints, including a tan linen for the sashing.

cotton batting during any period is not a reliable indicator of its source or processing method.

All four tops were quilted in a simple overall design of diagonal lines. The lines are paired in the Basket of Chips and the composite top, and grouped in threes in the Flyfoot and Double Squares. The quilting stitches, sewn with white thread, are somewhat uneven, suggesting that the quilter valued speed and efficiency over elegance. The quilter marked the quilting lines using what appears to have been a liquid paste. Over time the marking medium has interacted with some of the fabric dyes to produce discoloration, particularly in the Basket of Chips.[14] This is evidence that the quilts were never washed, and probably never used, after they were quilted.

The edges of all four quilts were bound with strips of fabric cut on the bias and sewn on by hand, but no two bindings are of the same fabric. The Basket of Chips was bound with a gray-and-white stripe, the Flyfoot with a solid dark blue, the Double Squares with solid black, and the composite quilt with a woven tan and white check.

Double Squares Quilt

"Quilt possibly pieced by Cousin Mag but quilted by woman near Mr. Gaston's on Reidville Road. Pieced after Mother married. Small quilt."

A pattern identified by one early source as Double Squares is an example of the many geometric pieced patterns that developed during the late nineteenth century

and circulated in family periodicals.[15] Like the Flyfoot and the Basket of Chips, this quilt is pieced from a wide range of colors and prints, producing a more random visual impression than the earlier quilts. The fabrics include remnants of shirtings, dress fabrics, and home-decorating prints. Lengths of a solid tan linen fabric form the sashing between the blocks.

The presence of linen fabric in scrap quilts of this period is unusual, but the color and sheen provide a pleasant ground for the multicolored blocks.[16] Two of the border strips are of the same tan linen; the other two are strips of two different floral prints. The floral borders are very wide, converting the otherwise square quilt top into a more practical rectangle. The widest of the borders is a floral border print reminiscent of the chintz borders on elegant early South Carolina quilts, but it seems somewhat misplaced in the context of this more humble quilt.[17]

The label states, "Quilt possibly pieced by Cousin Mag. . . . Pieced after Mother married." This suggests that Mary and Cousin Mag may have done quite a bit of piecing during the early years of Mary's marriage, so much so that Mary lost track of who pieced which blocks. As Mary was frequently pregnant during the early years of her marriage, she may well have found it more comfortable to piece patchwork than to sit at a quilting frame.

A Composite Quilt

"Quilt pieced by Mother or Cousin Mag.
Quilted by women at Reidville. Small quilt."

The remaining quilt appears to be a composite of leftover blocks from other quilts, arranged in three linear rows. Two of the rows contain blocks of the same pattern as the single odd block in the Basket of Chips quilt, although that one is green and white, and these eight blocks are mostly red and gray. The middle row is made of four slightly larger blocks of a different pattern. The pattern name, if it had one, is unknown, but it is similar to a number of patterns published later.[18] These blocks are more regular in appearance, all constructed from red and blue small-figured dress prints contrasted with a lighter ground of striped or checked shirtings. The fabrics in the blocks are typical of those available in the 1890s.

Four additional Churn Dash blocks form the corners of the quilt. These are the same size and contain some of the same fabrics as the blocks in Cousin Mag's quilt of this pattern made during the same period, so it is likely that these were left over from that project. The spaces between the blocks were filled in with a solid dull green, and the rows were sewn together with long strips of a tiny red and black check, which is also one of the fabrics in the middle row of blocks. Two short borders are of a coarsely woven yellow-green solid; two long borders are of an Alamance gingham woven in blue, tan, and white, the same fabric Nannie Coan used for the backing of Paul's Crazy quilt.

Passing on the Quilt Collection

The humble tops completed in the early twentieth century were clearly not of the same quality as those handed down from earlier generations. The earlier quilts

OVERLEAF Plate 31. "Quilt pieced by Mother or Cousin Mag. Quilted by women at Reidville. Small quilt." Hand-pieced blocks, ca. 1895, joined by machine. 95 × 78 inches. Composite of three different patterns of unknown names. Cotton fabrics; cotton batting; backed with dark blue print. Quilted in triple diagonal parallel lines. Applied bias binding of tan-and-white woven check.

were made with care from fine materials; the later quilts seem to have been made quickly from materials on hand. In several cases, leftover or unfinished patchwork blocks made years earlier were combined with additional fabric to fill out the tops. The impulse seems to have been toward completion, toward making something useful from otherwise useless remnants. Mary did not seem to have a specific purpose in mind for these quilts, as she kept them in her home unused. These quilts were not necessarily intended to become family heirlooms, but they were nonetheless valued for their potential for use.

Mary Black may not have thought about her sixteen quilts as a *collection*. She had acquired them in various ways: by the work of her own hands, as gifts, through inheritance, and by paying or bartering for the work of others. They were material reminders of her connections with other women in her family and of events in her own life. Even the humble quilts of the later years were albums of the fabrics from which she and others had made family garments, and these would have evoked memories of family members who wore those garments. Through the years there were probably other quilts, which may have been given away during Mary's life. These sixteen represent those in her possession in the mid-1920s, in the years just before her death.

ABOVE Plate 32. Composite quilt—detail. The blocks in the middle row of this quilt were pieced from red and blue small-figured dress prints and striped or checked shirtings typical of the 1890s. The pattern name, if it had one, is unknown, but it is similar to a number of patterns published during the twentieth century.

Two of the borders of the composite quilt are of the same Alamance plaid as the backing of Paul's Crazy quilt.

When Mary Black gathered with daughters Rosa and Mary Kate to transcribe the stories of the family quilts and sew the labels to the quilts, she indicated the intended recipients of certain quilts after her death. Rosa was to inherit the Sunflower made by her grandmother Rosa Benson Snoddy; and Mary Kate was to receive the whole-cloth chintz quilt made for their grandmother's marriage. Paul's name appears on both the multigenerational crazy quilt and the Handkerchief quilt. The absence of Sam Orr and Hugh from this distribution does not necessarily indicate that they were excluded. Both of the older sons were already married, and they would already have received their quilts.[19]

Mary's Final Illness and Death

On Thanksgiving Day 1926, J. R. Snoddy noted that he went "to Sweets for turkey dinner." Shortly thereafter Mary was taken to the Mary Black Clinic. The nature of her illness is not known, although grandson Sam Orr Jr. recalls that she was diabetic: "It wasn't real severe, but it was definitely diabetes and she had had it a long time. I remember on Thanksgiving Day I heard Daddy say something to Uncle Hugh about it."[20] Mary Black remained in the hospital for fifteen weeks. J.R. and his sons visited frequently during this period, noting on January 18, "Sweet not well at all," and on February 17, "Harry goes to Hospital every night to be with Paul," indicating that family members stayed by her bedside. Several weeks later, J.R. wrote, simply and formally, "Sister Mrs. H. R. Black died."[21] Mary Louisa Snoddy Black was sixty-six years old at the time of her death on March 11, 1925.

The death of Mary Black brought grief not only to her family but to the larger community as well. Under the subheadline "Life Spent in Unselfish Service," the *Spartanburg Herald* reported

> For several days Mrs. Black's life had hung by a thread, and members of the family had remained at her bedside constantly. . . . Until just a few hours before her death, she retained full possession of her faculties, and several days ago she requested that five ministers of the city be asked to visit her at the clinic. . . . With the ministers grouped about her, Mrs. Black talked calmly of her impending passing. Her attitude toward death profoundly impressed those at her bedside, and one of the ministers said as he left the room: "It was the most triumphant scene I have ever witnessed."[22]

An address at her funeral by the Reverend G. L. Kerr, pastor of the A.R.P. Church, also testified to the strength of Mary's religious convictions at the end of her life:

> This trial of her faith was not regarded as some strange thing that had happened unto her, but she readily accepted the teaching that the Lord loveth

whom he chasteneth. Sufferings were assuaged by the promise of sufficient grace, and face to face with the issue of death she said, "The will of the Lord be done." Her assurance that he unto whom she had committed the keeping of her soul is faithful to His word, had its evidence in the calmness in which she gave her farewell messages. Her words, "Give my love to all and tell them I'll meet them in Heaven," furnish an index to the victory that came after months of suffering, suffering which must have been at times intense.... Ready co-worker, faithful spirit, farewell, until we meet around the throne![23]

The funeral services were held at the family home on East Main. Granddaughter Shirley recalled seeing visitors arrive to pay their respects. "I remember people were just coming to the house, all the time. Sam and I were little, and we were out on the side street, riding our bicycles up and down the sidewalk."[24] In addition to eight active pallbearers, the funeral procession included twenty-two honorary pallbearers, among them Mary's childhood friend Boyce R. Pollard. Furthermore members of the Spartanburg County Medical Society were requested to serve with the honorary pallbearers, and nurses of the Mary Black Clinic attended as a group.[25] Mary Black was buried at Oakwood Cemetery.[26]

The family received hundreds of letters, telegrams, notes, and cards from friends, acquaintances, and professional colleagues. These notes convey not only the customary expressions of sympathy and condolence, but also reveal some of the personal impressions Mary created among those who knew her. Mary Black did not seek to perform major public roles in life, but, within the private sphere of home, family, church, and community, she seems to have exerted a powerful influence.

Weddings—and More Funerals

In retrospect Mary's death seems to have been only the first of a series of stressful family events—marriages as well as further deaths—that the family weathered during the following years. The family resumed their daily activities, but Mary's absence

MARY'S CHARACTER EMERGES THROUGH EXPRESSIONS OF SYMPATHY FROM THE FAMILY'S FRIENDS, RELATIVES, AND COLLEAGUES:

"My dear Doctor, ... Seldom have I known a lady of stronger faith & deeper religious conviction. ... I feel it is needless for me to write anything to you in the way of bringing comfort in your deep sorrow—you know all the sources of consolation which a Christian has in a time like this in your life.... Yours very sincerely, J. S. Watkins"

"My precious Friend: Words are impotent to express my sorrow and heart felt grief at the loss of your precious wife.... I am glad that when we have made our last run and swung into the grand central station of the sky, and have signed our pay roll and received a check from the superintendent of the skies for our eternal happiness, when the gates click on our heels as we enter that country where the flowers never wither and the rainbow never dies, and death will never come, we will understand all these things and, thank God! We will be satisfied. I am, your friend and brother, B. F. McLendon."[27]

"My dear Brother, I was mighty sorry to receive the message saying Mary had passed away.... So the only thing for each of you to do is to take up the threads of your life and weave them into that perfect pattern that, when you have ended this journey, will be accepted where all patterns are perfect through the grace of Jesus Christ.... With love to all, Your sister, Sallie."

"Dear Friends: ... Her death cast a gloom over us all.... A great and useful life has been brought to a close. Of her, it can be truly said: the world has been made better by her having lived in it. ... Carrie B. Perry, Supt., and Nurses of Providence Hospital."

(continued page 140)

"Dr. Sam Orr Black, my dear friend, My heart goes out to you and the whole family in this your greatest sorrow. . . We have known and loved each other since we were school girls together at dear old Williamston. It was said of Mary then, and I suppose thru life that 'she never shirked a duty.' With loving sympathy, your friend, Mittie S. Oliver"

"My dear Rosa, . . . It was not my privilege to know your mother intimately, but I have heard of her deep spirituality and lovely personality from those who were near her. The little glimpses I was permitted to see showed me that yours is a devoted family, and the love and affection you show each other is very beautiful. . . . I know her great mother-heart rejoiced in the skill of her sons and the lovely character of her daughters and she could not fail to see the result of her careful training. With all your mother's fine attributes, her Christian life stands out above them all. . . . Sincerely yours, Caroline C. DuPré"

"Dear Rosa and Mary Kate, . . . So many, many friends she had who are grieving over her passing. She has given so much to humanity and will go on giving it through the years to come. There are hundreds who will bless the very mention of her name. . . . My love to you both, Grace DuPré"

"My dear Rosa and Mary Kate, . . . It is a grand honor to have had such a Mother, and she has left her children a wonderful legacy—her faith, her charity, and her talent for making friends are causes for pride for you both. Ever your sincere and sympathetic friend, Rachel McCrary."

"Dear Mary Kate: The last time that I saw your Mother was when she and Miss Rosa went to Pacolet to my own Mother's funeral. And long before that time she had been so dear and thoughtful to all of us that I felt very much attached to her. . . . Your sincere friend, Gregg Black."

was deeply felt by all. Rosa, Mary Kate, and Paul remained in the family home with their father, along with Herbert Jenkins and a succession of other servants.

A few months after her mother's death, Mary Kate became engaged to Dr. Morton Elbridge Hundley, age forty-nine, a physician and owner of a private hospital in Martinsville, Virginia. Described as "outstanding in medical societies in this country and abroad," Dr. Hundley apparently met Hugh and Sam Orr Black at a European conference and, through this acquaintance, met Mary Kate.[28] Their courtship seems to have progressed quickly despite family opposition. A surviving letter from Dr. Hundley to Mary Kate—undated, but written during the fall of 1927—reveals the intensity of his passionate attachment:

My sweet angel child,

I failed today for the first time to get a letter from my little darling since our engagement, so you know dear it has been one long blue day for me. Dearest precious child, I have sorely repented for the way I have so often referred to your Dear Father. I now can better understand his position and feeling towards me, that is, in regards to asking him for his most precious child. It seems as now the few weeks go by between now and November 16 will be years, and I will be so glad when it is over and I can hold you in my arms again as a real wife this time in reality. Precious darling I want to have your Dear Fathers good will and love and respect, and I hope to have our home a place of rest and recreation for him where you may pet him, drive him out in your car daily and really make him happy and in doing this we both will always feel the happiest and, dearest, when I speak of him you well know it includes all your family especially Miss Rosa your darling sweet sister, Paul, and all. Ink is out.

Please write me daily, dear ?

Always yours, M.
(I hope you still love me.)

Dr. Hundley's desire to hold Mary Kate "as a real wife this time in reality" suggests that he and Mary Kate may have dissembled marriage at some point in their courtship. Her father's discovery of such behavior might explain the ill will evident between the two men. Sam Orr Jr. recalled that "Granddaddy didn't like Dr. Hundley;" and at age seven he found his own experience with his aunt's fiancé less than congenial: "I remember Dr. Hundley asking me, 'Would you like to have this nickel or would you rather have this shiny penny?' Well, I was no fool, I took the nickel. I found out later on that shiny penny was a gold dollar."

The wedding was held at the home on East Main on November 16, 1927. Although the event was described by a reporter as "of unusual social interest," only members of the immediate family attended: "Owing to a recent bereavement in Miss Black's family, the wedding will be a very quiet affair." Mary Kate wore "a handsome gown of rich green velvet with accessories to correspond. . . . Her only attendant was her niece, little Miss Shirley Black."[29]

The couple left immediately to spend the winter in Europe, sailing from New York on the *Ile de France* on November 19. They spent several weeks in Italy and France before arriving in December in St. Moritz, Switzerland, for the local ice carnival. A photograph shows the smiling couple sitting in a horse-drawn sleigh, wrapped in fur lap robes. Unfortunately, after Christmas, Dr. Hundley contracted pneumonia and was hospitalized.

Mary Kate sent an anxious telegram to her father, who responded, "Don't be alarmed. Use best judgment. Best consultant confer American consul. Cable daily." On January 2 the *Spartanburg Journal* reported that M. E. Hundley had died "after three days of delirium." Mary Kate, described as "weak and nervous" and accompanied by a private nurse, brought her husband's body home for burial on the steamship *Homeric.* This voyage was delayed and complicated by continuous, unusually heavy storms. Mary Kate's father, Rosa, and Paul went to New York to meet Mary Kate when the ship arrived on January 20.[30] H.R., Hugh and Iris, and Paul Black attended Dr.

"Dear Mary Kate, . . . You have been spared your mother, with all the attending love and care, for a long time. She lived to see you blossom into young womanhood—the realization of all her dreams and ideals for you, materialized. Her sacred memory is yours always. Her beautiful life and character are yours to pattern yours by. . . . Lovingly, Dorothy Glover, Atlanta."

"Dearest Mary Kate, Cousin Mary was always to me, a personification of all that was highest and holiest in motherhood. She was one of those rare souls who create an impression of being a refuge, an understanding and sympathetic haven to anyone who needed help. Yours in sympathy, Alice [Anderson, the daughter of H. R.'s sister Alice Lamon]"

"In the passing of Mrs. H. R. Black, Spartanburg has lost one of her ablest, most sincere and most indefatigable citizens. . . . Her life was unselfish and devoted always to the betterment of those she loved and those less fortunate. Her deeds of charity were manifold. So unostentatious was she in such acts that only few were cognizant of them. Her very name was loved by all. C. H. B."

"The many good and noble things that she did will remain a living monument for her. No one can ever give her the praise and honor that is due her. . . . You all were so sweet and good to me while I was a patient in your wonderful hospital and I shall never forget it. I love the 'Mary Black Clinic' and its name. With love and heart-felt sympathy, your sincere friend, Myrtle Parrish."

Dr. Morton Elbridge Hundley, age forty-nine, married Mary Kate Black on November 16, 1927.

Hundley's funeral in Martinsville, Virginia, along with J. R. Snoddy and his sons, Sam and James.[31]

Mary Kate and her family made several trips to Martinsville in the following months in reference to Dr. Hundley's estate, valued at around $200,000. The late doctor's brother-in-law contested Mary Kate's claim, but on April 3, 1928, a circuit court judge ruled in her favor.[32] Mary Kate returned to the family home in Spartanburg.

A second event later that year caused a family crisis of a different nature. Sister Nannie Coan died on November 9, 1928. Her obituary listed her nephews, Sam Orr, Hugh, and Paul Black, and Sam, Harry, and James Snoddy, among the "active" pallbearers, along with the names of twenty-five honorary pallbearers.[33] Although she was a member of the A.R.P. Church, Nancy Jane Snoddy Coan was buried with her husband and both their families at Nazareth Church.

Following the burial on November 12, family members gathered at Nannie's Spartanburg home to locate her will. As a result of the settlement of Colonel Snoddy's estate, Nannie owned the family's homeplace on Jordan Creek, the farm where she, Mary, and J.R. had grown up. Having no children of her own, it was generally assumed that she would follow the tradition of bequeathing the land to some relative in order to "keep it in the family." To their horror family members discovered that Nannie Coan had bequeathed the 391-acre farm to Erskine College in Due West, South Carolina, a school connected with the A.R.P. Church.

J. R. Snoddy recorded a number of family meetings held to discuss the implications of the will. On November 13 he noted, "Dr. Black draws me over the coals about 1898 business."[34] The details of the original dispute are unknown, but Nannie Coan clearly was disappointed in the division of her father's estate and harbored resentment toward her brother and sister for the remainder of her life. From the time she drew up her will on October 2, 1912, until her death sixteen years later, Nannie participated in family events, gave and received gifts, attended church and club meetings, all the while knowing that her family would receive their comeuppance at her death.

The property of her late husband, David M. Coan, including land, money, and furniture, Nannie bequeathed to Coan relatives. She left two thousand dollars to the Spartanburg A.R.P. Church and four hundred dollars each to two first cousins. Nannie completely ignored her brother J.R. and his entire family; but, although she left nothing to sister Mary, she pointedly included Mary's family.

On their honeymoon
Dr. Hundley and Mary
Kate traveled to St. Moritz,
Switzerland, for the local
ice carnival. After Christmas
that year, Dr. Hundley con-
tracted pneumonia and died.

Dr. H. R. Black was to receive five hundred dollars; Mary Kate, a piano; Rosa, a diamond brooch; Sam Orr, a watch and watch fob; Hugh, "the largest silver waiter" (a serving tray); and Paul, a silver water pitcher and silver cup. In the final article of the document, Nannie Coan wrote, "I have not made my will as I would like to have done, but owing to the way my people have treated me about my Father's property, this is the best I can do for them."

The family contested the will in probate court, but the judge upheld Erskine College's claim to the Snoddy homeplace. The full economic impact of the Great Depression had not become evident at the local level, but Paul Black lacked the financial resources to purchase the farm himself. Fortunately sister Mary Kate, now a wealthy widow, stepped in and provided the money to help Paul buy back the family farm. The issue of Nannie Coan's will and the unwitting role of the A.R.P. Church continued to rankle the family. All of them left the church for the First Presbyterian Church, except for Paul. According to his daughter, Paula Black Baker, "He always said that he would never leave the church that his mother went to. He really just adored her. I don't know why he had such a bond. It could have been because the others were all older. After Mary Kate, there was a baby that was stillborn, and then my father."[35]

Four years later, in December 1932, Mary Kate visited friends in New York City and went with them to a party. Jane Phillips, wife of oil magnate Frank Phillips, had decided to celebrate the recent divorce of her son John, age thirty-four. By the end of the evening, John had fallen for the visiting young widow. Mary Kate later described their first meeting: "John looked at me and said, 'Mary, you

John Phillips proposed to Mary Kate in December 1932, and they were married the following January 3.

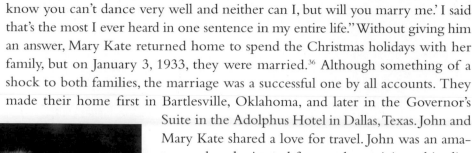

know you can't dance very well and neither can I, but will you marry me.' I said that's the most I ever heard in one sentence in my entire life." Without giving him an answer, Mary Kate returned home to spend the Christmas holidays with her family, but on January 3, 1933, they were married.[36] Although something of a shock to both families, the marriage was a successful one by all accounts. They made their home first in Bartlesville, Oklahoma, and later in the Governor's Suite in the Adolphus Hotel in Dallas, Texas. John and Mary Kate shared a love for travel. John was an amateur archaeologist and frequently participated in digs in South America. During their extensive international travel, they stopped off often to see the rest of the family in Spartanburg.

On October 8, 1933, Dr. H. R. Black died at the Mary Black Clinic as he was undergoing surgery for a blood clot in his leg.[37] His obituary described him as "a leading figure in the medical field," whose "leadership was recognized throughout the state and South as well as by the many prominent men in the medical world who were his friends."[38] Following the loss of their father, the children were further rocked two months later, on December 6, 1933, by the death of Hugh's wife, Iris, from cancer at age thirty. After this, Sam Orr Jr. recalled, "Dr. Hugh did nothing but work, except every other year, he would take a long trip somewhere. After Iris died, he took me on a Caribbean cruise one time."

Rosa, Paul, and Anna

Rosa and Paul stayed in the family home on East Main Street. Paul worked in the radiology department of the Mary Black Clinic, and, although he was not a doctor, everyone called him "Dr. Paul."[39] Daughter Marianna Black Habisreutinger recalled the family story of how her parents met. A pretty, young schoolteacher named Anna Maybry came to the clinic to see her family doctor, H. R. Black, for a rash on her chest. Dr. Black prescribed radiation and introduced her to his son Paul. "After several treatments, he asked her to go ride to the farm to check on an orchard, because he was getting into peaches about that time. And she thought, 'Isn't that a strange invitation,' but she went."

Daughter Paula Black Baker explained why her father did not marry until age thirty-four: "He always told us, 'I decided years ago, when I was young, that I would never marry unless I found someone that I would love as much as I loved my mother. And I wasn't going to marry anybody until I found someone that I thought was as beautiful as my mother, inside and out. And I finally found her, when I met your mother.'"

Marianna recalled the family story of how Paul's marriage affected his living arrangements with sister Rosa.

> In 1935, when my father told Rosa he was going to get married, she said "Paul, now it's time for me to find my own home." And he said, "Well, Rosa, where in the hell do you think you're going?" And she said, "Well, Paul, I'll just find a house." And he said, "Well, I don't know why! This is your home!" And she said, the story always went, "Well, because you're getting married." And he said, "Well, what difference does that make?"

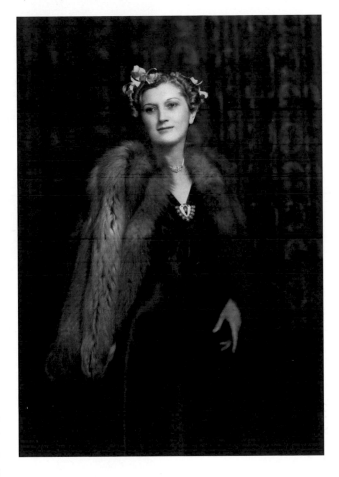

Paula also remembered the story:

> So Mother moved into this house with a new husband and a sister-in-law. Now, not too many people would be very happy with that situation, but Anna and Rosa complemented each other. They got along just beautifully, they really did. Then six years later, when Anna was expecting Marianna, Rosa kept saying "I'm going to move out," but she didn't. Then two years later, when I was coming along, they went through the same thing. "I'm going to move out," but she never did. And I'm glad she never did. It was like having two mothers.

On January 17, 1951, John Phillips, age fifty-two, died of a heart attack aboard the *Queen Mary,* on a voyage to New York from Spain, where he and Mary Kate had spent the holidays.[40] That summer, Marianna recalled, "Aunt Rosa took my sister and me to Dallas to help her move, then up to Oklahoma, where John was from, and then to Mexico. And from that summer on for years and years, we went on a trip every summer with our two aunts. The two sets of sisters, Paula and me, and Mary Kate and Rosa. My daddy was in the peach business, so that was never a vacation time for our family." Paula reflected, "I didn't realize how wonderful that was at the time, but now, of course, when I look back on all these fabulous trips that we took, I am so glad that my parents worked it out so that we could have the advantage of going and seeing things all over the world."

The Quilts in Storage

During this period, the quilts remained tucked safely in trunks in the basement. "I remember airing the quilts once with Rosa," Marianna recalled. "They were just quilts from the family, and she wanted to take care of them. Birdie Mae Thompson, who worked for us at the house, helped us, and we took those quilts

BELOW *During the 1950s*
Rosa Black and Mary Kate
Phillips spent summers travel-
ing with their nieces, Marianna
and Paula Black.

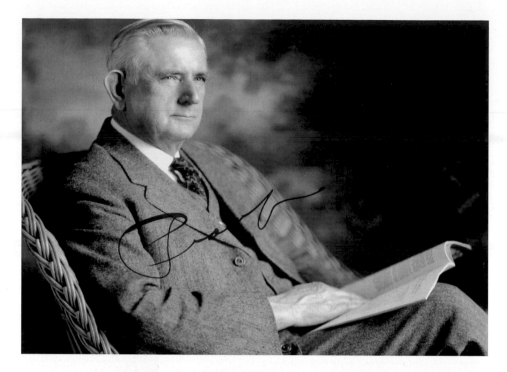

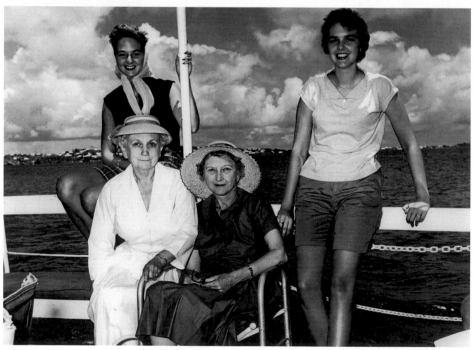

outside and hung them on clotheslines to air out. Then we packed them neatly back, and I didn't think another thing about them for years." Marianna recalls that she had graduated from college and was teaching school, so this probably would have been in the 1960s.

For their grandmother the family quilts had served as material reminders of a network of family relationships and interactions. Mary Black had known each of the quiltmakers intimately, and, to women of her generation, the gift of a quilt was valued more for its symbolic value than as a warm bedcover. To Rosa the quilts would have been among the family heirlooms entrusted to her care by a beloved mother. The quilts, along with some jewelry, clothing, and personal items, were relics of a bygone era—quaint and old-fashioned. Not old or rare enough to be valued for those qualities alone, they were belongings that needed to be preserved but that did not have a place in the family's everyday life.

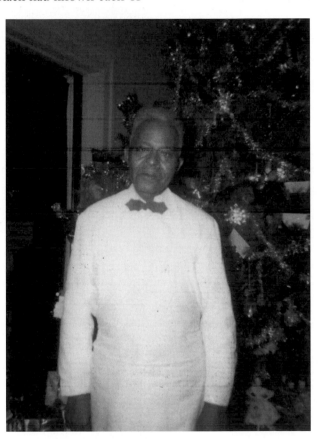

Herbert Jenkins worked for the Black family from the age of fifteen until his death in 1962.

Marianna and Paula were children of a very different era. Their family included not only their parents and Rosa but Mary Kate and John, their uncles Dr. Sam and Dr. Hugh, their older cousins Sam and Shirley, and their children. Rosa sometimes took her nieces out to the country to visit the families of their Snoddy cousins. The girls remember these visits, and they understood that these nice old people were related to them somehow. Their memories, however, are of being dressed up in Sunday clothes and of exploring the lovely old house at New Hope, with its wide floorboards and the inlaid marquetry pattern in the entry hall. With so many living relatives, the concept of ancestors as "family" was an abstraction.

For Marianna the process of airing the quilts served as a brief diversion in their lives—the surprise of discovering old stuff in trunks that had been right there in the basement all her life. Realizing that the girls would eventually inherit the responsibility for the quilts, Rosa may have made an effort to instill in them a sense of connectedness to their ancestors. And perhaps the brief discovery of the quilts kindled a momentary awareness of their grandmother's earlier life and her continuing presence in the house in which they were growing up.

After the quilts were returned to the trunks in the cool dry basement, they remained there for several decades. Marianna and Paula went away to college, returned to Spartanburg, married, and raised families of their own. Herbert Jenkins, who had worked in the family home for three generations, died in 1962. Dr. Paul died in 1975, Rosa in 1980, Mary Kate in 1994, and Anna in 1995. Thinking about the loss of her parents and her aunts, Paula realized, "All of a sudden,

we were the *grownups.* I called Marianna one day and I said 'Being the grownups is just *not fun,*' and she laughed and said, 'You're right!'"

Mary and H. R. Black and all of their children were gone, and their grand-children had inherited the responsibility not only for the family's place in the world but for their accumulated possessions. For nearly eighty years, the house on East Main Street had sheltered three generations of Mary's family. Eventually her grandchildren would have to deal with a house full of furniture, personal effects, and memories—including the trunks and the quilts. &

"LET'S SHARE THESE QUILTS"

The Reemergence of Mary Black's Quilts, 1990s

TO SPARTANBURG RESIDENTS, the most familiar association with Mary Black is the hospital that bears her name. Since 1925 the Mary Black Hospital has provided medical services to the Spartanburg community. In 1933 the hospital was chartered as a nonprofit organization, the first of its kind in South Carolina. The hospital moved to its present site on Skylyn Drive in 1968, where it was rededicated as the Mary Black Memorial Hospital. In 1996 the hospital was sold and is now owned by Triad Hospitals, Inc. The proceeds from the sale were transferred to the Mary Black Foundation, which expanded its mission "to benefit and enhance the health status and wellness of citizens of Spartanburg County."[1]

Mary Black's Public Legacy

The restructured Mary Black Foundation established its offices on East Main Street, just a few blocks east of Mary Black's home. Marianna Habisreutinger and Paula Baker, representing the Black & Phillips Foundation, made a commitment to furnish and decorate the offices so that the Mary Black Foundation funds could be reserved for community programs.[2] Marianna recalled a meeting with the designer, Alicia Fusselle, and Jan Yost, then president of the Mary Black Foundation:

> So then it came time to do something with those big walls, and you know that when it comes to art, what's gorgeous to somebody is just hideous to somebody else. Would we put up pictures of flowers, horses and dogs, or what? I think Jan was the one who said, "Well, we're in a textile area—let's think textiles." And then it hit me—those quilts. This is a perfect place for those quilts. And I

thought it was particularly appropriate since they were Mary Black's quilts. It was a way of letting others enjoy the quilts, because nobody was enjoying them while they were in the basement. Rosa enjoyed knowing that they were well cared for, but, you know, you can't take it with you. You might as well eat out of your nice china and drink out of your nice glasses and enjoy them. So we thought "Let's share these quilts."

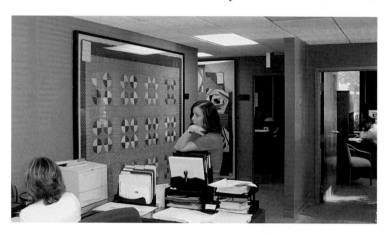

Mounted and framed, the quilts were hung in the offices of the Mary Black Foundation in 1997. The foundation staff includes Amy Page, grants associate; Christina Godfrey, administration associate; and Philip Belcher, president. Photograph by Mark Olencki.

Sharing the Quilts

The foundation staff consulted with textile experts at the Smithsonian to determine the proper way to display the quilts. Ten of the quilts were sewn to fabric-covered panels and framed behind Plexiglas, with care that the paper labels would remain visible. The mounted quilts were then hung on the walls of the foundation offices. Staff members enjoy the quilts, sometimes pointing out their favorites to visitors. In 2005 plans were under way to relocate the foundation offices, and the staff and family members looked forward to displaying the quilts in the new building.

The Mary Black Foundation is among the comparatively few charitable foundations named for a woman. An association with the handwork of women seemed particularly appropriate for a foundation committed to the health and well being of the community, as the quilts represent the work of women connected by bonds of kinship and friendship. Other organizations may display quilts on their walls, but the fact that these quilts were indeed the property, and even the handwork, of the woman for whom the foundation is named is a rare circumstance.

Mary Black's quilts had remained in the trunk in the basement of the family home during several decades of change. Following World War II, American society was fascinated by new technologies and the trappings of modernity. Some women continued to make quilts for their own satisfaction; but quilts themselves, whether old or new, were generally seen as old-fashioned and quaint. For many Americans who had grown up during the Great Depression, quilts were a reminder of making do in hard times. Most people preferred to cover their beds with bedspreads from Sears, Roebuck or local department stores. When Rosa aired the quilts during this period, she would not have considered actually using the quilts. To her their value lay in their associations with her mother's family, not in their potential for actual use on a bed.

The Symbolic Value of Quilts

When Rosa packed away the quilts after airing them in the 1960s, they were family relics. When they were unpacked thirty years later, however, the country had

entered an era of renewed appreciation for quilts. Museums from coast to coast found that they could boost attendance figures dramatically by sponsoring exhibitions of historic quilts. Collectors who had purchased beautiful but unappreciated quilts for almost nothing at estate sales and antique stores over the years found that prices skyrocketed as newcomers joined them in the search for textile treasures. Emerging in this new context, Mary Black's quilts were honored as objects of great historic, aesthetic, and associational value. Mary herself had been dead for over seventy years, but these quilts were imbued with her personal touch in a literal sense as well as by association.

American quilts are recognized as highly symbolic objects. Instead of signifying a single idea or value, however, quilts are *multivalent*—that is, they simultaneously represent a number of different ideas, some of which may at times be contradictory. Individuals who view quilts experience a complex mixture of attitudes, associations, and emotional responses. These impressions emerge automatically, without conscious awareness, and they profoundly determine what is seen.

Quilts are usually made by women, and they have been interpreted variously, depending on the agenda of the writer, as markers of women's subservience and household drudgery, as emblems of women's success in overcoming their imposed limitations, or as evidence of individual creativity and personal achievement. Quilts are associated with family and the home, particularly with bedrooms, the most private areas in the home, usually seen only by family and close friends.

At first appearance, we experience quilts as large and colorful textiles. From our previous "knowledge" of quilts, we may assume that the primary purpose of quilts is to serve as warm bedcovers. However, an objective examination of Mary Black's collection reveals that *none* of these quilts show wear or other evidence of use. None of them have ever been washed. Although all of them are rectangular, no two are the same size, and some of them are actually too small to function effectively as bedcovers. We must go beyond our original assumption and look for other motivations for their intended purpose.

Published research over the past quarter century has contributed to a realization that American patchwork quilts developed first among upper- and middle-class women who had access to fine materials. Nevertheless, Americans widely believe that patchwork quilts emerged on the frontier in response to a lack of warm bed coverings. Women are imagined to have cobbled up quilts from otherwise unusable scraps of fabric. Early American quiltmakers have been reinvented as the saviors of their families from the harshness of nature.

Collectively quilts have been exalted as an indigenous and distinctly American folk art. Unaware of parallel traditions in other countries, Americans have adopted quilts as emblems of such values as self-reliance and democracy. Quilt patterns, such as the Log Cabin, have been widely, though inaccurately, assumed to embody the cultural values of our pioneer ancestors. By making, purchasing, or displaying such quilts, many people have created for themselves what they perceive as a personal connection with the heritage of the nation.

Just as patchwork is seen as making something from nothing, of converting useless scraps into useable objects, Americans tend to cast their personal and family histories in the Horatio Alger mold of overcoming humble origins and multiple obstacles to achieve success on the basis of one's personal qualities. In this context quilts are often used as props to illustrate the poverty and lack of status existing before the subject's emergence into successful modern life. For this purpose any quilt, no matter how finely made, may serve to illustrate the less desirable condition prior to such a transformation.

We see that some of the quilts are made from a large number of small pieces of many different fabrics. We "know" that these are scrap quilts, pieced together from whatever small remnants were available by women who were trying to "make do." From information available about the Snoddy and Black families' resources, though, it is clear that this was not the case. Instead of automatically interpreting these as "scrap" quilts, we can open our eyes to them as evidence of abundance, documenting the makers' access to a wealth of different printed fabrics.

If we were to view the sixteen quilts in chronological order, we would notice that the quilts generally become smaller over time, that the later ones include a more random assortment of materials, and that the needlework becomes less fine. A standard interpretation of this visual evidence would lead incorrectly to an assumption that the family suffered a decline in resources during this time period. Although Mary's family experienced the same economic ups and downs as other southerners in the late nineteenth and early twentieth centuries, those events alone do not explain the differences among the quilts during this time. In order to understand the changes reflected in these quilts, we need to examine the shifting status of quilts in relation to the relative costs of fabrics.

As the monetary cost and the perceived value of fabrics decreased between 1850 and 1915, the status of the quilts made from them also declined. Quilts from the mid–nineteenth century were made from fine, imported fabrics and served prominent symbolic roles in family life. Only affluent families could afford the time or materials to make quilts. During the 1870s and 1880s, printed fabrics became more widely available and less expensive, and quiltmaking became popular among middle-class families. By the early twentieth century, southern textile mills produced a wide range of inexpensive fabrics, and even less prosperous families could afford to make quilts. Quiltmaking became associated with destitution and charity, and heirloom quilts were seen as quaint and old-fashioned.

Attitudes about American history, our ancestors, and their quilts are deeply ingrained in contemporary American popular culture, and they continue to influence the ways we experience quilts in the early twenty-first century. An awareness of the presence and power of these cultural attitudes does not eliminate them, but it does allow us to try to look beyond their influence. When we try to look at quilts and their accompanying factual data objectively, without too quickly interpreting them according to what we already "know," we find true stories that are more complex and just as compelling as the fictions we've held as true. We also find that there are always more questions than answers.

These sixteen quilts are not necessarily representative of general American quiltmaking traditions. Mary Black's collection reflects the quiltmaking activity of a single family within a specific time period in one geographic area. A particular combination of circumstances and influences has resulted in a unique configuration of patterns, fabrics, motivations, and meanings. The accumulated quilts of other families, near or far, would evince different conditions and resources.

The Mary Black quilt collection is significant for what it does not include. Mary's ancestors did not make chintz appliqué quilts in the early nineteenth century, as they were not a part of the fashionable lowcountry gentry. In fact, with the exception of Mary's Tulip, there are no appliqué quilts at all. During the late nineteenth century, both pieced and appliqué quilts were very popular in the Carolina upcountry, but there is no evidence that members of this family made any, other than the Tulip.

The collection contains no embellished silk crazy quilts. Mary; Sister Nannie; their mother, Rosa; and Cousin Mag Drummond were all actively making quilts during the 1880s and 1890s, when silk crazy quilts were an international phenomenon, but there is no evidence that they made any. This is not so surprising when we remember the influence of Williamston College and, in particular, its "calico commencement," on Mary's young womanhood. The dress that Mary recycled into a quilt in the 1890s was made of cotton. Her rejection of silk for clothing (except for her wedding dress) may have extended also to its use in quilts. She would not have had silk scraps available from sewing, and, unlike many other quiltmakers of this period, she may have been unwilling to buy factory remnants.

Mary's affiliation with the Associate Reformed Presbyterian Church was a major influence in her life and was probably a factor in her attitude toward crazy quilts. The women of the A.R.P. Church very early adopted the motto "Despise not the day of small things," which suggests an interest in bringing excellence to humble endeavors rather than seeking glory and public recognition. A church historian wrote of the women's work, "Conservatism was strong, then as now, in our church. Woman's place was in the home."[3] The idea of gathering pieces of silk and adding embroidered embellishments to make a purely decorative quilt simply did not fit with the self-image of women in this church.

The impracticality of silk crazy quilts set them apart from cotton quilts. Even though none of Mary Black's quilts show evidence of actual use as bed coverings, they embodied the *potential* to offer warmth and comfort if needed. Having a number of quilts in storage, in reserve, would have provided a sense of security similar to that of a pantry full of canned goods. After all an important part of a woman's traditional responsibility to her family has been to see to the "small things," the basic requirements of food, clothing, and shelter, in the eventuality of hardship or disaster.

Mary and her relatives also showed no interest in responding to an important influence of the early twentieth century. Mary's quilts for this period contrast sharply with the aesthetics of the Colonial Revival movement. Beginning in the 1910s, the *Ladies' Home Journal* published color illustrations and instructions for a new

style of quilts. Although promoted as "making quilts like our grandmothers did," the new styles were more influenced by Art Deco aesthetics than by actual historic quilts. Mary Black subscribed to the *Journal* during this period, but there is no evidence that either she or her sister ordered patterns or bought yards of delicate pastel fabrics to make quilts in this new style. Instead they seem to have been more interested in completing unfinished earlier work and in using up fabric already on hand.

Memory, Meaning, and Material Culture

The aesthetic and economic properties of quilts are visible in the quilts themselves, and from these they are analyzed as artistic and historical artifacts. Just as important, but generally not visible, are the commemorative and associational properties of quilts. The unique characteristic of Mary Black's collection is that, by having her daughters label the quilts, she ensured that some of this information would survive. She provided such facts as the identity of the makers, the relationships among family members, the names of patterns, the sources of fabrics, and the functions of the quilts. These otherwise invisible and unknowable fragments form the basis for interpreting the *meaning* of quilts.

Very few historic quilts are accompanied by written documentation, and orally transmitted data is fragile. The untimely death of a single elder can erase all knowledge of the significance of the family heirlooms. Given the precarious nature of oral records, it is surprising that so few quilts from earlier periods were documented in this way.[4] This may be a delayed response to changes in the structure of family life. When extended families lived in close proximity and participated together in local activities, the repetition of oral traditions may have resulted in better retention. As families dispersed, such information became less central to an individual's identity within the family and was not retained.

When Mary's daughters looked at the quilts, their experience was very different from that of their mother. Rosa and Mary Kate faced a stack of quilts, each one strange and different, some more attractive than others, and all of them perhaps smelling a bit musty from storage. Without their mother's help, they would not have been able to decipher the relative age, value, or significance of individual quilts.

In the process of describing the quilts to her daughters, Mary relied on the familiar memory aid of aligning smaller events in relation to larger ones. In this case, Mary found the most useful time markers to be the houses in which she was living at the time. Like many people she would have visualized herself and her surroundings, where she was and who else was present. Mary remembered that the Log Cabin was pieced by her mother "at home" before Mary "carried it when she went to housekeeping," a memory of physical relocation. Mary recalled making the Shoofly "probably after she moved to Wellford," and that the Basket of Chips was pieced before she moved to Spartanburg but not quilted until after the move to East Main Street.

Mary's assertion that her mother pieced the center of Paul's Crazy Quilt "during [the] Civil War" may stem from a childhood memory of watching Rosa piece

the small diamonds. As the fabrics actually date from the 1870s, however, Mary must have conflated the later image of this quilt with other childhood memories during the war. Sister Nannie later completed the top, and she quilted it and the other Crazy quilt with the help of other family members "at Ma's house." At this time Nannie Coan owned a house of her own in Spartanburg, but, whether for convenience or symbolically, she set up the quilting frame at the uninhabited homeplace.[5]

For Mary each quilt conjured an image of the maker, accompanied by a flood of associated memories. The chintz quilt might have evoked memories of her grandparents, Silas and Nancy Miller Benson, who died in the 1870s during Mary's teenage years. The quilts made by her mother, Rosa Benson Snoddy, marked three different life stages in the maker's life: The Sunflower demonstrated a young woman's accomplishments and suitability for marriage, the Log Cabin signified a mother's supportive role in her daughter's own preparation for marriage, and the somewhat whimsical Handkerchief quilt embodied affection for a young grandson.

Not all quilts descend in a direct line from mother to daughter. Mary received the Zigzag quilt from her unmarried aunt, Narcissa Benson, either as a gift during the maker's lifetime or as a bequest. Rosa and Narcissa, as the two oldest Benson children, maintained close ties with the families of their sisters and brothers. When their sister Margaret Benson Nesbitt died in 1878, Narcissa took responsibility for Margaret's young children. No doubt this demonstration of generosity and solidarity made an impression on the seventeen-year-old Mary, and Narcissa's quilt may have served as a reminder of the importance of family charity.

Looking at her Tulip quilt, Mary would have remembered the assistance of Cousin Theresa Snoddy. Her cousin was several years older, with the somewhat ambiguous status of an orphan within the extended family. Mary's mother, an expert needlewoman, could have helped her, but Mary would likely have looked up to her cousin and enjoyed receiving her attention. As young women they may have been eager to try out the Tulip pattern, which had become newly and widely popular in the Carolina upcountry at the time. Of Mary's surviving quilts, the Tulip is the only appliqué and the only one made from solid color fabrics in a limited palette. The choices of pattern and fabric indicate that this quilt was a special one. Like Rosa's Sunflower the Tulip testified to Mary's own womanly accomplishments preparatory to marriage.

In contrast with the bold elegance of the Tulip, Mary's Save All quilt includes a multiplicity of printed fabrics in muted colors. If we knew for certain that the Tulip was made before Mary's attendance at Williamston and her church membership, and that the Save All was made afterward, we would have proof of the influence of her education and religious conviction on her quiltmaking. The specific dates of construction for these quilts, however, cannot be pinpointed. Instead Mary simply may have intended to make one special appliqué quilt, then found that she preferred piecing from a variety of remnants and recycled fabrics for more humble "everyday" quilts.

The subdued colors and contrasts of the Save All are pleasing rather than spectacular, yet Mary took no shortcuts. She pieced the curved seams and matched the corners with care for precision. The labels for both the Save All and the Shoofly quilts specify that Mary recycled dresses to make the borders for these quilts. Of all the details that Mary could have recited in relation to these quilts, it seems significant that she remembered this association rather than some other. She did not describe her feelings about the dresses themselves nor of events to which she wore them. Instead she highlighted the act of transforming the dress fabric into her quilts.

Several labels seem to indicate Mary's confusion in distinguishing her own work from that of Cousin Mag Drummond. Mary remembered that her cousin pieced the Churn Dash, but she described the Double Squares as "possibly" pieced by her. The label on the composite quilt says "pieced by Mother *or* Cousin Mag," but it is likely that it includes the work of both women. In summarizing Mary's spoken memories, Mary Kate would not have understood the nature of this quilt as an amalgam of three different sets of leftover blocks. Whatever the details, Cousin Mag appears to have been a frequent companion in piecing quilt tops during the time that Mary was at home with young children. The unlabeled Flyfoot also dates from this period, and it may have been the work of either Mary or Mag Drummond.

Miss Mady Wingo is the only person named in full on the quilt labels who was not a family member. Her contribution is remembered as having "brought [the] pattern from Georgia," and she does not appear to have been further involved with its construction. Some of the other quilts in this collection were pieced by one woman and quilted by another. Mady Wingo's participation suggests that a quilt can be the product of an even more complex lineage, involving additional individuals in the acquisition and sharing of pattern, fabric, supplies, and equipment as well as technical advice and physical assistance. A quilt is typically described as either the product of a single individual or of a group. Typically a group is perceived as working simultaneously, particularly in the process of quilting the layers. The phenomenon of *sequential* quiltmaking, of a number of individuals working in sequence, is not unusual, but it merits more attention by researchers.[6]

Of the quilts in Mary's collection, perhaps the ones that are the most ambiguous in reconstructing meaning are the three that were made by Sister Nannie. The Cross comes from the period when both sisters were living at home with their parents. The nature of their relationship at this time is not known, although it is likely that the animosity that surfaced later may have developed earlier in their lives. In describing this quilt to her daughters, Mary indicated that she had had a dress from one fabric and that her mother Rosa had liked gray and white while Auntie preferred blue and brown. Mary did not relate the circumstances under which she acquired the quilt, which might well have been a gift in preparation for Mary's marriage.

We know from brother J. R. Snoddy's journal that Sister Nannie made a number of quilts as Christmas gifts in 1914. The two crazy quilts date from this period

and were probably part of the same effort. Mary Kate's transcription of Mary's narrative, however, again does not describe the circumstances of the gift exchange. The resulting label identifies Rosa as the maker of the six-pointed star in the center of Paul's Crazy quilt, "Auntie" as the maker of the rest, and Cousin Mag and unnamed other family members as the quilters. Mary did not mention whether or not she herself joined family members around the quilting frame. Further, Mary apparently specified that the maker's name be recorded as "Auntie Coan," reflecting her children's relationship, rather than "Sister" or "Nannie," which would claim Mary's own kinship.

Nannie Coan's gifts of quilts to family members came two years after she had written her will. Deeply unhappy with her share of her parents' estate, Nannie harbored resentments toward her brother and sister. She continued to take part in family activities aware that, upon her death, the provisions of her will would enact her revenge. In this context Nannie's motivations for her Christmas gifts in 1914 appear complex and enigmatic. Why would a woman with such animosity toward her family present them with gifts considered so extraordinary that her brother uncharacteristically listed them in detail in his journal? Neither Nannie nor Mary left additional written clues to the nature of these gifts. We know simply that Auntie Coan gave her nephew Paul a quilt containing patchwork made by his grandmother and that she gave Mary a quilt that falls short of the aesthetic standards of her other work.

Quilts and the Gift Economy

Quilts have been circulated within families and communities, particularly among women, as direct gifts, bequests, and purchases. The motivations for such exchanges include such factors as love, obligation, and charity. Quilts continue to function within an economy of informal exchange, which has existed alongside the more formal, public monetary economy. This gift economy is distinct from barter, which operates on a *quid pro quo* basis in the absence of money. In a gift economy the exchange of value may proceed in a circular path among members of a group rather than just between two parties.[7] This can be seen in practice, as the recipient of a gift quilt rarely reciprocates with the return gift of another quilt. Instead, a more complicated obligation is incurred.

In fact quilts do not fare well within a monetary economy. Anyone who has ever made a quilt and tried to sell it realizes the difficulty of receiving a just compensation for the expenditure of one's time, energy, and skill. Unlike the prices of consumer goods in a money economy, which are based on materials and labor with a markup for overhead and expected profit, quilts suffer from the stigma of anachronism. They have almost no value in an economy based on satisfying material needs. From a practical standpoint, if consumers can purchase a blanket for a few dollars, why would they pay many times that price for a quilt to supply the same need? The real value of a quilt resides not in its inherent usefulness but in the emotional associations embodied by the people involved in the exchange.[8]

Several manifestations of a gift economy are reflected in the quilts in Mary Black's collection. The labels and circumstantial evidence suggest that seven of

them were direct gifts or bequests from the makers to the recipient. The whole-cloth chintz quilt was a wedding gift. The Log Cabin and, probably, the Cross were given to Mary when she "went to housekeeping." The Zigzag was either a gift or a bequest from Mary's Aunt Narcissa. The Handkerchief and Paul's Crazy quilt were apparently gifts for Mary's youngest son. And the enigmatic Crazy quilts may have been a Christmas gift to Mary in 1914. In addition to these gift transfers, Mary named three of her own children as the eventual inheritors of several of the quilts: The Chintz quilt was to go to Mary Kate, the Sunflower to Rosa, and the Handkerchief and Paul's Crazy quilts were already designated for Paul.

Two other quilts, Mary's Save All and Shoofly, represent the transformation of value from a transitory medium (women's fashion) to the more lasting embodiment in a quilt. The quilts pieced by Cousin Mag and those quilted by women outside the family would appear to be simple monetary exchanges; however, there is the suggestion of an element of charity here. Mary did not pay these women because she actually *needed* the quilts. It is more likely that she saw her role as helping out women who lacked resources.

The role of quilts in a gift economy in some ways parallels the work of the Mary Black Foundation. These quilts were given not in expectation of receiving back something of equal value but as an investment in the social and emotional relations of the family and community. In a similar way the foundation bestows grants to community organizations not in expectation of a direct benefit of equal value but as an investment in the health and welfare of the community. The gift economy is the basis for the work of all charitable foundations and the community organizations they support. The Mary Black Foundation is unique only in demonstrating the underlying gift economy as manifested through its namesake's quilts. The quilt collection may be seen as a quiet precursor to the larger philanthropic activity pursued by the Mary Black Foundation in its support of wellness in the community. The legacy of Mary Black lives on, not merely through her quilts, but through the contributions of her descendants and through the philanthropy carried out in her name.

The example of this family's quiltmaking experiences suggests the importance of recognizing that, even during periods of popularity, not everyone approached quiltmaking in the same way. A variety of personal, religious, economic, cultural, and demographic factors influence an individual's level of participation. Age and marital status also influence the changes in quilts made by an individual at different stages in her life. All of these elements should be considered before making assumptions about *who* made *what kind* of quilts *where* and *when*.

This book has attempted to examine the changing functions of quilts within the context of everyday family life over several generations. This research reveals not a single interpretation of *what quilts mean* but a complex web of meanings interlaced with various associations of *memory*—not just living memory of family members but conjectured memories of past generations. The meanings of quilts are not inherent in their visual and physical presence but rather adherent in the accumulated associations of those who experience them. Michael Owen Jones

suggests that "to understand tangible things we must investigate the circumstances that obtained before their existence, the processes by which they came into existence, and the consequences of their existence."[9] This book has attempted to demonstrate a detailed analysis of quilts as evidence of one family's "material behavior." Only through additional careful study of family quilt collections will we begin to more fully understand the complexity, variety, and meaning of American quiltmaking traditions. ✤

NOTES

Introduction

1. Among the most influential books of this period were Jonathan Holstein, *The Pieced Quilt: An American Design Tradition* (New York: Galahad, 1973), and Patsy and Myron Orlofsky, *Quilts in America* (New York: McGraw-Hill, 1974). The founding of the American Quilt Study Group in 1980 and its publication *Uncoverings,* an annual volume of research papers, have been major factors contributing to a scholarly approach to quilts.

2. The first large-scale quilt documentation project was initiated in 1980 by the Kentucky Quilt Project, Inc. The success of this effort spawned the development and evolution of similar projects in many other states, regions, and countries.

3. Published quilt-related biographies include the following: Nancilu Burdick, *Legacy: The Story of Talula Gilbert Bottoms and Her Quilts* (Nashville: Rutledge Hill, 1988); Carolyn O'Bagy Davis, *Pioneer Quiltmaker: The Story of Dorinda Moody Slade, 1808–1895* (Tucson: Sanpete, 1990), and *Quilted All Day: The Prairie Journals of Ida Chambers Melugin* (Tucson: Sanpete, 1993); Gwen Marston and Joe Cunningham, *Mary Schafer and Her Quilts* (East Lansing: Michigan State University Museum, 1990); Grace Snyder, *No Time on My Hands* (Caldwell, Idaho: Caxton, 1963; reprint, Lincoln: University of Nebraska Press, 1986).

4. For a very useful introduction and overview of material culture study by folklorists, see Simon Bronner, ed., *American Material Culture and Folklife: A Prologue and Dialogue* (Logan: Utah State University Press, 1992), particularly Bronner's introductory essay, "The Idea of the Folk Artifact," pp. 3–40.

5. Michael Owen Jones, "How Can We Apply Event Analysis to 'Material Behavior,' and Why Should We?" *Western Folklore* 56 (1998): 202–3.

6. For similar patterns see Barbara Brackman, *Encyclopedia of Pieced Quilt Patterns* (Paducah, Ky.: American Quilter's Society, 1993), 190–91, #1450–1453. Brackman lists these names for specific variations: Rob Peter to Pay Paul, Indiana Puzzle, Snowball, Steeplechase, Polka Dots, and Millwheel.

7. James Deetz, *In Small Things Forgotten: An Archeology of Early American Life,* rev. ed. (New York: Anchor Doubleday, 1996), 259–60.

Chapter 1: "Arrived from Ireland and this Day petitioned for Land right"

1. Walter Edgar, *South Carolina: A History* (Columbia: University of South Carolina Press, 1998), 56–58; Billy Kennedy, *The Scots-Irish in the Carolinas* (Belfast: Causeway, 1997); James G. Leyburn, *The Scotch-Irish: A Social History* (Chapel Hill: University of

North Carolina Press, 1962), 210–22; Sam Thomas, *The Dye Is Cast: The Scots-Irish and Revolution in the Carolina Back Country* (Columbia: Palmetto Conservation Foundation, n.d.), 5–6; R. J. Dickson, *Ulster Emigration to Colonial America, 1718–1775* (London: Routledge, 1966), 60–61.

2. John H. Logan, *A History of the Upper Country of South Carolina* (Charleston: Courtenay, 1859; reprint, Spartanburg: Reprint Co., 1960), 251–52.

3. Edgar, *South Carolina,* 157; J. B. O. Landrum, *Colonial and Revolutionary History of Upper South Carolina* (Greenville: Shannon, 1897; reprint, Spartanburg: Reprint Co., 1962), 23.

4. Typescript of Miller genealogical information, dated September 8, 1917, in possession of Jane Snoddy Cook.

5. Variant spellings include Cowan, Coan, and Corven.

6. Genealogists have found both Snoddys and Cowens buried at St. Cedma's churchyard at Larne. http://bellsouthpwp.net/c/s/csbyler/Genealogy/Snoddy/Snoddy.html (accessed September 17, 2004).

7. The Snoddys were connected with a congregation of the Reformed Presbytery of Ireland, called "Covenanters," led by Rev. William Martin. The Snoddys were among 467 families who left Ulster with Martin on five ships between August 25 and October 27, 1772. Kennedy, *Scots-Irish in North Carolina,* 58; Dickson, *Ulster Emigration,* 248.

8. Passenger list, January 6, 1773, *Council Journal* 37, South Carolina Department of Archives and History. Photocopy in collection of Jane Snoddy Cook.

9. Edgar, *South Carolina,* 163–64.

10. "James Robert Snoddy," *The History of South Carolina* (New York: American Historical Society, 1934), 4:322–23.

11. "The animal called the tiger by the early settlers was in reality a species of panther." Hellene Carlisle, Dr. Mark E. Durrett, Florence Quinn, Anne Pitts, and others, *Nazareth Presbyterian Church, 225 Years of Service, 1772–1997* (n.p., [1971]), 1.

12. John Snoddy's land grant from King George III was filed on May 4, 1775. South Carolina Department of Archives and History.

13. Isaac Snoddy biography, undated typescript of an address by Dr. H. R. Black to a reunion of the descendants of Patrick Crawford, July 27, 1895, at Nazareth Church; Edgar, *South Carolina,* 201.

14. Carlisle et al., *Nazareth,* 3.

15. Leyburn, *Scotch-Irish,* 301–2.

16. Richard J. Hooker, ed., "The South Carolina Regulator Movement: An Introduction to the Documents," in Charles Woodmason, *The Carolina Backcountry on the Eve of the Revolution* (Chapel Hill: University of North Carolina Press, 1953), 166.

17. Edgar, *South Carolina,* 215, 221.

18. Landrum, *Colonial History,* 87–88, 90.

19. Isaac Snoddy biography. Later retellings identify the marauders as Tories, but it is more likely that this narrative was inspired by fears of Indian attacks. J. B. O. Landrum adds to this story that the Tories "had specific orders to put to death every male child in the vicinity" (*History of Spartanburg County* [Atlanta: Frankling Printing and Publishing, 1900], 222). However, this biblical allusion may have been a later addition to the original cautionary narrative. In other narratives related to the Revolutionary War, Tories were more likely to kill adult men, destroy homes, and steal supplies than to murder children.

20. Landrum, *Colonial History,* 91–92.

21. The legacy of the American Revolution era survives through the name of the Spartanburg area, reportedly taken from the Spartan regiment formed by the Whig colonel John Thomas in 1775. Landrum, *Spartanburg County,* 11–12.

22. Walter B. Edgar, *Partisans and Redcoats: The Southern Conflict That Turned the Tide of the American Revolution* (New York: William Morrow, 2001), 139–40.

23. Ibid., xvii.

24. John Snoddy and Samuel Snoddy, "Accounts Audited of Claims Growing out of the American Revolution," files 7192 and 7193, South Carolina Department of Archives and History.

25. Landrum, *Colonial History,* 356; George Howe, *History of the Presbyterian Church in South Carolina* (Columbia: Duffie & Chapman, 1870), 435.

26. Carlisle et al., *Nazareth,* 5.

27. Landrum, *Spartanburg County,* 228–29.

28. Ibid., 226.

29. Leyburn, *Scotch-Irish,* 259.

30. U.S. Bureau of the Census, 1790.

31. Leyburn, *Scotch-Irish,* 263.

32. Klaus G. Loewald, Beverly Starika, and Paul S. Taylor, eds. and trans., "Johann Martin Bolzius Answers a Questionnaire on Carolina and Georgia," *William and Mary Quarterly* 14 (April 1957): 243.

33. Howe, *Presbyterian Church,* 434.

34. Edgar, *South Carolina,* 189; Leyburn, *Scotch-Irish,* 222.

35. Ruth E. Finley, *Old Patchwork Quilts and the Women Who Made Them* (1929; reprint with an introduction by Barbara Brackman, McLean, Va.: EPM, 1992), 21.

36. John Snoddy estate, Spartanburg County probate records.

37. Sally Garoutte, "Early Colonial Quilts in a Bedding Context," in *Uncoverings 1980,* volume 1 of the Research Papers of the American Quilt Study Group, ed. Sally Garoutte (Mill Valley, Calif.: American Quilt Study Group, 1981), 18–27; Gloria Allen, "Bedcoverings in Kent County, Maryland, 1710–1820," in *Quiltmaking in America: Beyond the Myths,* ed. Laurel Horton (Nashville: Rutledge Hill, 1994), 54–69.

38. Laurel Horton, "An Elegant Geometry: Tradition, Migration, and Variation," in *Mosaic Quilts: Paper Template Piecing in the South Carolina Lowcountry* (Greenville and Charleston: Curious Works Press and the Charleston Museum, 2002), 13.

39. Mary Schoeser, *World Textiles: A Concise History* (London: Thames & Hudson, 2003), 112–33.

40. Surviving European examples of fine whole-cloth quilts date back to the fourteenth century. Whole-cloth quilts were so popular in Europe that by the late seventeenth century they spawned in the south of France "an immense commercial needlework industry" that employed over five thousand women to produce hand-quilted bedding, clothing, and yardage for an international market. Kathryn Berenson, *Quilts of Provence: The Art and Craft of French Quiltmaking* (New York: Henry Holt, 1996), 31–34.

41. Laurel Horton, "White Work," in *The Quilters Ultimate Visual Guide,* ed. Ellen Pahl, (Emaus, Pa.: Rodale, 1997), 261–62.

42. Valerie Wilson, "Quiltmaking in Counties Antrim and Down: Some Preliminary Findings from the Ulster Quilt Survey," in *Uncoverings 1991,* volume 12 of the Research Papers of the American Quilt Study Group, ed. Laurel Horton (San Francisco: American Quilt Study Group, 1992), 149–50.

43. Tina Fenwick Smith and Dorothy Osler, eds., Special Issue on the 1718 Silk Patchwork Coverlet, *Quilt Studies* 5 (2003): 24–109.

44. Laurel Horton, "Quiltmaking Traditions in South Carolina," in *Social Fabric: South Carolina's Traditional Quilts,* ed. Laurel Horton and Lynn Robertson Myers (Columbia: McKissick Museum, [1985]), 11–14.

45. Probate records, Spartanburg County Estate Papers #1756, SC microfilm roll #1044.

46. Laurel Horton, "Quiltmaking Traditions in South Carolina," 15–17.

47. Elizabeth F. Ellet, *Women of the American Revolution* (New York: Baker & Scribner, 1848), 1:262. For another version see J. B. O. Landrum, *Colonial and Revolutionary History of Upper South Carolina* (Greenville: Shannon, 1897), 131.

48. Martha McJunkin Rhyne, *McJunkin: A Family of Memories* (Greenville: A Press, 1989), 6.

49. Edgar, *Partisans and Redcoats,* 98–100.

50. Sara Sullivan Ervin, *South Carolinians in the Revolution* (Baltimore: Genealogical Publishing, 1965), 103.

51. Mannie Lee Mabry, *Union County Heritage* (Winston-Salem: Hunter, 1981), profile 425; Rhyne, *McJunkin,* 32.

52. According to a local tradition, in order to select a central site for the church, two men, one at the upper part of the settlement and one at the lower, simultaneously started walking toward one another, and the church was built close to the spot where they met. Carlisle et al., *Nazareth,* 26; Howe, *Presbyterian Church,* 341, 433.

53. The Presbyterian Church requires that ministers receive formal theological training before they are ordained. Because of the substantial growth of the Presbyterian population in the backcountry in the late eighteenth century, the demand for ministers for frontier churches exceeded the supply, and many pulpits remained vacant or relied on occasional visiting preachers. Howe, *Presbyterian Church,* 660–61.

54. *The Psalms of David in Meter* (Scottish Psalter, 1650) incorporated earlier material compiled by Francis Rous in 1638. Raymond J. Martin, "The Transition from Psalmody to Hymnody in Southern Presbyterianism, 1753–1901," master's thesis, Union Theological Seminary, New York, N.Y., 1963, 9, 36.

55. Richard William Kadel, "The Evolution of Hymnody in the Presbyterian Church in the United States, 1850–1900," master's thesis, Florida State University, 1968, 17; Carlisle et al., *Nazareth,* 6; Leyburn, *Scotch-Irish,* 290.

56. Carlisle et al., *Nazareth,* 6; list of names of individuals buried, *Nazareth Presbyterian Cemetery,* pamphlet dated September 1993, in collection of Jane Cook.

57. Howe, *Presbyterian Church,* 220–21.

58. Edgar, *South Carolina,* 183.

59. Carlisle et al., *Nazareth,* 28.

60. Isaac Snoddy biography.

61. U.S. Bureau of the Census, 1810, Spartanburg County.

62. Snoddy family genealogy chart, prepared by James Dunlap Snoddy Jr. and Mary Neely Snoddy, in collection of Jane Snoddy Cook.

63. Isaac Snoddy biography.

64. Robert C. Kenzer, *Kinship and Neighborhood in a Southern Community: Orange County, North Carolina, 1849–1881* (Knoxville: University of Tennessee Press, 1987), 8. The pattern of development of Southern neighborhoods is distinct from the geometric pattern of townships of Midwestern states.

65. Ibid., 20.

66. The post office at New Hope was established on August 15, 1811. In 1854 its name was changed to Vernonville, and it is now known as Duncan. Wayne C. Grover, archivist of the United States, letter to Honorable Joseph R. Bryson, August 8, 1952. Photocopy in collection of Jane Cook.

67. Landrum, *Spartanburg County,* 223.

68. Isaac Snoddy biography.

69. For a description see "The Log Rolling," in Dallas T. Herndon, *Centennial History of Arkansas,* vol. 1 (Chicago and Little Rock: Clarke, 1922), 209–10, quoted in Benjamin A. Botkin, ed., *A Treasury of Southern Folklore: Stories, Ballads, Traditions, and Folkways of the People of the South* (New York: American Legacy, 1984), 606.

70. *The Frank C. Brown Collection of North Carolina Folklore,* vol. 1, ed. Newman Ivey White (1952; reprint, Durham: Duke University Press, 1971), 243–44.

71. Isaac Snoddy biography.

72. Ibid.

73. Ibid. Although the nature of this trade is not specified, it is quite likely that it involved buying and selling slaves, not an uncommon practice among white farmers during this era.

74. Ibid.

75. *Nazareth Presbyterian Cemetery.*

76. Isaac Snoddy biography.

77. The third son, Patrick Crawford Snoddy, had died at age twenty-one in 1830 while studying medicine in Lexington, Kentucky. Landrum, *Spartanburg County,* 299.

78. Spartanburg County Estate papers, 2349, filed February 7, 1842.

79. Isaac Snoddy biography.

80. Kenzer, *Kinship and Neighborhood,* 12–14.

81. Spelling of personal names was inconsistent during this period. Thressa is also rendered as Teresa or Tricy; Elinor also appears as Ellender or Eleanor in various records.

82. Samuel M. Snoddy was appointed guardian ad litem for John's seven children, although they lived with Elinor Snoddy at the time of the 1850 census. John Snoddy estate; U.S. Bureau of the Census.

83. Index to Estate Papers, Spartanburg County Estate Papers #1974, SC microfilm roll #54.

84. Ibid.

85. Walnut Grove plantation, a historic property owned by the Spartanburg Historical Association, has a large number of overshot coverlets in its collections. While the provenance is unknown for the majority, they reflect local textile traditions of the mid–nineteenth century.

Chapter 2: "I am doing the best I know how"

1. The *Spartan,* October 13, 1853, abstracted in Brent Holcomb, *Marriage and Death Notices from Upper S.C. Newspapers, 1843–1865* ([Greenville]: Southern Historical, n.d.), 60. Robert Harden Reid had been installed as pastor of Nazareth Church only a year and a half earlier, in April 1852. In 1857 Reid was instrumental in the formation of the Reidville Female College and Male High School a few miles southwest of Nazareth, and he served as both pastor of Nazareth and president of the two schools for forty years. Landrum, *Spartanburg County,* 374–77.

2. Landrum, *Spartanburg County,* 224–25.

3. Nancy Miller Benson does not appear to have been closely related to Samuel Miller Snoddy's great-uncle and namesake, Samuel Miller.

4. Landrum, *Spartanburg County,* 288.

5. Typewritten genealogical information, dated September 1 and 8, 1917, in collection of Jane Cook.

6. The Bensons transferred their membership to Mt. Zion Baptist Church in October 1855. Church records indicate that they were "received from the Campobello church," but there is no record of a Baptist church in Campobello at that time." Mt. Zion Baptist Church, Spartanburg, SC, Minutes, rolls, 1815–1955," microfilm, pub. no. 5003–67, Greenville Public Library.

7. Florence Montgomery, *Printed Textiles: English and American Cottons and Linens, 1700–1850* (New York: Viking, 1970), 13.

8. Ibid., 312, fig. 345.

9. Simpson, Young, Dean, and Coleman Families Papers (1822–1900), Plb 736 MSS 3879, South Caroliniana Library, University of South Carolina, Columbia.

10. Ibid.

11. The magnolia tree is pictured, accompanied by a poem by John Lane, in *Noble Trees of the South Carolina Upcountry* (Spartanburg: Hub City Writers Project, 2003), 28–30. A variant of the story among some family members is that S. M. Snoddy brought the tree home from Charleston when he returned from the war.

12. Horton, "Quiltmaking Traditions in South Carolina," 13.

13. See, for example, The Heritage Quilt Project of New Jersey, *New Jersey Quilts, 1777 to 1950: Contributions to an American Tradition* (Paducah, Ky.: American Quilter's Society, 1992), 48–50.

14. Barbara Brackman, *Clues in the Calico: A Guide to Identifying and Dating Antique Quilts* (McLean, Va.: EPM, 1989), 20. For discussions of population migrations and their impact on material culture, see Henry Glassie, *Pattern in the Material Folk Culture of the Eastern United States* (Philadelphia: University of Pennsylvania Press, 1968); and David Hackett Fischer, *Albion's Seed: Four British Folkways in America* (New York: Oxford University Press, 1989).

15. Laurel Horton, "Quiltmaking Traditions in South Carolina," 13.

16. Brackman, *Encyclopedia of Pieced Quilt Patterns,* 410–21.

17. Florence M. Montgomery, *Textiles in America, 1650–1870* (New York: Norton, 1984), 184–85.

18. Diane L. Fagan Affleck, *Just New from the Mills: Printed Cottons in America* (North Andover, Mass.: Museum of American Textile History, 1987), 11.

19. "Inventory of the goods and chattels of S. N. Drummond, Dec'd, September 17th, 1856," Spartanburg County Estate Records, #2481.

20. Brackman, *Clues in the Calico,* 142.

21. Barbara Brackman has noted two examples with nine points in this pattern family (#3449 and #3450) and a single occurrence of a pattern with thirteen points (#3466). *Encyclopedia of Pieced Quilt Patterns,* 410–21.

22. Patricia Veasey, *Virtue Leads and Grace Reveals: Embroideries and Education in Antebellum South Carolina* (Greenville and Rock Hill, S.C.: Curious Works and York County Culture and Heritage Commission, 2003), 10.

23. Ibid., 10; Bruce William Eelman, "Progress and Community from Old South to New South: Spartanburg County, South Carolina, 1845–1880," Ph.D. diss., University of Maryland, 2000, 186.

Notes to Pages 37–40

24. Archie Vernon Huff Jr., *Greenville: The History of the City and County in the South Carolina Piedmont* (Columbia: University of South Carolina Press, 1995), 94–95.

25. Christie Anne Farnham, *The Education of the Southern Belle: Higher Education and Student Socialization in the Antebellum South* (New York: New York University Press, 1994), 28–32.

26. Veasey, *Virtue Leads,* 10.

27. This suggestion is merely speculative. There is no known evidence for South Carolina quilts reflecting the number of children in the family of the maker.

28. Snoddy Family genealogy. *Nazareth Presbyterian Cemetery.*

29. The Snoddys' situation was typical of white slave owners throughout South Carolina in 1860, for whom about half to two-thirds of their net worth consisted of slaves. The average per capita wealth of free persons in South Carolina in 1860 was $2,017 (equivalent to $36,635 in 1996), ranking the state third nationally, behind Mississippi and Louisiana. Although Spartanburg District ranked near the bottom in wealth among other South Carolina districts, it still ranked just above the national average. Edgar, *South Carolina,* 285–86.

30. David Golightly Harris, *Piedmont Farmer: The Journals of David Golightly Harris 1855–1870,* ed. and with an introduction by Philip N. Racine (Knoxville: University of Tennessee Press, 1990), 2.

31. In comparison Samuel's father-in-law, Silas Benson, owned eight slaves, and his widowed mother, Jane Crawford Snoddy, owned fifteen slaves. In contrast Samuel's first cousin, "Captain" John Snoddy, owned thirty-three slaves, half of whom were children under ten. U.S. Bureau of the Census, 1860, Spartanburg District, microfilm reel M653–1226, pp. 386, 418, #1747; U.S. Bureau of the Census, Slave Schedule, M653–1237, pp. 204, 205, 210. From the number and ages of these slaves, it is likely that Captain John was actively engaged in slave trade, as were many wealthy planters throughout the state during this period. Michael Tadman, "The Hidden History of Slave Trading in Antebellum South Carolina: John Springs III and Other 'Gentlemen Dealing in Slaves,'" *South Carolina Historical Magazine* 97 (January 1996): 6–29.

32. U.S. Bureau of the Census, 1850, 1860, Agricultural Census, Spartanburg County, South Carolina Department of Archives and History.

33. United Daughters of the Confederacy, South Carolina Division, *South Carolina Women in the Confederacy,* vol. 2 (Columbia: State Co., 1907), 39–44.

34. Ibid., 47–48. The publication mistakenly identifies the area as "Ridgeville," but the family names listed are those of the Reidville area.

35. For information on the influence of the war on quiltmaking, see Laurel Horton, "South Carolina Quilts and the Civil War," in *Uncoverings 1985,* volume 6 of the Research Papers of the American Quilt Study Group, ed. Sally Garoutte (Mill Valley, Calif.: American Quilt Study Group, 1986), 53–69; Brackman, *Quilts from the Civil War* (Layfayette, Calif.: C&T Press, 1997); Bets Ramsey and Merikay Waldvogel, *Southern Quilts: Surviving Relics of the Civil War* (Nashville: Rutledge Hill, 1998).

36. E. Bryding Adams, "Alabama Gunboat Quilts," in *Quiltmaking in America,* 96–103.

37. Edgar, *South Carolina,* 364–65.

38. Landrum, *Spartanburg County,* 226, 538.

39. The term "mulatto" was used to describe the offspring of one white and one black parent. The majority of mulattos were the children of enslaved black women and white men, who were not always their masters. Such relations were common knowledge, though rarely openly discussed; and they ran the gamut from consensual arrangements to forced

167

assaults. See, for example, Harriet Jacobs, *Incidents in the Life of a Slave Girl* (New York: Norton, 2001), 387; Edward Ball, *Slaves in the Family* (New York: Ballantine, 1999), 57–58, 106–9.

40. Confederate Service Records, 5th State Troops, microfilm roll 200, 1112. These records are incomplete, but movements and engagements can be partially reconstructed from other sources.

41. Ibid.

42. The date inscribed on the letter is 1863, but there is no indication that Captain Snoddy enlisted before August 1863. In her anxiety Rosa seems to have committed a common January error in misdating her letter.

43. Farmers constructed ditches in their fields to carry off excess rainfall and prevent erosion. Harris, *Piedmont Farmer,* 499n6.

44. Betsy Wakefield Teter, ed., *Textile Town: Spartanburg, South Carolina* (Spartanburg: Hub City Writers Project, 2002), 21–24.

45. Mary Elizabeth Massey, *Ersatz in the Confederacy: Shortages and Substitutes on the Southern Homefront,* with a new introduction by Barbara L. Bellows (Columbia: University of South Carolina Press, 1993), 85–88.

46. Harris, *Piedmont Farmer,* 317.

47. Ibid., 261.

48. Ibid., 286, 318.

49. Holcomb, *Marriage and Death Notices,* 102; Snoddy family genealogy.

50. Confederate Service Records; "Company Records 1863–1865," James F. Sloan papers (1819–1903), South Caroliniana Library, University of South Carolina, Columbia.

51. Massey, 70.

52. "Company Records 1863–1865."

53. Ibid.

54. Edgar, *South Carolina,* 375.

55. Holcomb, *Marriage and Death Notices,* 104.

56. *Roll of the Dead: South Carolina Troops, Confederate States Service* (Columbia: South Carolina Department of Archives and History, 1994).

57. Confederate Service Records, roll 372.

58. *Roll of the Dead;* Silas Benson estate papers, Spartanburg District Probate Records; Pension Applications, 1919–1926, #0035 001 0000 1054900.

59. Harris, *Piedmont Farmer,* 377.

60. Eelman, "Progress and Community," 259.

61. Edgar, *South Carolina,* 380–81.

62. Harris, *Piedmont Farmer,* 396–475, passim.

63. Edgar, *South Carolina,* 379. For a detailed discussion of the effects of emancipation in a single Southern county, see Kenzer, *Kinship and Neighborhood,* 102–111.

64. U.S. Bureau of the Census, 1870, Spartanburg County; Agricultural Census, 1870, Spartanburg County.

65. Iris Bomar, *The Roots of Mary: The Bomar Family History* (Orangeburg, S.C.: Williams, 2000), 15.

66. During the 1850s Nazareth had about two hundred members, including sixty "colored" members enslaved to local masters, not all of whom were themselves members of the church. After 1866, "many blacks joined colored congregations of other denominations, there being no colored Presbyterian church at that time." "The Roll of Nazareth

Church: Adult Roll of Black Members," 90; "The Journal of the Session of Nazareth Church," 52–53; "Congregational Record, Nazareth Church [1872–1887], 15; Presbyterian Historical Society, Montreat, N.C.

67. Spartanburg County Equity, Box 46, pkg. 9, South Carolina Archives and History.

68. See Gladys-Marie Fry, *Stitched from the Soul: Slave Quilts from the Antebellum South* (Chapel Hill: University of North Carolina Press, 2002). Fry relied heavily on the slave narratives collected by the WPA Federal Writers Project. Some of the narrated events and many of the quilts included in this book date from the postbellum period.

69. Some writers argue that African American slaves made quilts of patterned blocks as early as the 1840s and used them to communicate escape plans. There is no material evidence to support such theories. See, for example, Jacqueline L. Tobin and Raymond G. Dobard, *Hidden in Plain View: A Secret Story of Quilts and the Underground Railroad* (New York: Doubleday, 1999).

70. Edgar, *South Carolina,* 396.

71. Horton, "South Carolina Quilts and the Civil War," 53–69.

72. Landrum, *Spartanburg County,* 226–27.

Chapter 3: "The spirit of kindness and generosity"

1. Isaac Snoddy biography. See also Edgar, *South Carolina,* 201.

2. B. R. Pollard, "Mrs. H. R. Black," in "The Letter Box" column, clipping from unidentified newspaper, Spartanburg, March 19, 1927.

3. Ibid.

4. Sam Orr Black Jr., interview with author, tape recording, June 1, 1999. Richard Tinsley (b. ca. 1854) lived with his wife, Lillie, and their nine children on the Snoddy farm well into the twentieth century.

5. Pollard, "Mrs. H. R. Black."

6. Ibid. In the typesetting of Pollard's original handwritten letter, Mary's nickname was misprinted as "Lurettia." This error was corrected in ink by a later hand.

7. N. M. T. [Author's full name is missing along with title page and cover], *The Southern Reader, Book Second* (Charleston: n.p., [1841] 1845), 1.

8. Lander, S[amuel], *Our Own School Arithmetic* (Greensboro, N.C.: Sterling, Campbell & Albright, 1863), iii. The copyright page indicates that this book was entered "in the Clerk's Office of the District Court of the Confederate States, for the District of Cape Fear, North Carolina." For more on Confederate publishers, see Massey, *Ersatz in the Confederacy,* 143.

9. Ibid., 140, 210, 135, 171, 174, 159, 221, 219.

10. Barbara Brackman, *Clues in the Calico,* 71–72.

11. Craig H. Roell, "The Piano in the American Home," in *The Arts and the American Home Life, 1890–1930,* ed. Jessica H. Foy and Karal Ann Marling (Knoxville: University of Tennessee Press, 1994), 85.

12. Ibid., 85–86.

13. New York: J. L Peters, 1864.

14. Michael Leonard, *Our Heritage: A Community History of Spartanburg County* (Spartanburg: Band & White, 1986), 43.

15. *The Story of Lander, 1872–1922,* photocopy of unpaginated booklet from Linda Dennis, director of alumni affairs, Lander University, Greenwood, S.C.

16. *Catalogue Williamston Female College* (Charleston: Walker, Evans & Cogswell, 1878), 13. Photocopy from Dan Lee, reference librarian, Lander University.

17. Ibid., 13, 22.

18. Ibid., 21.

19. Ibid., 10.

20. Ibid., 11–12.

21. Ibid., 22–23.

22. *Story of Lander,* n.p.

23. *Catalogue,* 14.

24. Margaret Snoddy Drummond was the daughter of Samuel's sister Ann and S. N. Drummond and therefore was Mary's first cousin. In 1878 Cousin Maggie was about twenty-eight years old and unmarried.

25. "The people" is a term frequently applied to slaves before the war. Here it may indicate a local black community, as Mary's third-person reference indicates that the speech was for some group other than students.

26. Due West is the location of Erskine College, founded by the Associate Reformed Presbyterian Church. Mary's favorable impression of these preachers may have been an influence in her later decision to leave Nazareth Presbyterian Church and join the A.R.P. Church, a separate denomination.

27. I wish to thank needlework historian/editorial consultant Kathy Staples for pointing out to me this theme and its significance.

28. Susan Burrows Swan, *Plain & Fancy: American Women and Their Needlework, 1650–1850,* rev. ed. (Austin, Tex.: Curious Works, 1995), 205.

29. *Story of Lander,* n.p.

30. *Catalogue,* 23.

31. Ibid.

32. Undated manuscript, in family collection.

33. "The Journal of the Session of Nazareth Church," 96, 105; Presbyterian Historical Society, Montreat, N.C.

34. Erma Hughes Kirkpatrick, "Garden Variety Appliqué," in *North Carolina Quilts,* ed. Ruth Haislip Roberson (Chapel Hill: University of North Carolina Press, 1988), 67–71; see also Horton and Myers, eds., *Social Fabric,* 2.

35. Joyce Joines Newman, "Making Do," in Roberson, *North Carolina Quilts,* 19, 21–22; see also Laurel Horton, "Economic Influences on German and Scotch-Irish Quilts in Antebellum Rowan County, North Carolina," master's thesis, University of North Carolina–Chapel Hill, 1979, appendix B, quilt 4.

36. Brackman, *Clues in the Calico,* 69.

37. Barbara Brackman, *Encyclopedia of Appliqué* (McLean, Va.: EPM, 1993), 22.

38. Sewing machines were such a novelty that some quiltmakers used them not only for joining seams, but for visible appliqué work and even quilting. See Suellen Meyer, "The Sewing Machine and Visible Machine Stitching on Nineteenth-Century Quilts," in *Quiltmaking in America,* 112–21.

39. Theresa Singleton, "Textiles in South Carolina," in *Social Fabric,* ed. Horton and Myers, 8–9; Betsy Wakefield Teter, ed., *Textile Town: Spartanburg, South Carolina* (Spartanburg: Hub City Writers Project, 2002), 20–21.

40. Brackman, *Encyclopedia of Pieced Quilt Patterns,* 350–51.

41. Brackman, *Clues in the Calico,* 23, 24, 144–46.

42. Carrie A. Hall and Rose G. Kretsinger, *The Romance of the Patchwork Quilt in America* (New York: Bonanza, 1935), 53.

43. Diane L. Fagan Affleck, *Just New from the Mills: Printed Cottons in America* (North Andover, Mass.: Museum of American Textile History, 1987), 29, 46, 23.

44. Spartanburg *Herald,* May 19, 1875.

45. Colleen McDannell, "Parlor Piety: The Home as Sacred Space in Protestant America," in *American Home Life, 1880–1930,* ed. Jessica H. Foy and Thomas Schlereth (Knoxville: University of Tennessee Press, 1992), 170.

46. Spartanburg County Estate Records. This inventory was taken in 1898. Many of the pieces are described as "old style," which suggests that the house's furnishings reflect the selection and usage of an earlier generation.

47. Silas Benson Estate, Spartanburg County Probate Records #4260, SC microfilm roll #1042. In 1879, at the death of Silas's widow, Nancy Miller Benson, the remainder of their personal property was sold at auction. There is no indication that the sewing machine was auctioned, suggesting that a family member received it.

48. Anne Scott MacLeod, "Reading Together: Children, Adults, and Literature at the Turn of the Century," in Foy and Marling, *Arts in the American Home,* 111.

49. Beverly Gordon, "Cozy, Charming, and Artistic: Stitching Together the American Home," in Foy and Marling, *Arts in the American Home,* 125.

50. U.S. Bureau of the Census, 1880, Spartanburg County; Spartanburg County Probate Records.

51. Brackman, *Encyclopedia of Pieced Quilt Patterns,* 114.

52. Snoddy, *History of South Carolina,* 322.

53. James Robert Snoddy journal, transcribed by Mary Neely Snoddy, 1999. Mary Neely Snoddy is the wife of James Dunlap Snoddy Jr., the great-grandson of James Robert Snoddy. The author is deeply grateful to Mary Neely Snoddy for sharing her meticulous renderings of these valuable primary sources.

54. Lewis P. Jones, in collaboration with Dr. Sam Orr Black Sr., *Hugh Ratchford Black: A Medical Pioneer, 1856–1933* (Spartanburg: Reprint Co., 1963), 9.

Chapter 4: "Paid Sweet to get Sewing Machine"

1. J. R. Snoddy's journals during this period primarily reflect business dealings and include few personal notations. He made no entry at all for the day of Mary's wedding, suggesting that he was engaged in wedding festivities rather than conducting business. The lack of entries does not indicate nonparticipation or a lack of interest. The previous October he and his wife had lost an infant daughter at birth, and he made only two entries the entire month.

2. Jones, *Hugh Ratchford Black,* 10.

3. Ibid., 7–9.

4. Ibid., 9; U.S. Bureau of the Census, 1880, Spartanburg County, Soundex M245.

5. The Associate Reformed Presbyterian Church developed from the division and unification of a number of denominational strands. The Reformed church (Covenanters) and the Associate church separated from the Church of Scotland during the Restoration; but in 1782 the branches of the two groups in this country united as the Associate Reformed Church. See Robert Lathan, *History of the Associate Reformed Synod of the South, to Which Is Prefixed a History of the Associate Presbyterian and Reformed Presbyterian Churches* (Harrisburg, Pa., 1882).

6. Jones, *Hugh Ratchford Black,* 8, 10.

7. "The Journal of the Session of Nazareth Church," 27. Presbyterian Historical Society, Montreat, N.C.

8. James Robert Snoddy journal, August 24, December 13, 1887; May 7, 1888; February 14, July 17, July 30, August 12, 1889; February 20, 1890.

9. Raymond J. Martin, "The Transition from Psalmody to Hymnody in Southern Presbyterianism, 1753–1901," master's thesis, Union Theological Seminary, 1963, iii.

10. *The Book of Psalms: The Scottish Version Revised, and the New Versions Adopted by the United Presbyterian Church of North America* (Pittsburgh: United Presbyterian Board of Publication, 1871), 4.

11. These metrical designations refer to the number of syllables in each line of a verse, facilitating the match or interchange of verses and tunes within those sharing the same meter. For instance the familiar words to the text of "Amazing Grace" are in Common Meter (8,6,8,6), which allow them to be sung to the equally familiar tune "New Britain" or any other tune in the same meter.

12. Craig H. Roell, " The Piano in the American Home" in *The Arts and the American Home,* ed. Foy and Marling, 97–99.

13. Jones, 10.

14. Jessica H. Foy, "The Home Set to Music," in *The Arts and the American Home,* ed. Foy and Marling, 62.

15. Spartanburg County land records, RRR 168.

16. Jones, *Hugh Ratchford Black,* 10.

17. The name "Orr" may have come into the family in honor of W. W. Orr, an A.R.P. evangelist who held revival meetings throughout the Southeast in 1890. *Centennial History of the A.R.P. Church* (1903; reprint, 1979), 359. Shortly before his death, Sam Orr Black Jr. told his niece Sallie James that he had been told by his father, Sam Orr Sr., that he was named for a good friend of the family. The two accounts are not incompatible.

18. J. R. Snoddy journal; Spartanburg County Register of Deeds, TTT 105 (1889).

19. Spartanburg County land records, ZZZ576. This deed was filed on March 25, 1899, prior to the land survey and division. The provisions of this deed appear to have been pre-empted by the later deeds; nonetheless it is an indication of the unpleasant feelings within the family.

20. J. R. Snoddy journal, July 22, 1908; Leonard, *Our Heritage,* 44.

21. Betsy Wakefield Teter, ed., *Textile Town: Spartanburg, South Carolina* (Spartanburg: Hub City Writers Project, 2002), 313–14.

22. Ibid., 72. Stephen Greene was an architect in partnership with engineer and fellow New Englander Amos Lockwood. Lockwood, Greene & Company had already designed a number of local mills, including Pacolet, Spartan, Clifton, and Whitney.

23. Teter, *Textile Town,* 316.

24. J. R. Snoddy journal, April 12, 1897.

25. Jacquelyn Dowd Hall et al., *Like a Family: The Making of a Southern Cotton Mill World* (Chapel Hill: University of North Carolina Press, 1987), 53–56.

26. Phillip N. Racine, *Seeing Spartanburg: A History in Images* (Spartanburg: Hub City Writers Project, 1999), 181.

27. Teter, *Textile Town,* 312.

28. Sally Garoutte, "Marseilles Quilts and Their Woven Offspring," in Horton, ed., *Quiltmaking in America,* 77.

29. Brackman, *Encyclopedia of Pieced Quilt Patterns,* 208, #1645.

30. Erma Kirkpatrick, "A Study of 'Alamance Plaids' and Their Use in North Carolina Quilts," in *Uncoverings 1988,* volume 9 of the Research Papers of the American Quilt

Study Group, ed. Laurel Horton (San Francisco: American Quilt Study Group, 1989), 45–55.

31. J. R. Snoddy journal, August 16, September 19, 1902; June 2, 1905; April 1, 1909; January 8, 1923.

32. Brackman, *Encyclopedia of Pieced Quilt Patterns,* 208, #1646a.

33. Ibid., 92, # 713; 522.

34. The other unmarried Maiden Wingo was the daughter of John "Crust" and Cynthia Wood Wingo, born ca. 1829. (John was the second cousin of Burrell's father.) The two married Maiden Wingos were both wives of Burrell's brothers: Maiden High, who married Anderson Wingo, and Maiden Foster, who married Paschal Wingo. Lorene Burton Ambrose, *Jammie Seay: His Descendants and Other Allied Lines* (1977), 135.

35. Spartanburg County Estate Papers #3131, SC microfilm roll #1094.

36. This pattern was published in the *Farm Journal* as Duck and Ducklings at some point. Brackman, *Encyclopedia of Pieced Quilt Patterns,* 304–5, #2439. The corner figures also resemble a pattern called Sail Boat, 380–81, #3172.

37. Brackman, *Encyclopedia of Pieced Quilt Patterns,* 158, # 1130b.

38. Finley, *Old Patchwork Quilts,* 74–75.

39. Penny McMorris, *Crazy Quilts* (New York: Dutton, 1984), 12.

40. Laurel Horton, *Glorified Patchwork: South Carolina Crazy Quilts* (Columbia: McKissick Museum, 1989), 9.

41. A surviving typescript of Dr. Black's address provided the basis for the biographical information in chapter 1. As Dr. Black had not known Isaac Snoddy, the primary source for his information would have been Col. Samuel M. Snoddy. Dr. Black was representing his wife, as it would not have been seemly for a woman to speak in public. Reverend Reid had known Jane Crawford Snoddy before her death thirty years earlier. Although Jane's name never appeared on the church membership roll, Reid cited both her knowledge of the scriptures and her punctuality in attending services.

Chapter 5: "Let others live the rowdy life"

1. *A History of Spartanburg County,* compiled by the Spartanburg Unit of the Writer's Project of the Work Projects Administration (WPA) in the State of South Carolina (Spartanburg: Reprint Co., 1976), 206.

2. Jones, *Hugh Ratchford Black,* 12–13.

3. "From a Woman's Viewpoint," *Spartanburg Journal,* December 6, 1902.

4. According to historian Lewis Jones, there is no record that the loan was ever repaid. Jones, *Hugh Ratchford Black,* 17; Real Estate Mortgage Book, book 52, p. 102, in office of Register of Mesne Conveyance, Spartanburg County.

5. This building later became the Georgia Cleveland Home, a residence for elderly women. Jones, *Hugh Ratchford Black,* 17–18.

6. No records of the Wellford church survive. On August 12, 1899, J.R. noted, "Sold church seats for cash 6.75," which might have been those of the disbanded A.R.P. Church.

7. The *Sesquicentennial History of the Associate Presbyterian Church, Mainly Covering the Period, 1903–1951, Prepared and Published by Order of the General Synod* (Clinton, S.C.: Jacobs Brothers, 1951), 559–60.

8. Minutes of the A.R.P. Synod of the South, 1910–1914, Presbyterian Historical Society, Montreat, N. C.

9. *Spartanburg Journal,* October 10, 1902.

10. Information on the activities of the Ladies' Aid Society consists of handwritten documents, graciously provided by Agnes Coleman, historian for the Spartanburg A.R.P. Church.

11. Dorothy Cozart, "A Century of Fundraising Quilts, 1860–1960," in Horton, ed., *Quiltmaking in America,* 158, 161.

12. "Sketches of Ministers: Arthur Jones Ranson," *Sesquicentennial History,* 284–86.

13. In auctions the term "bought in" refers to a minimum reserve bid set by the owner in case the bid is less than the value of the item. If this is the intended meaning of the group's secretary, it may indicate that the quilt did not attract an appropriate bid at auction and the group later decided to give it to the Ransons.

14. Laurel Horton, "An 'Old-Fashioned Quilting' in 1910," in *Uncoverings 2000,* volume 21 of the Research Papers of the American Quilt Study Group, ed. Virginia Gunn (Lincoln, Neb.: American Quilt Study Group, 2000), 1–25.

15. *Sesquicentennial History,* 685–86.

16. Minutes of Board of Foreign Missions, A.R.P. Church, October 7, 1909, p. 89. Erskine College Library.

17. Jones, *Hugh Ratchford Black,* 15.

18. J. R. Snoddy journal, April 16 and 18, June 19, 1908.

19. *Spartanburg Herald,* August 24, 1910.

20. Ibid., September 4, 1910.

21. "Spartanburg Graded School Honor Roll," *Spartanburg Journal,* November 12, 1902. Sam Orr was in grade 6 and Hugh in grade 4.

22. "Baseball for the Monument Fund," *Spartanburg Herald,* July 28, 1910, 8.

23. "Markell Private Tours: Europe in 1913," promotional pamphlet, in family collection.

24. Emma [Jennings] to Rosa Black, July 12, 1913.

25. Mary Snoddy Black (MSB) to Rosa Black (RB), June 12, 1913.

26. Ibid.

27. MSB to RB, June 16.

28. Ibid.; MSB to RB, July 21.

29. MSB to RB, July 28; MSB to RB, July 16; MSB to RB, August 7.

30. Ibid., MSB to RB, June 23; MSB to RB, July 4.

31. Nannie J. Coan (NJC) to RB, July 11.

32. Hugh Ratchford Black (HRB) to RB, July 16; HRB to RB, July 12.

33. Hugh Snoddy Black (HSB) to RB, August 4; MSB to RB, August 10.

34. The causes of pellagra, a debilitating illness, were unknown in 1913. Rampant during this time, particularly among cotton mill workers, pellagra was later found to be caused by a vitamin deficiency.

35. MSB to RB, July 21; MSB to RB, July 28.

36. Interview with Dr. Sam Orr Black Jr., June 1, 1999; MSB to RB, July 16; MSB to RB, July 21.

37. HSB to RB, August 4; Sam Orr Black Jr. interview.

38. Mary Kate Black (MKB) to RB, July 21; MKB to RB, July 26.

39. MSB to RB, June 23.

40. Ibid.; MKB to RB, June 26; MSB to RB, June 16; NJC to RB, August 7; Paul Black to RB, July 28.

41. MSB to RB, July 21; MSB to RB, August 7.

42. MSB to RB, September 5.

43. MSB to RB, August 7.

44. *Spartanburg Journal,* November 12, 1902. For more information on the Chatham Manufacturing Company of Elkin, N.C., see Newman, "Making Do," in Roberson, *North Carolina Quilts,* 33–35.

45. *Spartanburg Journal,* October 17, 1902. Oil mills were a subsidiary industry to textile manufacturing. Cotton seeds were pressed for oil and the solid residue used for livestock feed. The salvage and resale of the short fibers adhering to the seeds represented an additional income stream for the oil mills.

46. Children's handkerchiefs, often printed with storybook designs, were sometimes combined into quilts during this period, but other examples of quilts from red bandannas have not been identified. J. J. Murphy, *Children's Handkerchiefs: A Two Hundred Year History* (Atglen, Pa.: Schiffer, 1998), 33, 35, 40–41, 61.

47. Susan S. Bean, "The Indian Origins of the Bandanna," *The Magazine Antiques* 156 (December 1999): 832–39.

48. Leonard, *Our Heritage,* 120.

49. Horton, *Glorified Patchwork,* 10.

50. See Brackman, *Encyclopedia of Pieced Quilt Patterns,* 308–9, # 2483, although the light/dark are reversed.

51. Actually the label says, "Quilted by her, Cousin Mag & Auntie." This suggests some confusion on the part of Mary Kate, and there is a black line drawn across "+ Auntie."

52. Brackman, *Clues in the Calico,* 91–92, 67–68.

53. Ethel Davis Seal, "Making the Most of the Colonial Revival," *Ladies' Home Journal* (June 1924): 197.

54. Rosalind Perry, biography of the author in *Quilts: Their Story and How to Make Them,* by Marie D. Webster, new edition (1915; reprint, Santa Barbara, Calif.: Practical Patchwork, 1990), 208–12.

55. Jeannette Lasansky, "The Colonial Revival and Quilts, 1864–1976," in *Pieced by Mother: Symposium Papers,* ed. Jeannette Lasansky (Lewisburg, Pa.: Oral Traditions Project, 1988), 97–105.

56. Application for membership, completed by Rosa Snoddy, photocopy provided by DAR office, Washington, D.C. For more information about the D.A.R. and its interest in historic quilts, see Nancy Gibson Tuckhorn, "A Profile of Quilts and Donors at the DAR Museum," in *Uncoverings 1990,* volume 11 of the Research Papers of the American Quilty Study Group, ed. Laurel Horton (San Francisco: American Quilt Study Group, 1991), 130–48.

57. UDC Application of Rosa Black, May 4, 1917. Photocopy provided by UDC office, Richmond, Va. In its early years the UDC had as its purpose "to aid and care for needy Confederates and their families," but by 1910 the group's effort had turned toward establishing monuments honoring Confederate dead and veterans in cities and towns throughout the southern states. The South Carolina chapter also published, in two volumes, *The Women of the Confederacy,* which records women's individual and group efforts during the war. "To the Daughters," *Lost Cause* 3 (October 1899): 42; *Spartanburg Herald* special Confederate memorial issue, August 17, 1910.

Chapter 6: "Her faith, her charity, and her talent for making friends"

1. Jones, *Hugh Ratchford Black,* 21.

2. Dr. Sam Orr Black Sr., *Dr. Sam: Individualist* (Spartanburg: Altman, 1970), 20–21, 26.

3. Jones, *Hugh Ratchford Black,* 22.

4. Interview with Sam Orr Black Jr., June 1, 1999.

5. Interview with Marianna Black Habisreutinger, Spartanburg, May 12, 1999.

6. "Students who take the entire four years' work . . . in Drawing, Painting, and General History of Art, but do not take the work in academic subjects, will be awarded a Certificate of Proficiency upon completion of the course." *Annual Catalogue of the Officers, Teachers, and Students of Converse College, Spartanburg, S.C., 1916–1917* (Spartanburg: Band & White, [1917]).

7. J. R. Snoddy journal, January 29, 1924 through September 18, 1924, passim.

8. J.R. mentioned Paul by name in his journal with increasing frequency during the 1920s: 3 times during 1920, 26 times during 1921, 44 times in 1922, and 38 times in 1923.

9. J. R. Snoddy journal, entries throughout the 1920s.

10. Jones, *Hugh Ratchford Black,* 20.

11. Ibid., 23.

12. Rosa was apparently visiting somewhere in the vicinity of Baltimore at the time, as Mary asked her to do an errand there. Letter in collection of family.

13. Interview with Sam Orr Black Jr. and Shirley Black Barre, June 1, 1999.

14. According to quilt researcher Pepper Cory, such household substances as self-rising flour, baking powder, and baking soda were used to mark lines for quilting. Heat and dampness can cause these materials to absorb moisture, initiating a chemical reaction with the fabric that can result in discoloration. Telephone message for author, August 11, 1999.

15. Brackman, *Clues in the Calico,* 308–9, #2472. The Ladies Art Company, credited as the first mail-order quilt pattern company, published this pattern under this name in a late-nineteenth-century catalog.

16. Quilt designer Marie Webster produced a number of appliqué quilts using linen motifs. Indianapolis Museum of Art, "Marie Webster's Quilts: A Retrospective," exhibition catalog, March 24–September 30, 1991. Otherwise the use of linen in other quilts influenced by the Colonial Revival or in utilitarian and scrap quilts is largely undocumented.

17. Laurel Horton, "Quiltmaking Traditions in South Carolina," 13–14.

18. See Brackman, *Clues in the Calico,* 265–66, #2246; Ladies Art Company catalog #10, Star Puzzle.

19. When Shirley Black Barre died, a quilt was found among her belongings by her son Walter Barre. The quilt dates from the late nineteenth or early twentieth century, and it is possible that Mary gave it to Sam Orr and Sallie Marvil Black when they married. If Mary gave a quilt to Hugh and Iris, it has not remained within the family.

20. Sam Orr Black Jr. interview.

21. J. R. Snoddy journal, November 25, 1926 through March 9, 1927, passim. Mary Black's date of death is recorded elsewhere as March 11, so it is likely that J.R. wrote this note later and recorded the wrong date.

22. "Mrs. H. R. Black Dies after Long Illness in City," *Spartanburg Herald,* March 12, 1927, 1.

23. "Address at Mrs. H. R. Black's Funeral," photocopy of typescript in family papers.

24. Shirley Barre Black interview.

25. "Mrs. H. R. Black Will Be Buried at 3:30 o'Clock," clipping, probably *Spartanburg Herald,* March 14, 1927.

26. The graves of Mary and H. R. Black were later moved to Greenbriar Cemetery, where their children are also buried.

27. Dr. Black was retained as a surgeon by both the Southern and the Charleston & Western Carolina railways; Jones, *Hugh Ratchford Black,* 26. The railroad imagery in his note suggests that Dr. McLendon of Blackwell, Oklahoma, may have served in a similar capacity.

28. "Dr. Hundley Dies Suddenly in St. Moritz," *Spartanburg Journal,* January 2, 1928.

29. "Black-Huntley [*sic*] Wedding of Much Social Interest," unidentified newspaper clipping in family collection.

30. Telegrams and newspaper clippings in family collection.

31. J. R. Snoddy journal, January 20–21, 1928.

32. "Mrs. Hundley Received Estate of Husband," *Henry Bulletin,* April 3, 1928, 1.

33. "Mrs. D. M. Coan Burial Sunday," *Spartanburg Herald,* November 10, 1928.

34. J. R. Snoddy journal, November 9–13, 1928.

35. Interview with Paula Black Baker, Spartanburg, June 21, 1999.

36. Michael Wallis, *Oil Man: The Story of Frank Phillips and the Birth of Phillips Petroleum* (New York: Doubleday, 1988), 346–47.

37. Sam Orr Black Jr., interview.

38. "Black Rites to Be Held at Home Tuesday," *Spartanburg Journal,* October 9, 1933, 1.

39. Family members use this form when writing the names of the men in the family. However, when speaking, they elide *doctor* using a glottal stop, a vocal sound made when the vocal cords are pressed together, as in the sound in the middle of the interjection *uh-oh.* Thus, the names are heard as *Dah Paul, Dah Hugh,* and *Dah Sam.*

40. Wallis, 467.

Chapter 7: "Let's share these quilts"

1. The Mary Black Foundation had been established in 1986 as the fundraising arm for the nonprofit hospital. As a result of the conversion to investor-owned status, the foundation assets expanded from about $2 million to over $60 million, making the Mary Black Foundation the third largest foundation in South Carolina. Mary Black Foundation, Inc., *Annual Report, 1997–1998;* The Foundation Center, *Top 50 South Carolina Foundations by Assets,* http://fdncenter.org/fc_stats/pdf/09_top50_aa/2001/sc_01.pdf (accessed September 26, 2004).

2. The Black & Phillips Foundation was set up by Mary Kate Black Phillips, Marianna Habisreutinger, and Paula Baker in 1991, originally to provide financial support for the Mary Black Memorial Hospital.

3. Julia Oates and Alice H. Skelton, *Woman's Work in the Associate Reformed Presbyterian Church* (Greenville, S.C.: A.R.P. Center, 1982), 4.

4. Written labels on paper sewn to quilts are very rare. More often inscriptions were written or embroidered directly onto the fabric, though these typically include only the maker's name and the date of completion. During the late twentieth century, many quiltmakers signed or labeled their quilts in an effort to convey this information to future generations.

5. Folklorist Susan Roach analyzed a similar late-twentieth-century family quilting event, in which "quiltmaking creates a situation that brings a woman, her daughters, and her grandchildren together." Without the object and task, there would probably have been no gathering of kin of this size on a nonholiday. "The Kinship Quilt: An Ethnographic

Semiotic Analysis of a Quilting Bee," in *Women's Folklore, Women's Culture,* ed. Rosan A. Jordan and Susan J. Kalèik (Philadelphia: University of Pennsylvania Press, 1985), 58.

6. Becky Herdle, *Time-Span Quilts: New Quilts from Old Tops* (Paducah, Ky.: AQS, 1994) includes some discussion of this phenomenon.

7. Lewis Hyde, *The Gift: Imagination and the Erotic Life of Property* (New York: Random House, 1983), 11–20.

8. Ibid., 106–8.

9. Michael Owen Jones, "How Can We Apply Event Analysis to 'Material Behavior,' and Why Should We?" *Western Folklore* 56 (Summer and Fall 1997): 209.

INDEX